DENVER
FOOD

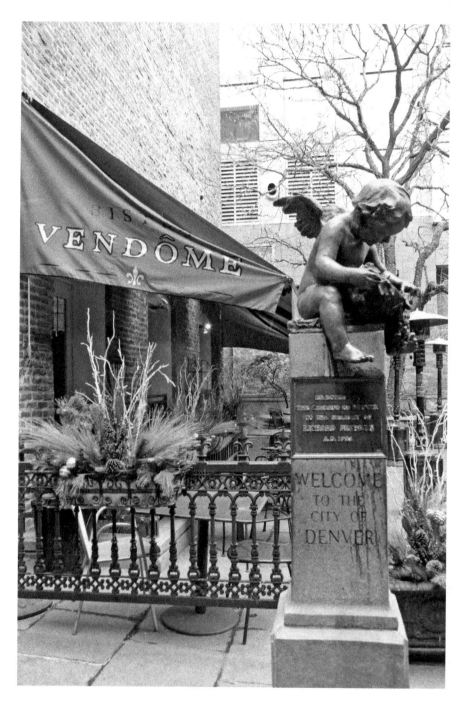

Bistro Vendôme angel. "Welcome to the City of Denver." This beautiful angel, located in the Kettle Arcade courtyard, was dedicated in 1926. *Author photo.*

DENVER FOOD

A CULINARY EVOLUTION

Simone FM Spinner

AMERICAN PALATE

Published by American Palate
A Division of The History Press
Charleston, SC
www.historypress.com

Front cover, clockwise from top left: Denver Union Station Farmers Market, *author photo*; Alex Seidel at Fruition, *courtesy of John Poplin*; Eat Here, *courtesy of John Poplin*; The Kitchen LoDo patio, *courtesy of The Kitchen.*

First published 2018

ISBN 9781540235695

Library of Congress Control Number: 2018940086

I would like to dedicate this book to the culinary sensualists of the world.

For my loves, Oscar Wilde Spinner and Zen Zen Spinner, for bringing me joy every moment of every day.

CONTENTS

ACKNOWLEDGEMENTS

I would like to express my most sincere thanks to Artie Crisp, my editor with Arcadia Publishing/The History Press, for giving me a chance and the time needed to learn my way. Without your enthusiasm for the culinary evolution underway in Denver, this book would have gone unwritten. Being given the opportunity to become an author fulfills one of my lifelong dreams, and to be honest, I learned more about myself researching and writing this book than the topic at hand. I have always loved my city, but taking a closer look around my hometown brought many pleasant surprises, and the research was delicious! Thank you also to my Arcadia Publishing/The History Press team—Abigail Fleming, Katie Parry and Erin Owens—for your guidance, patience and dealing with major time zone differences and last-minute details.

I must express my most sincere gratitude to all of the amazingly talented chefs and industry professionals who graciously offered their time, their stories and their passion for these pages. Mel and Janie Master, Bill Miner, Brian Albano, Liz and Mike Nail, Alex Seidel, Aaron Forman, Justin Brunson, Ryan Leinonen and Pierre and Jean Wolfe—without you, Denver wouldn't be so delicious. Thank you Anthony Bourdain for challenging me to take up my pen against your acerbic, unrepentant critique of the Denver food scene.

Thank you to my mother, Colleen E. McKenna, for her constant encouragement, understanding, and reading and rereading draft after draft. Thanks to my boys, Oscar and Zen, for sacrificing so much so I could spend the time learning to write a book. Thank you to Margaret Woodhull, PhD;

David Hildebrand, PhD; and Marta Garcia Barbera and Domingo Chomin Robledo, for exploring the tapas trail in Logroño, Spain, with me. Many thanks to Antonio Bellisaro, PhD, for always inspiring me to see another point of view. And a special thank-you to Dr. Suzanne Kenneally for always believing in me.

This book would have been impossible without the resources and staff at the Denver Public Library and Colorado History Museum. The images in this book are the author's own work unless otherwise credited. Thank you to The Kitchen and John Poplin for providing additional photographs to this work.

PREFACE

My passion for food was born in my mother's kitchen, where measuring spoons were my rattle, and pots, pans and wooden spoons were my favorite toys. My mother is impeccable in every way: elegant, precise, adventurous and creative in her life and her cooking. I learned my fractions by using measuring spoons and cups to parcel out flour, sugar, spices, baking powder and soda, herbs, butter and cocoa making brownies, apple crisp and savory pastries. I was drawn to the creativity of the flavors, textures, colors and smells as they blended and transformed into something completely new. Being able to gather groupings of ingredients, combining them with careful technique, in such a way and in a certain order, to create something delectable fascinated me.

She is a sensualist, and I must have gotten that from her. She makes a delicious spaghetti pie, beef stroganoff, picnic meat pies, boeuf bourguignon, flavorful and hearty soups, soft shell tacos and amazingly juicy hamburgers. She loves to bake pies, cakes, cupcakes, brownies, cookies and cheesecakes. She always followed her recipes to a tee. My mom dared to make ethnic foods, tried new recipes and even created a few of her own. When I was a child, she used Julia Child's *Mastering the Art of French Cooking* or Betty Crocker's red-and white-checked cookbook nearly every day but also clipped dozens of recipes from newspapers, magazines and even books—a trend I have taken up and to the extreme. Over the years, I have collected several binders filled with clippings. When I was a little girl, I was presented with Betty Crocker's *Cookbook for Kids*, and I made just about every recipe in the book. I still have it on my shelf. One of my most treasured possessions is a notebook my mother

gave me with all of her favorite recipes handwritten inside. The pages have become faded and stained from all of my years of use, but I treasure it nonetheless. I have added three notebook volumes to the collection of hand-scribbled recipes. In the 1970s and 1980s, when I was a child, there weren't many culinary-focused magazines or television shows, but we watched Julia Child together. I loved her. We got Williams Sonoma catalogues in the mail and would lust over the gadget-filled glossy pages.

In high school, I entertained culinary school for a brief moment. I worked front of house in a dozen restaurants in my youth, but in the end, I chose another path for myself. My love of cooking and dining never subsided. I find myself to be an adventurous and skilled cook, breaking more rules and creating more recipes than my mother. Cooking shows have evolved from Julia Child's day and now *Avec Eric* (Ripart), *No Reservations* and *Parts Unknown* (Anthony Bourdain) and *New Scandinavian Cooking* (Andreas Viestad) have taken her place as my inspiration when I cook at home, which is nearly every day. I enjoy dining out and often have the opportunity to do so, but in my career as a wine expert, it can become a bit monotonous and unhealthy dining even in the best restaurants. Nevertheless, those dining experiences inform and inspire my own creations every single day.

Author's Note

I first met Anthony Bourdain and Eric Ripart while they were out on the *Good vs Evil* tour at their Boulder, Colorado stop in April 2013. When asked about the culinary scene in Denver and Boulder, "Good" Eric Ripart had positive things to say but "Evil" Anthony Bourdain gave a particularly scathing review of Denver food. His Travel Channel show *No Reservations* had taken him there twice, and while he admitted to some minor improvements and his adoration of Biker Jim's hotdog cart, he had few kind words about the scene. He was unapologetic in his assessment even though he knew that he was speaking to a room filled with chefs, dishwashers, line cooks, bussers, servers, bartenders, industry professionals, food writers, foodies and loyal fans from Denver and Boulder. I respected him for that.

Our next conversations were at the Cayman Cookout in January 2015. Four days of chef mingling, cooking demonstrations, stingray swims, beachy cookout deliciousness and a chance for me to pose my questions again. All things culinary were booming in Denver: we were getting national press, making top restaurant lists, James Beard award recognitions and a flood of new culinary talent opening up shop. I wanted Anthony to know about these amazing changes and to give the city another chance to excite him.

When I asked him if he was still disenchanted with Denver, he shrugged his shoulders with a grimace and quipped that all of the legal pot smoking was probably interfering with greatness. He graciously joked about knowing a thing or two about the obvious downsides of smoking pot on the cooking line. Eric nudged him a little and he said he might give Denver another chance if something really big were to happen there. Something like Nobuyuki "Nobu" Matsuhisa opening a sushi place in Cherry Creek (he did) or Daniel Boulud opening a Daniel outpost in Denver (he hasn't).

Bourdain's work on *Parts Unknown* for CNN never brought him back to Denver. His celebrity platform and his world of influence continued to expand, and he had other corners of the world to explore. I wish he could have seen how Denver blossomed in 2017 and 2018. I wrote *Denver Food: A Culinary Evolution* as a response to those last conversations at the Cayman Cookout: to shine a light on a long neglected food scene, a group of truly talented, passionate and determined chefs and culinary professionals, to show that they deserve a second look and they are finally earning the recognition they all deserve. I wish Anthony, Eric and I could have had one more conversation about the culinary evolution of Denver food or about anything at all.

I find it tremendously ironic that I received my edited manuscript from The History Press for final review the same day that I, and the world, learned of Anthony Bourdain's passing. I am deeply saddened by this tragic and most surprising news. His career as an author inspired me to finally put pen to paper. Anthony Bourdain inspired not just this book but a certain attitude that I take toward my life: my culinary scouting travels, my adventurous food and life choices, my move to Portugal and the risks I have taken in the face of "glorious failure" to live authentically and fearlessly, like Anthony. I owe him so much, and he never knew. He never knew just how loved, admired and appreciated he was by so many people around the world. Thank you for the gifts you gave to all of us, so freely. You will be forever missed.

From Cascais, Portugal, June 10, 2018

Please visit my website for additional information about *Denver Food: A Culinary Evolution*: www.winerocksllc.com

There, you will also find information about my companies: Wine Rocks and Chasing Grapes, LLC, along with links to my academic work exploring the effects of climate change on wine culture, other musings and my pending books, *Lessons from the Lisbon Coast* and *Chasing Grapes*.

Thank you for reading *Denver Food: A Culinary Evolution*, I hope that you enjoy the delicious journey.

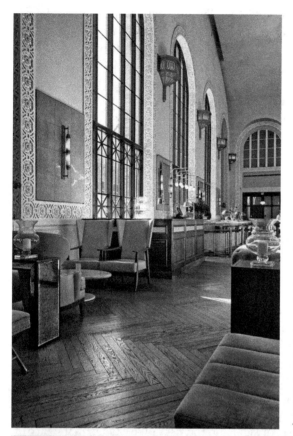

Left: The beautiful Cooper's Lounge inside of Union Station. Its upstairs location provides a seemingly private dining and drinking experience. *Courtesy of John Poplin.*

Below: Terminal Bar: the exterior patio is a beer garden; the interior bar opens into the central atrium of Union Station. The Cooper Lounge is on the upper level. *Courtesy of John Poplin.*

INTRODUCTION

I n Denver, Colorado, where I live, we are so fortunate to have rich and abundant farmers' markets, market-style grocery stores, natural food stores and a few superb specialty shops to source ingredients for our daily dinners. We have a small but growing extraordinary population of culinary professionals who are individually and collectively changing the way the population relates to food. Slowly, dining has become an experience not to be missed once again. Gone are the days of white tablecloths and tableside service, but the food can be as exquisite. Dining is an important signifier of a culture that brings people from all walks of life together. Creative and inspired dining reflects everything else a community has to offer. Denver has so much to offer. Denver has quietly evolved into a major metropolitan skyline and has entered the global stage offering world class cuisine along-side its world class entertainment and outdoor attractions. There is a tremendous community of artists, musicians, dancers, actors and athletes, all ready to entertain. Denver doesn't have the reputation as a food town like Chicago, San Francisco, New York, Seattle or New Orleans. It doesn't have to. Denver has its own signature that is every bit as delicious and memorable as what can be found in other great cities. Denver has never been viewed as a city of sophistication—although valid attempts have always been made. Yet even though Denver isn't known for haute cuisine or haute couture, perhaps it should be.

One of the greatest misconceptions about Denver is that it is a cow town. Denverites laugh at this notion. You would be more likely to see a cowboy

hat and cowboy boots on an LA socialite in Beverly Hills than you would in Denver. Denver isn't Texas, Oklahoma or Montana. Denver isn't big ranch country. Denver was founded on gold quests and weary pioneers who looked at the imposing Rockies and thought to themselves, "This is far enough." Denver is not representative of the rest of Colorado, not really. Denver is a mile high, so the sun is close and searing hot, and oxygen is sparse. We have long, mild winters, speckled with plenty of sixty-degree days. Springtime in the Rockies is truly glorious however short; wildflowers and wildlife bloom with the season. Our intensely hot summer days are devoid of humidity and last well into October. Autumn is fleetingly lovely amid changing colors, golden hues of aspen trees glittering in the sun; ruby-red maples and orange cottonwood trees lose their leaves prematurely to the first snows of the season. While we might get a few blizzards and several feet of snow, it melts within days, and we are dining and playing outside all winter long. People flock to Colorado for the great outdoors, partaking in skiing, professional and amateur sports, cycling, hiking, whitewater rafting and a range of other activities. The state boasts the lowest rates of obesity, attributed to our healthy lifestyles. We have a broad network of health food conglomerates, natural food producers and markets along with our thriving craft brew, ciders and spirits, urban wineries and marijuana industries. Denver offers an incredible fine arts community, world-class shopping, thriving nightlife, rooftop bars, comedy and arts, music, food and wine festivals across the state nearly every weekend. We literally make money in Denver; it is home to one of the only original U.S. Mints that produces coins as well as dollars. My favorite place in Denver is actually just outside of Denver to the west, nestled in the foothills near my home: Red Rocks Amphitheater.

While it is true that Denver is a casual, outdoorsy, feel good and fun city, it is still filled with gold dust and culture. Denver residents have always supported the arts. Thomas Edison dubbed Denver the "Great

CBCA At a Glance. *Courtesy of Colorado Business Community for the Arts.*

ECONOMIC ACTIVITY STUDY OF METRO DENVER CULTURE
AT A GLANCE

cBcA

TOTAL ECONOMIC ACTIVITY
$1.8 BILLION

ECONOMIC IMPACT
512.8 MILLION

ATTENDANCE
13.9 MILLION

GIVING TO THE ARTS
$176.4 MILLION

JOBS
10,731

SCFD DISTRIBUTION
$53.2 MILLION

OUTREACH TO CHILDREN
3.9 MILLION

White Way of the West" because of the flourishing early theater scene flooded in white-hot lights. In the 1920s, downtown's Curtis Street was studded with theaters boasting bright white-lighted marquees showcasing stars and famous vaudeville acts of the era. Harry Lubelski started the trend of illuminating the outside of the buildings on Curtis Street when he installed the first electric lights at his Novelty Theatre in 1903. The lights of Denver's theater row were so bright it was said that street lamps were never used. Thomas Edison, upon visiting Denver, supposedly said Curtis Street was "the best lighted of any street in the country."[1] Eighty-six years later, in 1989, and every year since, Denver residents voted to institute the innovative Science and Cultural Facilities District (SCFD), which

> has distributed funds from a 1/10 of 1% sales and use tax to 307 cultural facilities throughout the seven-county Denver, Colorado metropolitan area: Adams, Arapahoe, Boulder, Broomfield, Denver, Douglas, and Jefferson counties. The funds support cultural facilities whose primary purpose is to enlighten and entertain the public through the production, presentation, exhibition, advancement and preservation of art, music, theatre, dance, zoology, botany, natural history and cultural history.[2]

This generous fund supports cultural institutions like the Denver Art Museum, Denver Zoo, History Colorado Museum, Colorado Symphony Orchestra, Colorado Ballet, Denver Museum of Nature & Science, along with cultural and historical events, smaller dance troupes, theater groups, cultural learning centers and venues across the Denver metropolitan region.

Denver is home to the Denver Center for the Performing Arts (DCPA), the nation's largest nonprofit theater organization. The complex covers four city blocks, twelve acres, and houses ten venues with more than ten thousand seats, including the Denver Theater Company, the Temple Buell Theater, Ellie Caulkins Opera House, Boettcher Concert Hall and Helen Bonfils Theater Complex.[3] Also present are Limelight Restaurant and the legendary Kevin Taylor Restaurant at the Opera House. The Ellie Caulkins Opera House is one of three opera houses in the nation and nine in the world featuring seatback titling for every seat. The Boettcher Concert Hall was the first symphony hall built in the round, placing 80 percent of its seats within sixty-five feet of the stage.[4] The DCPA is brimming with creativity, innovation and artistry. Many iconic Broadway, Off-Broadway and regional shows visit the complex annually. The DCPA is considered to be second only to Lincoln Center in New York City for productions and attendance. World-

Left: Denver Center of the Performing Arts, the largest nonprofit theatrical complex in the United States, second only to Lincoln Center, in New York City. *Author photo.*

Right: Denver Center of the Performing Arts atrium and Limelight Restaurant. *Author photo.*

famous Red Rocks Amphitheater, an open-air rock and sandstone structure that featured prominently in legendary rock band U2's *Live at Red Rocks: Under A Blood Red Sky* docufilm, is nestled in the foothills west of Denver. The venue first came to prominence in 1911 when famed opera singer Mary Garden performed at the rudimentary venue, pronouncing it the finest venue in which she had ever performed.[5] On August 26, 1964, Red Rocks hosted its very first rock show, The Beatles. Red Rocks quickly became the summer destination venue for important musical acts, hosting dozens and dozens of concerts every summer. Since then, Red Rocks has undergone a transformation and has played host to musical acts as diverse as acclaimed violinist Joshua Bell, Chris Botti, Pink Martini, Jackson Browne, Diana Ross, Page and Plant, Jethro Tull, Fleetwood Mac, the Moody Blues, Big Head Todd and the Monsters, Blues Traveler, Widespread Panic, Depeche Mode, Colorado Symphony Orchestra, Metallica and everyone in between. Red Rocks also plays host to Film on the Rocks, which features retro movies and music, and one of the most inspiring religious celebrations, Easter

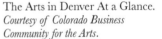

The Arts in Denver At a Glance.
Courtesy of Colorado Business Community for the Arts.

sunrise services, every year. Red Rocks is widely considered to be the best outdoor concert venue in the country, if not the world. I consider myself to be extremely fortunate to have attended hundreds of concerts and events at this glorious site and other amazing venues across the Front Range (Denver Metropolitan Area). According to Visit Denver and the Colorado Business Committee for the Arts, residents and tourists spent $1.8 billion on cultural and arts events with 13.9 million people in attendance and 10,731 people employed by the arts in 2016.[6]

According to reports, Americans spent more dollars on dining than groceries in 2016.[7] Nevertheless, 2016 was an interesting year for Denver's diners. Gone are many iconic restaurants, and more than one hundred new locales opened their doors. The competition is fierce for the diner's dollar, and the bar is increasingly set higher and higher. Working on the fringes of the restaurant industry, I am confronted daily with the question, "Have you been to…?" Sadly, I haven't been able to keep up with the pace of creativity presented by the culinary world along the Front Range in Colorado. Every meal out is a surprise in some way, whether it is innovative fusions of multicultural flavors or dishes peeled back to ultimate simplicity,

dining in Denver rarely disappoints from a food standpoint. Many of my favorite go-to restaurants have closed their doors in recent years, longing for new opportunities or simply a rest from the hectic chaos that is the restaurant industry. I truly miss the renowned Le Central Affordable French Restaurant, where I sipped my first French wines and learned the European way to dine on mussels using the shells to pry out the buttery meat. We lost industry favorite Z Cuisine, perfect for a solo night on the town. Patsy's Inn Italian Restaurant, one of the oldest and last of the red sauce restaurants, took down its placard after nearly a century. The Russian Tea Room became Red Square Euro Bistro. Innovative Black Pearl, Mona's, Osaka Raman, Fuel Café, Indulge Bistro, La Scala, Trillium and Sonoda's Down Town all lost the battle for their share. St. Mark's Coffee survives, yet iconic Paris on the Platte vanished, with trendy Carbon Coffee taking its place. The landscape of Denver is changing and changing quickly. Along with the skyline, the restaurant scene is shuttering out the authentic past to make room for the new and often imported. Restaurateurs and chefs are flooding Denver from all over the nation and the world, hoping to capitalize on the waves of culinary exploration, excitement and the immense population boom. For several years after the Great Recession, more than one thousand people moved to Denver each week, looking for a fresh start, healthy lifestyle and laid-back culture and consumption. Many of these newcomers arrive demanding more diversity, more creativity and, in the end, a significantly more expensive dining experience. Longtime residents are welcoming the change, if ever so slightly reluctantly. Many of the people who I talked with for this book are nostalgic for the way things used to be, as people so often are. The city is swiftly becoming unrecognizable, and missing just a week downtown, a person becomes out of touch with everything new. One of the downsides to all of this growth is the loss of the iconic independent businesses that contributed to the local flavor of Denver for decades. Growth spurts often lead to a flood of chains, even sneaky, lesser known chains like the Garlic Knot, Pizzeria Locale and Garbanzo Mediterranean Grill. These types of restaurants are glamorized versions of chains, but chains nonetheless, offering often bland, homogenized menus and service. Denver has its own, highly successful, genre of fast-casual chain restaurants, including Chipotle, Noodles & Company, Tokyo Joe's, Einstein Bros Bagel Shop, Boston Market, Mad Greens, Qdoba, Larkburger, Smashburger and MoD Market, which are all headquartered along the Front Range, making Denver the fast-casual capital of the nation.[8]

Starbucks, Chipotle, Noodle & Co.: Denver is one of the fast-casual dining concept capitals of the United States. *Author photo.*

Denver has always had a reputation for steakhouses, greasy burger joints, novelty Mexican food and bland Italian cuisine. Gold rushes, saloons and early sophistication soon brought waves of German, Japanese, Chinese and Italian immigrants to Denver along with their food, wine and beer. By the 1970s, a few daring and creative restaurateurs came to Denver with dreams of gold and fine dining. Among them were Pierre Wolfe, Mel Master, Blair Taylor, Noel Cunningham and Frank Bonanno, all taking a chance on a small-time, reformed cow town. As Denver transitioned into a cultured, theater and art scene, exceptional fine dining followed. Denver always attracted talented and creative food and beverage industry professionals. Now, it is attracting them in droves. Iconic second wave Denver/Boulder restaurateurs and chefs such as Jen Jasinski, Lachlan Petersen, Bobby Stuckey, Ryan Leinonen, Brian Moscatelo and Aaron Forman paved the way for a new generation of innovative, award-winning talent such as Eric Skokan, Daniel Asher, Steven Redzikowski, Bryan Dayton, Justin Brunson and Justin Cucci. Internationally acclaimed sushi master Nobu Matsuhisa opened Matsuhisa Denver, his second Colorado restaurant, in 2016, and Toshi, the world renowned chef/owner of Sushi Den, opened Izakaya Den and Ototo in Denver the last year few years. Slow food icon Alex Seidel

Larimer Square, Fifteenth and Larimer. The first buildings on historic Larimer Street were built in 1865. Reservationist and developer Dana Crawford saved Larimer Street in 1965. Now it's a culinary hot spot. *Author photo.*

of Fruition and Mercantile Dining & Provision has founded his own fully functional farm, Fruition Farms, where he sources most of his vegetables, eggs, cheese, meats and herbs. He was also instrumental in founding Denver's premier producer-focused farmers' market on the Union Station plaza this past summer. Locavore Chef Eric Skokan of Black Cat and Bramble and Hare Farm fame is known for foraging and using strictly organic and locally sourced ingredients. This is an exciting time to be a Colorado resident and tourist. Rooted in the *Keep It Local* movement, the culinary revolution and craft brew craze, rise of the local craft cocktail and cult coffee explosion prove the time is ripe for a new journey through culinary Colorado.

How did Denver become something of a culinary hot spot? Denver is truly in the center of the country, where vast plains meet the rugged Rocky Mountains. Founded at the confluence of the South Platte River and the Cherry Creek waterways, Denver was born in a natural location for a city. Denver has never been given the attention of Dallas, Chicago, Atlanta, the Twin Cities or even St. Louis. But Denver, even though its culinary evolution has been under the radar of the national

eye, is happening. Much has been said about Denver's lack of identity, creativity and consistency. This may have been true a decade ago, but it no longer applies. Great chefs reside in Denver and create cuisine worthy of attention. International celebrity chefs are taking notice and opening restaurants in Denver. Cookbooks are being written, icons are being forged and reputations are exploding, one plate at a time. There is a unique camaraderie between local chefs and proprietors in the Denver restaurant scene that is unparalleled in New York, Dallas, Chicago or San Francisco. Restaurateurs and chefs collaborate in a common goal of making Denver food truly a remarkable, memorable experience. They come together at festivals, for competitions, charitable causes and just for fun. The argument has been made that the Denver food scene has passed over greatness for sophistication. How does one reconcile exalted creativity with consumer demand? With the influx of diversity along with the flood of new residents, the old Denver is quickly disappearing. In its place is a new city and evolution of architecture, culture and culinary experiences. Where do we go from here?

This book will be a historical and cultural introspective of the evolution of the most iconic restaurants across Denver and the people who devoted their livelihoods to making them a success. Included in this book are a collection of memories, recipes, menus, anecdotes and stories revealing the early sophistication of the Colorado culinary landscape through its tremendous culinary revolution. There are dozens if not hundreds of amazing dining spots in the city, far too many to recount in these pages. Much has already been written about the early days of Denver dining, often focused on the same few chefs and restaurants. Each of the restaurants and chefs I have selected are an integral thread in the tapestry of Denver cuisine. Some may be lesser known, neighborhood favorites or industry secrets, but each illustrates a culinary evolution in Denver.

Our journey begins in the early days of Denver with "Gold, Glitz and Gourmet Surprises." A flood of newly minted money and tourism called for rapid change in the fledgling Denver settlement. While it was once home to transient Native Americans, the miners and cowboys, waves of immigrants, socialites, freed slaves and saloon girls quickly built a city of social venues. Restaurants, hotels, breweries and bars sprung up to serve the growing population. Oysters were as easy to find as venison. "The Lost Decades" explores Denver after the Great Depression, Prohibition and end of the gold/silver rush. Denver's once rich culinary scene gave way to chain

Coney dogs, hamburger joints, diners and the rise of prepackaged home-cooked meals. "Culinary Kitsch" illustrates how postwar-era attempts to provide more choices to the growing, increasingly diverse population paved the way for a culture of New Mexican, the Italian Underground, soul food, BBQ, ethnic cuisine and the rise of bland, novelty food. Denver's culinary situation was considered an unfortunate joke on a national scale. Any sophistication left over from the golden years had long since faded.

Aside from being founded on waves of mineral hunters, early Denver was big cattle country and the home of the National Western Stock Show. "Steaks and Cigars" highlights Denver's agricultural tradition, enforced by the oil and gas industry; great steakhouses seemed a necessity. Oil and gas brought much needed economic growth to Denver. During the late 1960s and through the early 1980s, a new crop of innovative restaurants appeared. "A New Kind of Gold" shows the early innovators, including Mel Masters, Blair Taylor, Kevin Taylor and Noel Cunningham, opened a group of restaurants that changed the way people thought about culinary Denver. The 1990s brought a new wave of culinary professionals to Denver. During this "Transitional Decade," creative chefs working under the tutelage of Wolfgang Puck, Alice Waters, Thomas Keller and other industry greats began seeking out a new frontier. Denver has always been known for its pioneer spirit. National ethnic fusion themes hit Denver in a big way. The next wave of chefs was "Modern Before Their Time," introducing daring, new approaches to cuisine in Denver during the late 1990s and early 2000s. They applied a global focus, including Scandinavian, Brazilian, Spanish and Euro/Northern Californian Slow Food movement themes, cuisines and techniques. Many of these restaurants struggled to gain traction but have since become iconic hot spots. The rise of the Food Network, celebrity chefs, famous home cooks and food festivals inspired Americans to learn more about their food sources and quality in dining. "Sophisticated Comfort Food" discusses Denver chefs inspired by their mothers' kitchens, and culinary simplicity ushered in a third wave of culinary innovation, which blossomed during the late 2000s and early 2010s. The pig has assumed an exalted place of importance among foodies and culinary professionals unlike any other ingredient. "Hail the Mighty Pig" celebrates the artisanal butchers and sausage makers devoted to crafting, curing, smoking and cooking with every inch of the pig. It seems as though every menu, regardless of food style, has a pork belly focus. After the Great Recession, Americans longed for security and a sense of local and national connection. People became interested in home gardens, farmers' markets

and fresh cuisine. "Slow Food and Locavore Colorado" explores concepts like professional micro urban farming: goats, bees, backyard hens, local sourcing and foraging, farmers' markets, produce stands and personal micro farms for your kitchen. Locally sourced ingredients are all the rage among foodies, chefs and general consumers. Along with all of this amazing food creativity came "The Third Wave of Craft Cuisine Accompaniments: Cocktails, Coffee, Beer and Wine." Craft coffee roasting and post-modern coffee shops brimming with shiny silver computers and hipsters are springing up alongside packed neighborhood breweries, cider houses and urban wineries. Spandex-clad cyclers with dogs in tow sip on everything, all under the shining Denver sun. Denver is coming into its own as a culinary scene. "Enter the World Stage" showcases Denver chefs receiving mostly positive, national and international attention for the culinary scene and attempts at evolution, diversity and modernization. Food Network and Travel Channel shows frequently visit; the James Beard Foundation and awards have turned its attention to Denver. Denver appears regularly in various food, wine and travel magazines. Internationally acclaimed chefs are opening vanity restaurant projects across the city. "Where Do We Go From Here?" concludes our journey by discussing relevant food issues in Denver across the country and the globe. Chefs and culinary professionals are working to educate people on how to grow and cook their own food. The culinary community is working together to solve food insecurity. Chefs are inspiring the next generation of culinary superstars, line cooks and home chefs. A movement is underway to provide fresh produce to all levels of consumers across Denver and a broader Colorado. Residents are leasing/donating their yards to Denver Urban Gardens and MicroFarm Colorado to increase food production and alleviate fresh food deserts in the Denver metropolitan region.

Denver is undergoing a tremendous transformation in terms of growth. There are cranes and construction zones in every neighborhood. Every single day, there is a shiny new apartment building, mixed-use center or commercial district to explore. According to the *Denver Post*, since 2010, Denver has been the second fastest-growing city in the nation, but began to experience a slowdown in 2017.[9] Austin, Texas takes the top spot. The record-setting construction boom spent $7.8 billion in 2016, with the majority of building in the residential sector, primarily apartment buildings that all look alike: modern, muted, monotonous and massive—25,382 apartments were under construction with 26,884 in the planning phase. At the height of our 2015–16 population boom, an average of 1,000

people flooded into Colorado every week. By 2017, that number had trickled down to 1,000 a month. All of those people needed homes.[10] All of the construction and growth stimulated the city, its residents and its restaurants, but it made Denver more stressful too. Driving from one end of the city to the other can no longer be done with ease. Our streets are congested, and our infrastructure is suffering under the weight of all of the new growth. The once unique, historic skyline has become a mass of drab sameness, lacking character and devoid of personality. Everything is glass and steel, gray and cold. The Denver I knew thirty years ago, when I arrived, is harder and harder to find, obscured by these enormous, modern, residential and commercial buildings. Preservationist developers like Dana Crawford are doing their part to restore and maintain the original flavor of the city with sites like Union Station and Larimer Square, and thanks to them, these historic sites are repurposed and flourishing. The flavor of long ago Denver is gone, and lamenting the past is fruitless, especially when the Denver of the present and future has so much to offer. Exploring the culinary evolution of Denver, from its earliest mining camp days to its entrance onto the world stage, has been a fascinating and delicious journey.

Denver Is Officially a Food City. *April 18, 2018, Conde Nast Traveler:*

Is Denver a food city? I had heard it's a beer city, and a pot city…so its progression to "food city" seemed appropriate.…Despite being in a city known for its sunny disposition—like, 300 days a year of sun—I didn't go outside much during a recent weekend trip to Denver. I was preoccupied, head down, focused on my food.

—Laura Dannen Redman[11]

Thirty Most Exciting Food Cities in America: No. 4: Denver, CO, *Zagat 2017*

If major restaurant openings were the only criterion for a hot food city, Denver would be a shoe-in for a top 2017 slot. Nearly every established chef or restaurateur of the past several years either launched or is about to launch a new, landscape-changing hot spot.…Yet major openings aren't the only criterion. The executives at Slow Food named Denver the new home

of international conference Slow Food Nations, held annually in July. The producers of Top Chef *also decided to film Season 15 here. In fact, it was Tom Colicchio himself who observed that Denver's strong network of cultural support would guarantee its future, nurturing the talents of tomorrow. In short, as food towns go, the Mile High City has just hit the stratosphere.*

—*Ruth Tobias, Denver-based food writer,* Zagat *2017*[12]

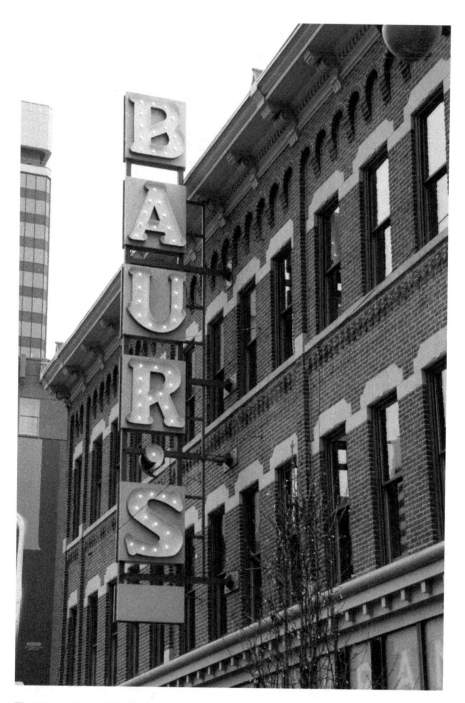

The historic, lighted Baur's sign represents the golden age of Denver and its time as America's Western Theatrical Great White Way. *Author photo.*

1

GOLD, GLITZ AND GOURMET SURPRISES

I t is said that Denver lacks a native dish. Historically, the region was an uninhabited basin only visited by nomadic peoples visiting the confluence of rivers during annual migration patterns. Essentially, Denver's native cuisine is just that, Native American cuisine. Elements of Native American cuisine are found in every southwestern-themed, Mexican-influenced, locavore restaurant across Colorado. Denverites and Coloradoans owe much of our culture and cuisine to the nomadic peoples that inhabited the Rocky Mountain Front Range for hundreds of years before European and American settlers explored and populated the region.

NATIVE PEOPLE AND NATIVE CUISINE

Ten thousand years ago, nomadic hunters and Paleo-Indian cave dwellers habited Colorado. By AD 1000, many of these nomadic tribes began to build villages and engage in agriculture to sustain their growing populations. The Ute tribe was the predominant society in Colorado, but Cheyenne, Apache, Arapaho, Kiowa, Pawnee, Comanche and Sioux cultures also emerged across the Colorado plains. While none of these tribes established permanent villages along the Front Range of the Rocky Mountains, seasonal encampments were common, particularly at the confluence of the South Platte River and Cherry Creek, in the heart of modern-day Denver. It was

there that these tribes hunted and foraged to sustain their societies with native foods, including chanterelle and porcini mushrooms, asparagus, raspberries, iris bulbs, pine nuts, trout, grouse, wild turkeys, small birds, rabbit and maybe even a wild plum or two. By the time of the great migration west and the gold and silver rush, the Great Plains were home to more than seventy-five thousand thriving native peoples with highly developed, unique and ordered cultures.[13] Even well into the nineteenth century, many Native Americans who habituated the Colorado Front Range region were largely nomadic tribes not accustomed to agriculture. Perhaps influenced by white settlers, later generations began adopting semi-sedentary practices by living in villages and engaging in simple agriculture as a means of sustaining society. These tribes did practice animal husbandry and rudimentary farming to an extent. In 1862, the U.S. government enacted the Homestead and Morrill Acts, offering vast stretches of land to people willing to stake land claims and settle in the central region of the vast United States for little or no money. Floods of mostly European immigrant settlers took the deal and headed west. By chance or luck, one California-bound settler, Lewis Ralston, discovered gold in Clear Creek just west of Denver in 1850. Silver discoveries followed, and by 1858, the foothills and mountains of Colorado were teeming with miners looking for gold dust and found nuggets of wealth. This westward expansion and the discovery of gold and silver in Colorado soon changed the lives and cultures of native peoples in the region. Quickly and often violently relegated to federally "protected" reservations, native peoples were forced to abandon traditions like following the buffalo and take up horse and plow to sustain their societies.[14] As early as 1764, the early American government was proposing a "Plan for the Future Management of Indian Affairs," and by 1824, the Office of Indian Affairs had been established to regulate native and European settler interactions and proximity. By 1830, the Indian Removal Act had been passed, and then in 1851, the Indian Appropriations Act officially established a specific network of reservations forcing native peoples across the continent onto a mere 56,200,000 acres of land, which is about the size of Idaho.[15]

Nonnative populations think of the trinity of pan-native American cuisine as maize, beans and squash. However, most native populations were skilled foragers and hunters subsisting on wild crops such as wild berries, venison, pumpkins, wild rice, alfalfa, wild peas, wild onions, wild garlic, chives, cabbage, cactus, bulbs, turnips, mushrooms, tubers, seeds, nuts, fish, rabbits, prairie dogs, quail, native turkeys, doves, pheasant and other small birds, buffalo, elk, deer, antelope and wild boar, which was made into pemmican

(buffalo meat sliced into strips and dried, pounded into shreds, blended with dried berries, buffalo fat, and possibly herbs and other fruits, poured into bags and left to cool, harden and dry). Native peoples were skilled herbalists, relying on herbs such as sage, chamomile, mints, flowers, rose hips and other roots and barks for tisanes, flavorings and medicines.[16] The climates of the North American continent are wildly diverse, and food sources vary tremendously from coast to coast. To simplify Native American cuisine into one concept is as unfortunate as it is naïve.

Modern Native American cuisine is relatively unknown among nonnative Americans. The Native American cuisine from Colorado consists of uncomplicated preparations with simple ingredients and robust flavors: squashes, mushrooms, berries, small game birds, bison, rabbit and freshwater fish factor heavily. Native American cuisine in Colorado evolved with Spanish and Mexican influence into something that resembles traditional Mexican cuisine, including tortillas, guacamole, tostadas, tacos, salsas, mole, cornbread, stews and pozole with additions such as chilies, green chili stew, game meats and birds, chocolate, South and Central American fruits, vegetables and influences. Later additions included fry bread, the staple of Navajo cuisine, made from whole wheat, lard, salt, water and leavening such as baking powder and yeast, then fried on a hot skillet and served with a drizzle of honey. Elements of Native American cuisine appear on Denver menus as diverse as The Fort Restaurant, Café Jordano, an Italian bistro that features buffalo dishes, as well as locavore restaurants known for foraging like Black Cat. There are Native American cuisine–focused restaurants like Grayhorse: An American Indian Eatery and Tocabe Indian Restaurant, with two locations and a popular food truck. More on Tocabe Native American restaurant eatery later.

DENVER'S EARLIEST DAYS

On December 8, 1867, the capital of Colorado Territory moved from the township of Golden to a growing village called Denver, a few miles to the east, situated on the banks of Cherry Creek. The territory was organized out of lands in the Rockies on both sides of the continental divide and incorporated the area of the Pikes Peak gold rush that had begun two years previously. A flood of newly minted money and tourism called for rapid change in the fledgling Denver settlement. Once home to transient Native Americans,

First opened in 1881, Denver's newest hotspot is Union Station. Reopened in 2014, the space is fully renovated and home to the city's best restaurants. *Author photo.*

Denver became a thriving city of social venues with the arrival of miners and cowboys, waves of immigrants, socialites, freed slaves, entrepreneurs and saloon girls. Restaurants, hotels, breweries and bars sprang up to serve the crowds of hungry residents. The population of Denver was booming, bringing throngs of brave explorers and opportunists to the little city. Early settlers, following the gold rush trails, brought the comforts and luxuries of the East with them when they positioned themselves in their new homes in the tiny city that became Denver. Entrepreneurial women and men started baking bread and pies, selling them to the miners, frontiersmen and Native Americans. Within a few decades, seafood was as easy to find as venison. Soon, delicacies followed, including a daily supply of fresh oysters, imported confections, French wines and champagne. The small prospecting village was quickly becoming quite a tony city. Shortly after the construction of the Union Station train hub, luxury hotels were established along with world-class theaters, vaudeville houses and much-needed dining establishments to serve the booming population. Much ink has been spilled about the early days of Denver and its culinary scene. Restaurants came and went, but a few restaurants managed to live on through the decades and several incarnations. During Denver's infancy, many an entrepreneur, mostly immigrants, found

in Denver that legendary American Dream just waiting to unfold—and often it was in the kitchen.

BAURS

Otto Baur, a German immigrant, made his way to Denver around 1867, bringing his ability as a baker and confectioner from Württemberg, Germany, after stints honing his talent and working in Pennsylvania and New York City. Once in Denver, he found a position at City Bakery supplying restaurants and residents with his skillfully crafted breads and pastries. City Bakery, located on Fifteenth and Blake Streets, was the main supplier of baked goods for Denver restaurants and residents and conveniently adjacent to the hotel that Otto Baur's brother-in-law owned. Baur quickly made a name for himself distributing baked goods to hungry miners and Native Americans on the side. By 1870, Otto Baur had a

Baur's on Curtis Street, 1920s. *Courtesy of Baur's. Author photo.*

Otto Baur's original mosaic tiled floor. 1512 Curtis Street, Denver, circa 1872. *Author photo.*

Baur's booth. *Author photo.*

new partner in James Colwell, a bookkeeper and financier, and a new business called Colwell & Baur, which was the first catering business in Denver. Baur went on to open O.P. Baur Confectionery Company. Baur, specializing in cakes and candies, quickly became the sole owner of the confectionery. "The Baur Confectionery Company was established in 1871. The final destination for Baur's business was the Baur Confectionery Company Building, constructed in 1881 by real estate developer Rodney Curtis, who later became the Denver Tramway President, and designed by Denver Architect Leonard Cutshaw."[17] In 1891, Baur officially moved the confectionery to 1512 Curtis Street, and the company quickly emerged as an innovative and successful purveyor of candies, cakes and other confectionery items. On July 18, 1891, a particularly hot summer day, Baur reportedly invented the ice cream soda by substituting ice cream for cream and combining it with seltzer water.

But Otto P. Baur, the German-born owner of a Denver candy establishment, claimed that he introduced the world to the effervescent combination of ice cream and soda water. In an interview published Aug. 12, 1902, in the Denver Times, *Baur said, "The first ice cream soda was sold at my confectionery at 16th and Lawrence Streets where the Golden Eagle is now, and that was back in 1870." As Baur told the story, one of his patrons routinely ordered soda and cream each morning. One day, the patron arrived before the milkman did. Baur substituted ice cream for fresh cream, and created delicious history.*[18]

By 1891, Baur had added catering to his repertoire again. Baur was responsible for creating elegant wedding feasts, extravagant parties and other lavish events for Denver's most elite Edwardian-era society register crowd, such as Molly Brown, Emily Griffith, Louise Crawford Hill, Mary Elitch Long, Mary Brophy Grace Tobin, Caroline Nichols Churchill and Annie Whitmore, along with entrepreneurial ladies like Emily Griffith, Dr. Justina Ford and Dr. Susan Anderson. Baur's business flourished and expanded over the next decades, and he gained national acclaim for his specialties, including his sixteen-layer cake and Mija candy (almond butter toffee), crystal candy, imported marzipan, macaroons, pastries, rich ice creams and the ice cream soda. At the turn of the twentieth century, the O.P. Baur Confectionery Company employed more than twenty workers who produced, packaged and shipped confections and candies across the United States and the globe. Otto Baur developed a love for traveling in his youth and was ever curious

BAUR'S
RISTORANTE

For long-time Coloradans, the name Baur's evokes memories of fine food and old-world elegance. Otto Baur founded the restaurant, bakery and candy shop while Colorado was still a territory, and for the next 100 years customers were enticed through its doors. The company slogan, "Famous for Good Things to Eat," is now the legacy of the new Baur's Ristorante.

Jimmy Lambatos, founder of Footer's Restaurant and Catering Company, has opened the new Baur's in Denver's thriving Theater District. Offering contemporary cuisine in a relaxed, elegant atmosphere, Baur's features seasonal dishes focused on high quality, fresh ingredients. The new Baur's is not only a tribute to Denver's past, but is also an exciting new dining experience not to be missed.

The Denver Public Library Friends Foundation is honored to be the beneficiary of Baur's generosity. The Friends provide advocacy and funds for the Denver Public Library, supporting such vital programs as *Summer of Reading* for children, and the world-renowned Western History Department. Thank you for supporting one of Denver's most important institutions.

Photo from the Denver Public Library's Western History Photo Collection.

Friends

Join us for a
Grand Opening Celebration
at Baur's Ristorante

to benefit the
Denver Public Library Friends Foundation

SWEET ENDINGS
$8.00

DOMESTIC HAPPINESS
Spiced Apple Cake, Apple Butter, Whiskey Ginger Ice Cream, Beetroot Apple Chip, Micro Greens

CAUGHT WITH YOUR KILT UP
Whiskey Caramel, Oatcake, Cranberry Compote, Honey Panna Cotta Chantilly

THEATRE DISTRICT
Frangelico Chocolate Cake, Chocolate Ganache, Mija Toffee, Hazelnut, Chocolate Buttercream

NOT YOUR AUNT'S CASSEROLE
Brown Butter Polenta Financier, Vanilla Marshmallow, Poached Butternut Squash, Candied Pecans

ICE CREAM SODA FLOAT
"They say it was invented in this historic building…"
Rocky Mountain Soda Company and House-Made Vanilla Ice Cream
Root Beer, Prickly Pear, Lemon Lime, or Elderberry

HOUSE-MADE ICE CREAM
Taste of Three $3.00 | Taste of Six $6.00

Baur's desert menu, the latest incarnation, 2016. *Author photo.*

about the world and its cultures. He and his wife frequently visited New York City to brush up on the latest trends and culinary techniques. In 1898, Otto traveled to Mexico City, where he studied the Aztecs' use of cocoa, and he applied this newly found expertise to creating chocolate candies.[19] Baur's Confectionery Company became legendary for serving ice cream to children for free all through the Depression. Otto Baur died in 1904, and his nephew John Joseph Jacobs took over the business. With his business acumen and a well-established reputation for fine confections, Jacobs ushered in the most successful era for the Baur's brand. In 1918, Jacobs added a full-fledged restaurant to the business:

> Over the decades, Baur's experienced continued success, and Denverites enjoyed the "sweet magic" that was created at 1512 Curtis Street and other Baur locations around town. In the 1970's Baur's closed its doors to competitive times as that area of downtown became run-down and criminal. Following that, offices and other restaurant tenants were never able to experience the success that Baur's had for so long.

KEW Realty purchased the building in 2004 and, over the next few years, restored and renovated the space, maintaining many of the original, elegant details like the storefront windows, crown moldings, the original hand-carved wooden bar and the tiled entryway emblazoned with the Baur's name.[20]

On a recent cold and snowy day, I was wandering around downtown Denver taking photographs for this book. I tucked into Baur's for a late breakfast. Sitting at the bar, I sipped my hot coffee and found myself slipping back in time. Decades faded away as I took in the room around me. Just inside the door, the name Baur's is emblazoned in black on the original white tile floors. An opulent hand-carved bar, a small stage in the corner with a grand piano and an ancient phonograph sitting under a row of dimly lit, black-and-white photographs document the restaurant through the ages; the menus make mention of Otto Baur, as does a handwritten manuscript by his granddaughter that was sitting on the bar. The space transforms into a jazz hall by night. Gone are the sixteen-pound chocolate-iced layer cakes, the ice cream sodas and the Mija Almond Toffee, but the essence of Otto Baur survives.

BRUNCH

BAUR'S BREAKFAST PASTRY	BAUR'S SIGNATURE GRANOLA	
5.00	House-Made Granola, Fruit and Berries, Honey Yogurt	
BANANA DOUGHNUTS	9.50	
Banana Custard, Dulce de Leche, Nutella, Berries, Hazelnuts	CRÈME BRÛLÉE FRENCH TOAST	
7.95	Choice of Bacon, Chorizo or Breakfast Sausage, Bananas and Berries, Maple Syrup	
	11.95	
BELGIAN WAFFLE	THREE BUTTERMILK PANCAKES AND	
Whipped Butter, Berries, Whipped Cream, Choice of Maple Syrup or Lemon Curd	MAPLE SYRUP	
9.95	9.00	Add Strawberries, Blueberries or Chocolate Chips .95

FRESH EGGS

THE STANDARD*	BREAKFAST TACOS*
Two Cage-Free Eggs,	Handmade Corn Tortillas, Scrambled Eggs,
Choice of Bacon, Breakfast Sausage or Chorizo,	Pico de Gallo, Avocado, Jack Cheese,
Home Fries and Choice of Toast	Choice of Steak, Carnitas, or Chorizo
9.95	10.95
STEAK AND EGGS*	HUEVOS COLORADO*
Bavette Steak, Fried Eggs, Cheesy Tater Tots, House	Two Cage-Free Eggs, Crisp Flour Tortilla,
Steak Sauce	Pinto Beans, Pork Chile Verde, Queso Blanco
19.95	11.95
GARDEN OMELET	PIONEER OMELET
Spinach, Caramelized Shallot, Wild Mushrooms,	Applewood Smoked Bacon, White Cheddar,
Pecorino, Tomato Confit	Leeks, Pepperonata
Home Fries and Choice of Toast	Home Fries and Choice of Toast
9.95	10.95

MISSION OMELET
Ham, Carnitas, Pico de Gallo, Avocado, Pepper Jack Cheese
Home Fries and Choice of Toast
13.00

CLASSIC BENEDICT*	HOUSE BENEDICT*
English Muffin, Canadian Style Bacon,	Hash Browned Potato Cake,
Poached Eggs, Hollandaise	Guanciale Vinaigrette,
11.95	Tomato Confit, Spinach
	11.95

*Consuming raw or undercooked meats, poultry, seafood, shellfish, eggs or unpasteurized milk may increase your risk of foodborne illness. These items may be served raw or undercooked, or contain raw or undercooked ingredients.

Baur's brunch menu, circa 2016. *Author photo.*

Baur's bar and fruit. *Author photo.*

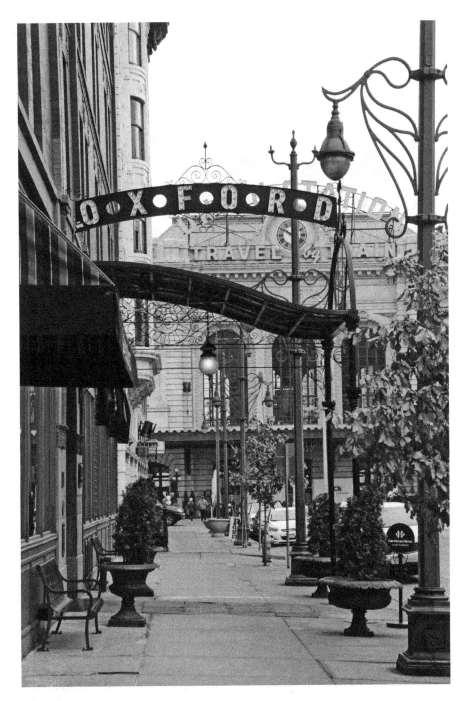

The Oxford Hotel was the first luxury hotel in Denver. Established in 1891, the Oxford Hotel is owned by famed preservationist and developer Dana Crawford. *Author photo.*

Mija Almond Toffee

1 cup sugar
1 cup butter
3 ounces slivered almonds
1 tablespoon water
1 tablespoon white corn syrup
4 ounces milk chocolate

Combine sugar, butter, almonds, water and syrup in a heavy sauce pan and cook over high heat, stirring constantly. The mixture will gradually turn a dark amber brown, and the almonds will begin to toast just slightly. Carefully pour the hot syrup into a generously buttered 9x13 pan. Spread the candy evenly and allow to cool. In the meantime, place the chocolate in the top part of a double boiler and slowly melt it over simmering water. Be careful not to burn the chocolate. Drizzle the melted chocolate over the cooling toffee. Spread evenly or leave in a drizzled design. Once the toffee has completely cooled, break it into pieces and try not to devour it in one sitting![21]

Modern Denver is a fun-loving, casual city, known for its easy stance on adult beverages and other intoxicating substances. According to reports, Denver is home to more craft brewers, distilleries, urban wineries and cideries than any other metropolitan region in the country. Since our gold rush days, Denverites have always loved a good cocktail or glass of something stronger. During Prohibition, underground networks of speakeasies, gambling parlors, brothels, gin joints and private clubs sprang up across the young city. A handful of these tawdry establishments still exist today, steeped in mystique and still serving classic cocktails.

THE CRUISE ROOM

Speaking of champagne and cocktails, one of the best places to sip on something stronger is the legendary Cruise Room, which is a National Historic Trust Landmark. The Cruise Room Cocktail Bar is located in Denver's oldest luxury hotel. The Oxford Hotel, decked out in Colorado marble, beveled glass, polished wood staircases and elegantly tiled and

paneled walls, with glittering chandeliers hanging low above the velvet and leather furniture, Denver's first glamour hotel, opened on October 3, 1891, just months before the world-famous stately Brown Palace Hotel. The Oxford was built just a block away from Union Station Train Station to welcome weary travelers after their long journeys across the Great Plains and the Rocky Mountains from the eastern states to the West. The Cruise Room, a tiny cocktail bar, opened to much fanfare in the lobby the day after Prohibition was repealed in 1933. The glorious vintage art deco lounge is an exact replica of an elegant stateroom lounge on the *Queen Mary* luxury passenger ocean liner. The narrow room is bathed in dusky red light and gilded with shimmering mirrors, chandeliers and a lighted glass back bar. Art deco artwork graces the walls, and the bar is lined with red leather booths. Known for its classic cocktails and martinis, the Cruise Room is an institution harkening an elegant era of the scandalous past. As if in a scene from a film noir movie, one can only imagine the room filled with swirling cigarette smoke, laughing flapper girls and men in zoot suits or Bogart and Bergman sitting in a plush red-leather booth, sipping on Red Window Cocktails, listening to jazz.

Red Window Cocktail

Peach vodka
St-Germain elderflower liqueur
Fresh lemon juice
House-made simple syrup
Jalapeno juice
Raspberries
Topped off with a splash of champagne

**exact measures are a mystery*

THE BROWN PALACE

The Brown Palace is the second-longest continuously run hotel in Denver and one of the first glass atrium–lobbied hotels in the country. Arguably one of the most iconic buildings in all of Colorado, the red granite and

sandstone building was built in 1892. At the time, the structure was the tallest and most luxurious building in the western region of the United States. The interior boasts a crystal and cut glass atrium, gleaming marble and mahogany, red velvet– and gold-embellished furnishings and liveried bellmen. The Brown Palace is home to the exquisite yet stoic Palace Arms fine-dining restaurant, which still serves exquisitely French cuisine, and Ellynton's restaurant, which serves a traditional British-style afternoon tea every day and an extravagant Dom Pérignon champagne brunch featuring all of the classics, such as eggs benedict, brioche with sweet cream butter and home-made lemon curd, a fresh lobster scramble, waffles, croissants and succulent berries—all served with endless glasses of the finest Dom Pérignon champagne on Sunday mornings in the glass atrium. The Dom Pérignon brunch is one of Denver's longest traditions and has satisfied rock stars, dignitaries, presidents, politicians and celebrities for generations. The Brown Palace is also home to Ship Tavern, opened on the heels of the Twenty-First Amendment, the repeal of Prohibition. The bartenders specialize in vintage cocktails and beers served Prohibition-style—meaning, it is poured from a teapot to disguise what it really is, beer. Legend has it that during Prohibition, there was a secret passage connecting the Brown Palace under the city street (Tremont) to 1725 Tremont Place, home to a well-known high-end brothel and later the Navarre Café. Everyone who is anyone has stayed at the Brown Palace, from presidents, royalty and diplomats to The Beatles and world champion bulls. Yes, that's right, world champion bulls. Every January, the gorgeous prize-winning bull from the National Western Stock Show is exhibited for all to see in the impeccably decorated lobby of the Brown Palace.

CHAMPAGNE'S COLORADO CONNECTION

Charles Camille Heidsick was born of two legendary champagne dynasties in France in 1822. His story is well known to Colorado oenophiles because of his unusual ties to Denver. He is famous for successfully opening the United States as a champagne market in 1852. Within a few years, thousands and thousands of bottles of Heidsick were being poured in the best establishments across America. Unfortunately, by the time of Denver's incorporation in 1861, nearly half of the Heidsick Champagne Company's assets were tied up in mostly unpaid accounts in the United States. Fearful of massive losses

bound to occur during the Civil War, the fun-loving playboy Champagne Charlie, as Heidsick had come to be known, journeyed to the United States to collect on his debts and move his champagne safely to the politically stable and favored North. His unscrupulous sales agent, David Bayaud, refused to pay his fees, claiming that the Union government had absolved him from paying any foreign debts. Champagne Charlie had no other choice but to try to collect on the debts himself. Mistakes were made, and Charlie landed in prison on the grounds of spying for the French government and the Confederacy, inciting an international incident between the United States and France that came to be known as the Heidsick Incident. After lengthy negotiations between President Abraham Lincoln and Napoleon III, Heidsick was finally, reluctantly, released from prison in 1862—but not before being swindled out of his entire fortune. He returned to France a sick and broken man. In 1862, an American missionary to France delivered a parcel to Charles Heidsick from one Thomas Bayaud, the brother of his former American sales agent. The man lamented that Thomas was remorseful of how his brother had taken advantage of Heidsick and gave Heidsick a stack of American land deeds as a gesture of good will. Heidsick never visited his new lands somewhere west of the Mississippi River. In fact, he was quite dismayed by the gesture and wanted no part of the deal. Those deeds accounted for more than one-third of the land in a newly established little silver-prospecting village in the Colorado Territory located in the western United States. The town had recently been connected by a transcontinental railway and was soon to become one of the fastest growing and wealthiest cities in the American West, known now as Denver.[22] With the help of Denver's Reverend John Baptist Raverdy, the vicar general of the bishop of Colorado, Heidsick was able to claim what turned out to be 127 parcels of land in Denver proper. After the conclusion of the Civil War, he opted to quickly sell the Denver land deeds and was able to raise enough money to finally save his champagne house from ruin. In recent years, Charles Heidsick's iconic champagne has earned a place of honor in modern champagne bars across the city.

Larimer Square with string lights. The Historic Larimer Square showcases Denver's early days and is home to world-class dining and shopping. *Author photo.*

2

THE LOST DECADES

As the country succumbed to the effects of World War I, Prohibition, the Great Depression and World War II, culinary delicacies fell off the plate of most diners. Long, dark days of war and poverty ravaged the country's spirit, culture and culinary scene. America began to wake up from the cultural and economic slumber in the 1950s under the *Happy Days* illusion of family and societal bliss in which Americana and nationalism thrived.[23] Americans wanted to have fun and approach life simply. Everyone was looking for a feel-good, all-American meal, which in pop culture involved car hops, rock 'n' roll ditties, roller skates, a teenaged dream named James Dean and a blonde sex symbol in Marilyn Monroe.

In the decades following World War II, America experienced growth like it had never seen before. Television shows like *Leave It to Beaver*, *Father Knows Best*, *I Love Lucy* and *The Dick Van Dyke Show* began to color and influence the American Dream. People fled inner cities for the new frontier: the suburbs with their large homes, upgraded kitchens and neighborly existences. With their newfound freedom from apron strings and constant pregnancy, women continued to enter the workforce until a two-income family became the norm. Gone were the days of toiling in gardens, canning fruits and vegetables, smoking and curing meats and fish and slaving over a hot stove. Career women needed convenience, and the women of Denver adopted packaged foods just like everyone else in America. Families embraced Banquet TV dinners, Hamburger Helper, Tuna Helper (really?) Ore-Ida tater tots, Campbell's soup casseroles, Jell-O, Rice-A-Roni and Chef Boyardee. As a

result, Americans everywhere lost their connection to the kitchen and to their families, optimal health and local agricultural communities. In many ways, Americans lost their sense of culinary taste as fast and packaged foods destroyed cuisine all across America.

Due to the city's isolation, the end of the gold and silver rushes further impacted Denver's growth and shifted the national spotlight in different directions. Denver's once rich culinary scene gave way to chain Coney dogs, hamburger joints, cheap diners and the meteoric rise of prepackaged meals. In Denver, fast food was *the* food with brands like Long John Silvers, Taco Time, Dairy Queen, Shakey's Pizza and endless burger chains cluttering the culinary scene. By the 1970s, Americans developed such a taste for bland, quick and easy convenience food like Kraft macaroni and cheese, Jiffy quick breads, Betty Crocker boxed cake mixes and an endless supply of sugary cereals, crackers, breads and salty snack foods that fine dining in the heartland struggled to survive. Chain restaurants like Red Lobster, Olive Garden, Chili's and TGIF popped up on every corner. Denver succumbed to the same fate as the rest of the country, buckling under the pressure of quick-n-cheap chain restaurant conglomerates, the swiftly growing fast food culture and the rise of the Happy Meal marketing schemes. Everyone was looking for a speedy meal to alleviate the stresses of longer workdays along with the increase of obligatory grammar school extracurricular scholastic activities and the endless high school soccer, volleyball, football and baseball games. McDonald's, Wendy's, Burger King, Good Times, Taco Bell and Taco Time "drive thrus" sprang up to supply the demand. Yet Denver is home to a few independent burger joints that stand out from the crowd.

MY BROTHER'S BAR

My Brother's Bar, at 2376 Platte Street, is credited with being the oldest bar in Denver. When M.A. (Maria Anna) Capelli opened her little brick boardinghouse and bar at the corner of Fifteenth and Platte Streets in 1873, she named it Highland House. Maria was reported to be a graduate of Baker Graduate Business School at Harvard University. Maria Anna and her husband, Angelo, came to Denver by way of St. Louis looking for a fresh start. Denver provided ample opportunity for these, the first Italian immigrants to arrive. They were quite entrepreneurial; responsible for an Italian butcher shop, a fruit stand business and an Italian restaurant along

with their boardinghouse and bar. The Capellis housed, fed and cared for other immigrants, mostly poor laborers of Italian descent, and essentially founded Little Italy in northwest Denver. According to Tom Noel, writing about the Capellis and the history of My Brother's Bar in 1997, "Maria cooked old world Italian food for her guests, served them wine and song, and reminding them of their home country."[24] Angelo and Maria fostered positive relationships with their Italian countrymen and other Denver settlers from Germany, Ireland and the East Coast of America, paving the way for a sense of community among the rapidly growing population of Denver. In those days, Italian immigrants had it particularly hard in America and were treated as nothing more than the lowest class of workers. They brought their culture of hard work and low expectations with them from the old country. Few Italian immigrants to America or to Denver enjoyed the early successes of the Capelli family.

America's first saint, a fragile-bodied, strong-spirited Italian-born nun, Mother Maria Francesca Saverio Cabrini, heard of the plight of her countrymen and asked for appointment to the United States. Shortly after her arrival, she went on a sixteen-city tour, establishing orphanages and sanctuaries across the country. Mother Cabrini visited Denver in 1902. It is said that she visited with Maria Anna and Angelo Capelli to discuss the Italian community during her visit to the city. Mother Cabrini loved Colorado and found inspiration in its mountains. She founded the Queen of Heaven orphanage in Denver, and her Sisters of the Sacred Heart built a summer camp for girls called the Mount of the Sacred Heart on Mount Vernon just west of Denver in the foothills west of Golden. Her shrine and church are still there, maintained by the Denver chapter of the Knights of Columbus, and an enormous white statue of Jesus is still visible from I-70 eastbound, sitting high above the city of Golden, overlooking the entire Front Range. Mother Cabrini, Maria Anna and Angelo Capelli did much to advance the Italian community in Denver. Angelo was instrumental in founding the country's first and one of the largest Columbus Day parades in Denver. The Capelli family maintained Highland House until 1907, when they sold it to the Schlitz Brewing Company.[25]

Over the course of the next few decades, the space transformed from restaurant to restaurant and passed hands from owner to owner. At one point in its storied history, the restaurant and bar became a watering hole for Denver's Beat generation scene. In the 1940s, as Paul's Place, it was the favorite hangout for a young and troubled early Beatnik, Neal Cassady, whose favorite place at the bar still has a little brass plaque to hold

his chair. A few years later, Jack Kerouac, who loved Denver, visited the restaurant and bar, then known as Whitie's, while researching Cassady's steps and writing his most famous work. Kerouac went on to immortalize Denver and Neal Cassady as Dean Moriarty, a character in his book *On the Road*. Famous Beatnik Allen Ginsberg also visited Denver, but it isn't known if he saddled up to the bar at Fifteenth and Platte. What is known is that Ginsberg followed his spiritual teacher, Tibetan Buddhist the Venerable Chögyam Trungpa, to Colorado. Trungpa founded the internationally renowned Boulder-based Naropa Institute of Higher Learning, a center of spiritual exploration. Years later, in 1974, Ginsberg and poet Anne Waldman started the Jack Kerouac School of Disembodied Poetics at the modern Naropa Institute liberal arts university.

The timeworn bar and restaurant languished through the 1960s. Then, in 1970, Jim and Angelo Karagas bought the old brick building, freshened up the space, restored the original, hand-carved wooden bar and christened it My Brother's Bar. My Brother's Bar is known for four things: it doesn't have a street sign with its name, it doesn't display televisions, it plays only classical music and it has some of the best hamburgers in the city. In the early days, two of the bartenders also worked as disc jockeys at KUVO, Denver's classical music radio station. They took it upon themselves to enlighten their blue-collar patrons with symphonic sounds, and the theme stuck. My Brother's Bar has a full menu offering a wide variety of classically greasy dive bar food, each order accompanied by a plastic condiment caddie stuffed with chopped onions, relish, pepperoncini peppers, sliced pickles, sauerkraut, yellow mustard, ketchup, mayonnaise and a variety of spicy hot sauces. The Karagas brothers installed a secluded patio that serves as a beer garden but offers the entire menu of food and drinks. The bartenders and servers are a part of the institution. They are never quite friendly, always cordial, and never seem to leave their jobs at the bar.[26]

CHERRY CRICKET

Cherry Creek lies to the east of Denver proper, just past the Denver Country Club. Now a luxury shopping and residential district, Cherry Creek is home to elite stores like Burberry, Louis Vuitton, Hugo Boss, Restoration Hardware's four-story shopping experience, Nordstrom and Tiffany's. Cherry Creek North is an adjacent shopping and dining district featuring

options as diverse as Arhaus Furniture, Le Creuset Boutique, Hermès, Lawrence Covell, Max Clothing, Eileen Fisher and Hamilton Furs, along with countless jewelers and art galleries. Many of Denver's best restaurants are in Cherry Creek North, including Del Frisco's Grille, Crepes & Crepes, Quality Italian (of NYC fame), Hapa Sushi, Cherry Creek Grill and Nobu Matsuhisa's namesake Denver eatery. Cherry Creek is known for its annual Arts Festival and Side Walk Sale, where deep discount deals on everything from cooking gadgets to couture can be found.

Cherry Creek wasn't always so fancy. Decades ago, the Denver Dump was located on the very site of Cherry Creek Mall. Plowed under and paved over, it is one of Denver's best-kept secrets. Back in those days, the sector was a bit more blue collar than elite. Mary Zimmerman lived on First Avenue, just blocks from the trash dump. In 1945, she opened a small restaurant in her home to service the hungry garbage truck drivers and other residents in the area. Within a few years, Zimmerman purchased the building on the corner of Second Avenue and Clayton Street and opened an official restaurant, Mary Zimmerman's Bar. She expanded with additions as her popularity soared. In the 1960s, Mary Zimmerman's Bar was sold to Bernard Duffy, the owner of Duffy's Tavern, who owned it until 1972. Over the course of the next two decades, the Cherry Cricket survived on consistently great yet greasy bar food, increasingly large portions and by becoming a sports-themed dive bar. Cherry Creek gentrified around the dive bar, which soon gained a dark reputation while maintaining its clientele. The Cricket, as it became known, was considered a place for delicious slumming.

Eli McGuire dreamed of transforming the space into "the best damned bar in town," while maintaining what made it great: its hamburgers and bar food. She bought the place with her husband in 1990. The McGuires worked long and hard to restore the space and reputation of the Cricket, as it is fondly known by Denverites. Now, owned by Wynkoop Holdings, established by brewer, restaurateur and Colorado governor John Hickenlooper, the Cricket serves businessmen, fashionistas, students, families, politicians and golfers looking to relax after a sunny round at the Denver Country Club. The Cherry Cricket has become a living room and patio for everyone, serving famous burgers and icy cold adult beverages to residents and tourists seven days a week. The Cherry Cricket closed due to a disastrous November 2016 kitchen fire but finally reopened in the late spring of 2017 and added a second location on Blake Street in the Ball Park district of lower downtown later that year.

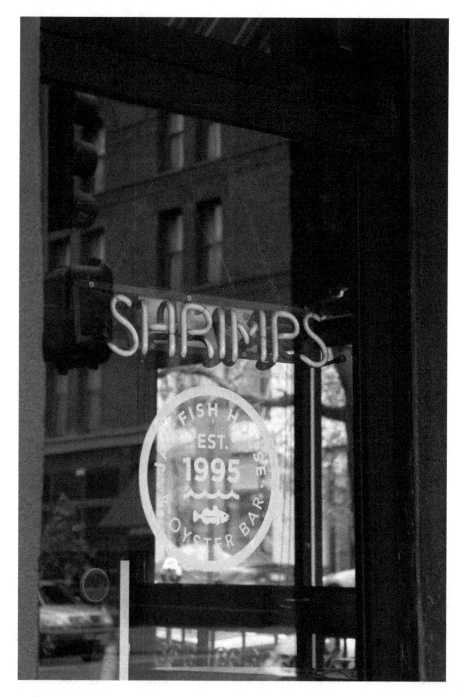

Jax Fish & Oyster Bar, on Seventeenth and Wazee Street, offered oysters on the half shell before the bivalve resurgence. The love of oysters is a Denver tradition. *Author photo.*

3

CULINARY KITSCH

Postwar attempts to provide more choices to the growing, increasingly diverse population paved the way for a culture of New Mexican, the Italian Underground, soul food, BBQ, Asian fusion ethnic cuisine and the rise of bland novelty food. Denver's culinary situation was considered an unfortunate joke on a national scale. Any sophistication left over from the golden years had long since faded. Smart immigrants, looking for opportunity, often found it in Denver. Ethnic restaurants seemed a novelty, but a welcomed one. Americanized versions of Indian, Japanese, Chinese, Mexican and Italian food seemed exotic and quickly became trendy.

This was a time before haute cuisine re-infiltrated Denver, and family-owned ethnic restaurants ruled the culinary scene. Many of these restaurants are multigenerational and offer truly amazing international food. Denver has wonderful, traditional Mexican food. It has a flourishing Vietnamese culinary scene and abundant Indian restaurants. Denver has a strong Russian community, a thriving Arabic population and world-class Japanese food. Ethnic restaurants abound in Denver, with Italian American, Mexican and Vietnamese food leading the categories.

RED SAUCE RESTAURANTS

An Old-School Red Sauce Joint

There is an old saying in the United States: "Everyone is Italian on Sunday." I believe what it means is that everyone loves the simplicity and comfort of

classic Italian American food. Americans dream of the Old World and of simpler times with an Italian grandma in the kitchen preparing her best secret recipes with love in abundance. Classic red sauce restaurants with their red-and white-checked tablecloths offer this retro feel, akin to the iconic scene from *Lady and the Tramp* in which two young pups fall in love under the stars, in an alley, over a plate of shared spaghetti and meatballs. Similarly, Stanley Tucci's inspiring Italian American food film *Big Night*, a comedic drama about two Italian immigrant brothers trying to make it on the 1950s New Jersey shore, is all about dreams of success and dreams of comfort food. The characters' restaurant represents every red sauce restaurant in America.[27]

Walking into a room lined with ancient red leather banquettes, black-and-white tiled floors, plump wine racks and tables embellished with half-burned candles and tiny vases of daisies conjures images of elegant ladies in fitted dresses with full skirts, pillbox hats, elbow-length gloves, stockinged legs and heels on the arms of dapper men in hats and pinstriped suits. The elegance was a juxtaposition to the delicious simplicity of the dining. Hardworking Italian immigrants fiercely adhered to their culture and their cuisine as they made their place in their new home country. Integrating enough to learn the language and the customs, they maximized their gifts to make a living and capture the American Dream.

I fell in love with this ultimate comfort food as a girl at the iconic Blue Parrot Restaurant in Louisville, Colorado, where the Colacci family served their legendary sauce for ninety-eight years, then again at Mama Capella's tiny restaurant in Hot Sulphur Springs, Colorado, or the Italian Underground in Glenwood Springs, Colorado, as a young teen. I adored classic dishes made with homemade, thick-cut pasta, aromatic marinara sauce, spicy Italian sausage and enormous meat balls dripping in bubbling hot mozzarella and provolone cheeses, served alongside a cold iceberg lettuce salad studded with cherry tomatoes and pepperoncini peppers drizzled with Italian dressing and the garlic bread, the cheesier the better, warmed under a broiler and perfect for mopping up every last drop of the sweet, red sauce left on my plate. I loved linguini with clams, veal parmesan, spaghetti Bolognese, osso buco, spicy puttanesca, spinach gnocchi, or my personal favorite, seafood and ricotta-filled ravioli. Mmmm. Mama Capella always sent a round of tiny Sambuca-filled glasses to our table, even for the teenagers, before indulging us one last time with her elegantly layered, ultra-rich tiramisu or chocolate-dusted cannoli served with a tiny coffee and real cream. For me, this was fine dining and my favorite family dining experiences outside of my own home. These meals sent me into my mother's kitchen to try my hand at stuffed shells, manicotti and lasagna. Years later, when I moved to Denver, I would explore the red sauce restaurants seeking the familiar, warm, comforting dishes and environments. I would bring home takeout chicken alfredo from

Angelo's on Sixth or the occasional pizza from Saucy Noodle. There were evenings spent at former Mafia hangout Gaetano's and at Dino's, just west of Denver proper, and lunches at Patsy's or Lechuga's for their original Italian sausage and pepper cannoli. Lechuga's started in 1961, not as a restaurant but as the bakery for Carbone's Italian Sausage Market & Deli and became famous in its own right. Proprietors were families who emigrated from the Old Country with little more than their recipes, customs and work ethics.

Looking for new opportunities and less legal hassle, Prohibition brought bootleggers to Denver in waves. During the 1920s, made men and immigrants from Sicily and Italy by way of New York City and Chicago brought their families, customs and recipes to Denver, settling in Little Italy in Denver's Northside neighborhoods. Some of these families opened up classic red sauce restaurants across budding Denver neighborhoods such as Lo-Hi, Highlands, Sunny Side and Berkley all to the northwest of downtown. Patsy's Inn, Gaetano's, Romano's, Carbone's, Carmines, Pagliacci's, the Saucy Noodle, Dino's Italian Restaurant, Carl's, Amato's, Lechuga's, Gennaro's and Angelo's all thrived, representing the Italian immigrant drive for success in the United States and the city's search for delicious cuisine.

Maggie Tolve opened Patsy's Inn Italian Restaurant on Navajo Street with her husband, Mike Aiello, in 1921. Family owned and operated for ninety-eight years, Patsy's Inn quietly closed in 2016. "Fans of Patsy's are not just mourning the loss of a vintage Italian eatery. They're also sad about losing one of the last pieces of local history. In the '70s and '80s, that neighborhood was simply called 'the Northside,' and it was dotted with red sauce places like Patsy's, Carbone's, Gaetano's, Pagliacci's, Carl's, Amato's," said influential restaurant consultant John Imbergamo. "One by one, relentless development has robbed us of 'Sunday gravy' and pasta, leaving behind a wake of designer pizza, seared octopus and clever neighborhood nicknames."[28] I tend to agree with him.

A few blocks away, Ralph and Mamie Smaldone opened Gaetano's Italian Restaurant during the Great Depression as a place to meet and a place to have Sunday gravy meals—Colorado Italian slang for red sauce pasta dishes. Moonshiners and bootleggers, Colorado's most prominent Mafia crime family of the era, the Smaldones, were known as the most charismatic and debonair mobsters in Denver. The three sons—Eugene "Checkers," Clyde "Flip Flop" and Clarence "Chauncey"—went on to "own" Denver and owned and operated Gaetano's as well. The trio did much to advance the classic cocktail culture by serving up their moonshine in an illegal yet popular gambling room upstairs. The family quietly reigned over Denver well into the last decades of the twentieth century.

The Blue Parrot wasn't a Denver restaurant, but its legendary sauce is sold by the quart in every grocery store in the city. Mike and Mary Colacci settled

in Louisville, twelve miles northwest of Denver, just after the turn of the twentieth century. Mary, a congenial woman, welcomed her neighbors into her home for a traditional Italian feast on many Sundays after church. Her family meals became the Blue Parrot Restaurant in 1919. Sons Tony and Joe were raised in the place and went on to run the Blue Parrot for decades. Five generations of the Colacci family owned and operated the restaurant, which served its last meal in January 2017.

In my business, I am fortunate enough to dine in the best restaurants Denver has to offer. I love exploring the creativity, the fusion, the intense flavors and the highly constructed haute cuisine. Sometimes, I just crave an uncomplicated dish offered by a classic red sauce restaurant. One by one, these Denver treasures are shuttering their doors, making way for the new, the hip and the overhyped. Luckily, one of the few remaining icons is just blocks from my Green Mountain home.

Elisa Heitman, born Elisabeta Sicuranza and raised in Naples, Italy, owns one of the most iconic Italian restaurants in Colorado. Nestled in an unassuming strip mall in west Lakewood, near the foothills in a friendly neighborhood, Elisa has been serving classic American Italian cuisine for more than twenty-five years. Elisa came to the United States, not even eighteen years old and just newly married to a young American man. Within a few months, her world turned upside down, and she found herself alone. Working as a waitress, she learned English, learned the restaurant business and discovered that she could not only support herself but also thrive by bringing a little bit of her culture to Denver.

A few years later, Elisa and her second husband fell in love with a little storefront restaurant space near a grocery store on South Kipling Street and West Jewell Avenue. They opened Cafe Jordano on February 21, 1990. The spot quickly became a local favorite, serving up classic comfort food and handcrafted desserts with a special homemade touch.[29] Since then, Elisa expanded into the next room to accommodate her endless line of patrons. After perfecting her classic Italian cuisine, Elisa opened Mediterranean Italian–themed Jordano Grille on Green Mountain in the foothills to the west of Denver.[30] In late 2017, Elisa took another risk and moved Cafe Jordano next door into a gorgeously renovated space with three times the seating capacity to serve her loyal and ever-growing fan base.

I visited Cafe Jordano on a cold and rainy spring afternoon for a steaming hot plate of sweet homemade ravioli served with Italian sausage and a plummy glass of Montepulciano d'Abruzzo followed by strong espresso and the most deliciously creamy, slightly sweet cannoli that I have ever had in Denver. It was late in the afternoon; the air was infused with garlic and basil, and the place was packed. Every table was booked with satisfied locals on

their regular lunch stop. And why wouldn't they be? The soups and sauces are made from scratch every morning, and each entrée is made fresh to order. Elisa substitutes buffalo for veal and uses real cream, pure butter and the freshest cheeses she can find. Her menu is balanced with pasta dishes and chicken dishes. Shrimp scampi and calamari make an appearance. Traditional dishes such as gnocchi, tortellini, manicotti, Sicilian lasagna, cannelloni and a few luscious vegetarian dishes round out the reasonably priced menu. In a sea of overly complicated haute cuisine, the simplicity of Cafe Jordano is a welcomed respite.

PHO HAU II NOODLE BOWL & GRILL

The west end of the city has long been ignored by the culinary elite. Finding delicious and nutritious cuisine can be challenging. Peppered with chain restaurants and underwhelming ethnic options, 240 Union, Simms Steak House and Cafe Jordano are a few of the lone standouts. Discovering a truly delicious meal is always a welcomed surprise. Federal Boulevard, just west of downtown, is studded with Asian and Mexican grocery stores, restaurants and shops. North of Alameda is largely home to Mexican cuisine; south of Federal is devoted to Asian culture and cuisine. The dividing line is Denver's tiny China Town, encompassing one block on Alameda Street and Federal. With the dish's recent rise in popularity, there is a busy pho shop on every corner in Denver.

Among the city's best is Pho Hau II Noodle Bowl & Grill, tucked away in a strip mall on Green Mountain. Yes, the pho trend is a few years old, but few things warm me up better on a cold winter afternoon than piping hot beef broth–drenched noodles served with herbs, bean sprouts and tender brisket. Housed in a small room, brightly decorated with generic paintings of koi, flowers and landscapes and crammed with four tops and banquet tables, Pho Hau II looks a bit like a cheap cafeteria. Several wall-mounted muted televisions stream the news while relaxing classical music drowns out the noises of the partially open kitchen. Pho Hau is clean, welcoming and warm. The place is always full, and there is a steady flow of quickly turning tables and takeout orders.

Servers Ivy and Hoa know your order, and your favorite dish never disappoints. The pho at Pho Hau II is, in my opinion, the best in Denver. The owner and matriarch, Cathy Tran, prides herself on her flavor-rich, ultra-nutritious broth, made fresh every day using soup bones, cuts of beef, cardamom, star anise, ginger, cinnamon and onions rather than salty packaged seasoning mixes. The broth is ladled over a generous portion of perfectly cooked rice noodles. Go ahead and order the thinly sliced brisket

and shrimp combination. The brisket can be a little bit fatty and isn't well trimmed, but this just adds to the amazing flavor. The pho is served with a mountain of crisp bean sprouts, fragrant Thai basil, cilantro, sliced jalapeños and lime wedges so each bowl can be perfectly customized. Three sizes are available, but the small bowl is more than enough for a satisfying meal for just about anyone.

Pho originated in the early twentieth century in the Nam Dinh province in northern Vietnam. It was a popular and nourishing street food most commonly served at dusk to people on their way to work. Street vendors would carry long wooden poles across their shoulders with a pot of broth hanging from one end and a pot of noodles and herbs from the other. In the southern provinces, vendors added bean sprouts, Thai basil, hot chili sauce and bits of meat. The very first American pho restaurant, Little Saigon, opened in 1980 in California. Two decades later, pho experienced its pinnacle of popularity with pho houses springing up all over the country. Pho Hau II offers two dozen combinations, including various cuts of beef, chicken, seafood, meatballs and a vegetable tofu vegetarian broth dish.

On my recent weekly visit to Pho Hau II, I cozied up at a small table in the window near a gorgeous ancient jade plant. Ivy brought over a pot of hot tea to welcome me. I mentioned how delicious the pho is and commented about the beautiful plant. Cathy rushed over to explain her special broth and then cut off a branch of the jade plant, offering it to me for good luck. With her encouragement, I decided to deviate from my traditional choices and explore other options on the menu. Pho Hau II also makes the best spring rolls in the city. Too often, restaurants scrimp on the stuffing and fill them with mushy rice noodles. Cathy serves her freshly made spring rolls filled with julienned carrots, cucumbers, beef, lettuce, basil and whole shrimp with an accompanying peanut sauce that is a bit too thin and sweet, but the rolls are so good that they don't really need sauce. The shrimp tempura was unfortunately the usual frozen fare, but instead of deep frying to reheat, these are oven baked to a toasty crispness and drizzled with a blend of fish sauce and honey. The tempura was garnished with a refreshing pickled carrot and cucumber salad. The Bun Tom Thit Nuong special that I ordered was a grilled shrimp and pork noodle bowl, with rice vermicelli serving as a bed for the smoky grilled shrimp and juicy strips of pork, crisp lettuce and radish, bean sprouts and lime. A bit of tangy sweet nuoc mam sauce is spooned over the dish to finish and blend the flavors. Another house specialty that I tried was the Ga Nuong Rau Son Ban Trang, grilled chicken breast marinated in lemongrass and sesame oil. The chicken is easily overcooked, but the chargrilled marks add flavor and texture to the dish. The chicken is served with rice paper wrappers, an assortment of fresh vegetables, pickled carrots,

basil, cilantro and marinated rice noodles so you can build your own spring rolls. This dish also comes with a crispy classic pork and vegetable egg roll. Each table has an assortment of fish sauce, hot chili sauce and the obligatory bottle of sriracha so you can add as little or as much heat as you desire. For dessert, Cathy offers fried bananas and honey or a lychee green tea boba drink, or you can finish your meal with a strong Vietnamese espresso served with sweetened condensed milk and ice.

With its spare menu, Pho Hau II focuses on Vietnamese street and casual cuisine but also serves classic Asian cuisine appetizers like egg rolls and crispy shrimp and pork paste, a selection of salads, a Vietnamese grilled sandwich and a succulent crispy chicken leg quarter. The specialty of the house, the Pho Hau Grilled Combo, includes grilled chicken, pork and shrimp along with pork paste, tempura shrimp and egg rolls, all served over marinated rice vermicelli with fresh vegetables and herbs—it is generous enough to share on date night or with the kids. The steaming hot pho, with its incredible broth, is the star of this show and still my favorite dish.

EL TACO DE MEXICO

El Taco de Mexico is a true Denver insider secret serving up what are considered to be the best street tacos in town. The restaurant was opened in 1985 by Maria Luisa E. Zanabria and her family, who brought traditional recipes, flavors and culinary tradition with them from Mexico City, many of which exemplify the flavors and ingredients of Native American cuisine. The menu focuses on classic Mexican fare but offers a few Americanized options, including enchiladas, chile rellenos, burritos, tamales, gorditas, synchronizadas, chilaquiles and sopes. The small, colorful building is on a corner lot set back from the street and adjacent to a showy Mexican restaurant called El Noa Noa, another family-owned icon with one of the best patios in the city. Located on Seventh Avenue and Santa Fe Street in the popular Santa Fe Arts District, El Taco de Mexico is flanked by art galleries, theaters, boutiques and the new, state-of-the-art home and training center for the Colorado Ballet. It is easy to drive by the restaurant as you make your way up the busy one-way street. El Taco de Mexico operates more like an indoor food truck offering up classic Mexican street tacos, all-day breakfast and smothered burritos. The room is small, with fewer than ten indoor booths and a handful more on the patio, but it is fantastically decorated with artwork from famous and emerging Mexican artists. The Santa Fe Arts District plays host to one of the most popular First Friday open house art gallery events in the city, and the line starts at El Taco de Mexico.

The iconic Sullivan's Steak House, known for its jazz-era bar and murals with a speakeasy feel, closed in 2015. *Author photo.*

4

STEAKS AND CIGARS

A side from being founded by waves of precious metal and mineral hunters searching for streets dusted with gold and silver, early Denver was big cattle country and is still the home of the world's largest agricultural stock show, the National Western Stock Show and Rodeo, which is in its 112th year. Since 1906, the event has grown into a worldwide phenomenon attracting 705,547 visitors in 2018 according to the official website. The annual show hosts more than eighteen thousand animals on display while in show and competition, several professional rodeos and competitions, Native American displays, dances, ceremonies, and a rodeo, educational programming for children and adults and dozens of family fun events, such as a hilariously serious dog pull competition.[31] The National Western Stock Show is also a place where rural kids participating in Future Farmers of America partake in children's "mutton busting" and "catch a calf" competitions. The winners of such events keep the animal they catch for a year of animal husbandry training through their local FFA chapters, returning to the next annual National Western Stock Show to sell their ward, earn their bounty and praises and even scholarship funds. These competitions and others like them often fund young students attending agricultural-based colleges such as Colorado State University in Fort Collins, Colorado, and look great on résumés and college applications.

Colorado depends on its agricultural roots for statewide economic success and growth. Agriculture is an integral part of the Coloradoan culture. Upholding these agricultural traditions in Denver—and enforced by the

The Kitchen chalkboard cow, The Kitchen, Denver. *Courtesy of The Kitchen.*

oil and gas industry—abundant and great steakhouses seemed an obvious necessity. The most famous steakhouses in Denver are vanity projects, and many are odes to former Denver sports figures such as (Mike) Shanahan's Steakhouse in Greenwood Village and (John) Elway's Cherry Creek, Elway's Downtown and Elway's Denver International Airport. These Denver steakhouses serve up a fantastic filet at an equally fantastic price; side dishes are sold à la carte for a premium. In addition, classic East Coast and midwestern steakhouse chains fill out the category with the Palm, Sullivan's, the Keg, Landry's Simms Steak House, Morton's of Chicago, Del Frisco's, Ruth's Chris and Capital Grille. Denver also has a string of classic seafood and steak grills like McCormick's & Schick, Quality Italian, Chop Houses, Ocean Prime and a cluster of Outback Steakhouses and Texas Roadhouses. Longtime LoDo legend McCormick's Fish House & Bar shuttered in 2017 much to the surprise of local residents.

In 1996, the Palm Restaurant opened in the Westin Hotel in downtown Denver. The world-famous restaurant is a part of the largest, family-owned international restaurant chain based in this country. It has always been one of my favorite surf and turf spots. Known for the caricatures depicting celebrities, famous politicians and prominent sports and media figures as well as its steaks, Italian dishes and enormous lobsters, the Palm has

Morton's of Chicago, Steak House, recently moved from its home on Seventeenth and Wynkoop, taking over the Sullivan's Steak House space on Eighteenth and Wazee Streets. *Author photo.*

always been "the place to be seen." The Palm is another Italian immigrant made good story. Pio Bozzo and John Ganzi immigrated to New York City from Parma, Italy, in 1920. Within a few years, the pair decided to open a restaurant incorporating their native cuisine with American steakhouse fare. They registered their restaurant in 1926, and due to a clerical error, the name morphed from Parma to Palm and The Palm was born. By 1931, The Palm cemented its reputation as a steakhouse by catering to the media and entertainment industries. In the 1940s, the second generation, Walter Ganzi and Bruno Bozzi, took over and added the infamous two-pound lobster to the menu, solidifying a reputation for decadence and excellence in dining. By the 1960s, third-generation restaurateurs continued to build upon the hedonistic menu by adding a four-pound lobster to the lineup and loosening the dress code in order to reach a broader clientele. Soon after, The Palm began expanding to other cities across the country. Denver was anointed with its very own Palm Restaurant in 1996, and for me, it is still the place to be seen.

Buckhorn Exchange

Everyone writes about the Buckhorn Exchange.[32] The reviews are mixed, but nothing can take away from the fact that the Buckhorn Exchange represents Denver's earliest days. Nestled in a rapidly gentrifying downtown neighborhood, the Buckhorn Exchange is more kitsch than classic, but it makes the list because it is still an iconic steakhouse and Denver's oldest continuously operational restaurant and liquor license. The steak on your plate could be beef, elk, venison, rabbit or even rattlesnake. With so many hunting trophies on the walls, the place could be a taxidermy museum. The Buckhorn Exchange is still housed in its original location on 1000 Osage Street, just south of the Cherry Creek, which divided Denver from its southernmost neighborhood, Auraria. The Buckhorn Exchange originally was a saloon when it opened its doors in 1893, and the place was issued and still holds liquor license number one. Over 125 long years later, the Buckhorn Exchange hasn't changed much. Declared a National Historic Landmark, the Buckhorn Exchange serves up kitsch 1800s fare and historic cocktails like the Buffalo Bill, a bourbon and apple juice creation, named after the drink the man himself sipped on at the bar. Legend has it, the opulent hand-carved bar was crafted in Germany in 1857 and shipped to America, only to be brought west to Denver in the 1880s. The who's-who of the American Wild West, Western film stars, politicians, athletes, astronauts, Native American royalty and even a British royal princess all graced the place with their presence at one time or another.

President Theodore Roosevelt ate here in 1905 when his Presidential Express train pulled into the Rio Grande rail yards. Roosevelt strutted in presidential style, asked old Shorty Scout to be his guide and hunting partner, and after dinner and drinks, the pair took off by train to hunt big game on Colorado's western slope. Today a photo of the train and a flag from its engine are among hundreds of pieces of museum-quality memorabilia on display in the Buckhorn Exchange which today is as much a museum as a restaurant and bar. Another historic moment and most incredible scene was recorded in 1938 when Sitting Bull's nephew, Chief Red Cloud, and a delegation of thirty Sioux and Blackfoot Indians rode slowly down Osage Street in full battle regalia, and ceremoniously turned over to Shorty Scout Zietz the military saber taken from the vanquished General George Custer in the Battle of Little Big Horn. The sword remains in the Zietz family today. The Buckhorn Exchange brims with historic artifacts, legends

and notable moments. Five Presidents—Theodore Roosevelt, Franklin Roosevelt, Dwight Eisenhower, Jimmy Carter and Ronald Reagan—dined at the Buckhorn. Hundreds of Hollywood legends, too, have savored our fare, including Bob Hope, Jimmy Cagney, Charleton Heston, astronauts Scott Carpenter and Jack Swigert, Great Britain's Princess Anne, Roy Rogers and Will Rogers. The list is virtually endless.[33]

These days, the Buckhorn Exchange is populated by curious tourists and locals looking to enjoy a nostalgic evening listening to local bands and daring one another to try the Rocky Mountain oysters and other curiously named and ever so deceptive dishes representing regional cuisine and old-timey flavors.

The Fort Restaurant

Sam'l P. and Elizabeth "Bay" Arnold were visionaries. They were also amateur historians and concerned parents. In 1961, the Arnolds were looking for a quiet life where they could raise their children, Keith and Holly, in fresh, clean air away from the hustle and bustle of city life. The couple fell in love with drawings of the original Bent Fort in a historic book about the region. Bay turned to Sam'l and said, "Let's build an adobe castle like this!"[34]

The original Bent Fort was established by Charles and William Bent in partnership with Ceran St. Vrain's Trading Company. The Bent brothers

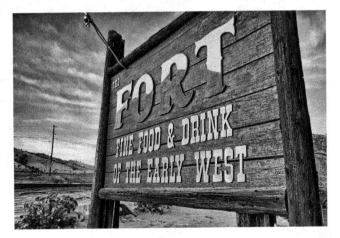

The legendary Fort restaurant in Morrison, Colorado. *Courtesy of John Poplin.*

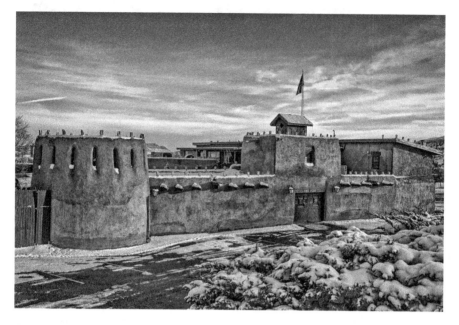

The Fort Restaurant, a replica of Bent Fort. *Courtesy of John Poplin.*

The Fort Restaurant. *Courtesy of John Poplin.*

The Fort Restaurant. *Courtesy of John Poplin.*

constructed the adobe and wood beam structure in 1833 to serve as a hub of trading between the white settlers, Mexicans and nomadic Cheyenne and Arapaho Plains Indians. Trappers and hunters traded buffalo robes and other hides for goods, wares and other commodities. Situated along the Santa Fe Trail, in southeastern Colorado territory in what is now Otero County, Bent Fort flourished for nearly sixteen years. The fort was essentially abandoned in the years after the Mexican-American War.

In 1961, the Arnolds bought a beautiful property in the red sandstone and granite rocky foothills just southwest of Denver in Morrison, home to world-famous Red Rocks Amphitheater. Architect William Lumpkins designed the place, and a contractor from Taos, New Mexico, and his crew of twenty-two workers, painstakingly built the replica Fort one straw and mud brick at a time. Incidentally, there are over eight thousand bricks in total. In the end, the Arnolds decided to build a restaurant on the first floor of the building to offset the exceedingly high costs of the construction. Moving their family into the second level, the pair opened The Fort Restaurant in 1963. The Arnolds hired Taos artists to craft furniture and doors, replicating the original furnishings from Fort Bent, circa 1833. Sam'l researched authentic Mexican, Native American, Spanish and European cuisine from the 1800s and painstakingly re-created and modernized many of the recipes for his menu:

> *The Native Americans ate all parts of the buffalo including the bone marrow (Julia Child's favorite), tongue, and Rocky Mountain oysters. Try them! You'll like them! The Hailstorm was the first Colorado cocktail served in 1833 at Bent's Fort. It is our signature drink today. By exploring our rich Western cultural and culinary past, we reintroduce food trends of the 1800's, which create current trends of their own. Our Executive Chef continues to be inspired by historic recipes and introduce new items to our menu such as the buffalo empanadas…delicious like the first kiss!*
>
> *The word "restaurant" means to restore. Let us restore your soul as well as your stomach! A Hearty Welcome to my home. WAUGH!* (Mountain Man lingo for "Right On!")[35]

Having grown up with her family at the Fort, Holly Arnold Kinney still owns and operates The Fort Restaurant. She is nationally known for her advocacy of southwestern design, arts, history and culture. In 1999, Holly created the Tesoro Cultural Center, which focuses on protecting, preserving and promoting the culture and history of the southwestern

United States. She also published a cookbook, *Shinin' Times at The Fort: Stories, Recipes and Celebrations at the Colorado Landmark Restaurant*, revealing recipes and anecdotes of her time growing up in and around The Fort. Among Holly's favorite memories of her childhood include time spent with her pet, Sissy. "In 1963, we adopted a Canadian black bear cub named 'Sissy' who lived at The Fort for 19 years. She was my pet bear, and died of old age." There are many photos and stories of Sissy and her adventures available in old press clippings and on the restaurant's website. Holly is very active in her culinary community:

> *Kinney has served on the Board of Directors of the CRA (Colorado Restaurant Association), and received the association's highest individual award, the Distinguished Service Award, in 2010. She has also served on the Board of Directors for the Colorado Historical Society (History Colorado) and currently serves on the Advisory Board for the Department of Agriculture Colorado Proud program. She is the former president and founding member of the Colorado Chapter of Les Dames d'Escoffier, and a member of the International Association of Culinary Professionals (IACP), American Institute of Wine and Food (AIWF), Meeting Planners International (MPI) and the Denver Metro Convention and Visitor Bureau's marketing committee.*[36]

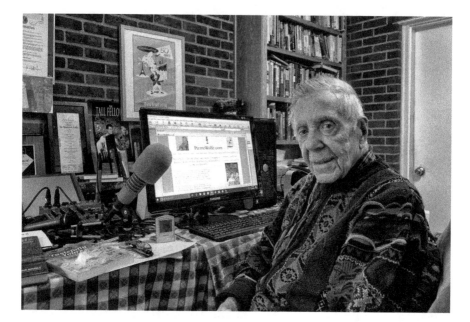

Pierre Wolfe, radio personality, chef and restaurateur. *Courtesy of John Poplin.*

5

A NEW KIND OF GOLD

In the 1970s and 1980s, the booming oil and gas industry brought much needed economic growth to Denver. During this era of the late 1960s through the early 1980s, a new crop of innovative restaurants appeared. These early innovators, including Mel Masters, Blair Taylor, Kevin Taylor, Noel Cunningham and Corky Douglass, opened a group of restaurants that changed the way people thought about culinary Denver. "In the '70s and '80s, French food was the gold standard of fine dining," said restaurant consultant John Imbergamo. "French or continental dominated the category."[37] This new class of restaurateurs, however, owe their opportunities and successes to pioneering French chef Pierre Wolfe, who claimed that "restaurants are about status and celebrity, power and politics, money and sex."[38]

I met the legendary Pierre and Jean Wolfe late in September at their Cherry Creek home. At ninety-two years old, Pierre is a dapper and gracious fellow, excited to reminisce about his remarkable life. Jean is an eighty-six-year-old feisty bundle of energy and was rushing out the door to her decades-long position volunteering at a local museum on the day we met for our interview. Lola and Bambi, their two little white Maltese dogs, were happily yapping under foot as Pierre recalled his long and winding tale. Pierre is a Berlin-born Alsatian-French, who, at the tender age of sixteen, voluntarily served with the Allied forces in the Middle East and North Africa during World War II.

Young Pierre received an honorable discharge as a second lieutenant, and shortly thereafter his culinary training began in 1948, on the advice

Lebanese

A Lebanese Cake

Pastry Crust:
1 cup flour
pinch of salt
1 stick butter
1/4 cup sour cream

Cut the flour into the butter with a fork until small pebbles are formed. Add the salt and work in the sour cream until a soft, moist dough is formed. Divide the dough into three parts and roll each out on a heavily floured surface. Cut the dough to fit a 9 inch pie dish and place in the dish. Puncture the dough with the tines of a fork to prevent the crust from rising during the baking process. Bake at 425 degrees until lightly brown and crisp. Remove and cool.

Cake Layers:
From your bakery, buy an uniced sponge cake 9 inches in diameter and one inch thick. Freeze for three hours and cut into three layers with a bread knife.

Fillings:
1 cup honey
1/4 cup chopped filberts
1/4 cup chopped walnuts
1/4 cup chopped pecans

Mix together and hold at room temperature.

1 8 oz. jar seedless berry preserves
1/4 cup shredded cocoanut

Mix together and hold at room temperature.

(Continued on next page)

Left: Pierre Wolfe's famous Lebanese Cake recipe. *From the collection of Pierre and Jean Wolfe.*

Below: Pierre Wolfe cookbook scrapbook. *Courtesy of John Poplin.*

of his commanding officer aboard the cruise ship *Caronia*, part of the Cunard Green Goddess Cruise Line. He accepted a position working as a liaison between the first-class guests and the kitchen, managing special requests, dietary needs and special meals. The luxury liner sailed from South Hampton through the Strait of Gibraltar and along the northern Mediterranean coastline, past Turkey and finally into Palestine and Syria. Pierre learned a trade and saw the world. His sister, Suzanne Joshel, sent letters to the ports along the way to communicate details of her life in her new home country, the United States. Pierre took time off from the *Caronia* to formally attend a renowned hotel management school in Switzerland. By 1950, with the threat of the Korean War, Suzanne was encouraging Pierre to seek safety by joining her in the States. She was living with her husband in Denver, and he agreed to sponsor the young immigrant. Finally, Pierre agreed and arrived at Idlewild, now Kennedy Airport, on a British Air D7, decked out in his only suit, a military uniform, with his papers, affidavit of support and $3,000 in his pocket, which he had saved over his months on the cruise ship. He planned to see New York City first before traveling to his final destination in Denver. Unfortunately, his plans didn't go accordingly. The U.S. Customs clerk, evaluating his military uniform and papers, tried to send him into the U.S. military and on to Korea. Pierre was detained for noncompliance. Pierre's brother-in-law flew to New York City to negotiate his release and, as his official guardian in America, chaperone him to Denver by way of a brief stop in New York City. As a part of the deal, Pierre could be conscripted, but he never was.

Once in Denver, Pierre used his training to find work in restaurants. Capitalizing on his skills honed on luxury cruise liners, Pierre began his official restaurant training at the Brown Palace, Palace Arms restaurant as sous chef. He quickly headed out on his own; most notably, in 1952, he landed at the Lamaze Patio Restaurant on Belleview and South Santa Fe Drive, next to Centennial Race Tracks. Centennial Race Tracks opened in 1950 for horse racing and became a nationally renowned racetrack and horse stable facility. Pierre essentially ran the entire restaurant, and the owner, pleased with his success, left him to it. In 1956, the owner suddenly died. Pierre inherited "the whole mess" when the lease holder gave the place to Pierre but kept all the liquor for his profit. Pierre admitted that it was a struggle serving up an elegant meal without appropriate libations, but he persevered. The Patio, as it was then known, served up a popular cuisine driven lunch buffet for a mere ninety-nine cents.

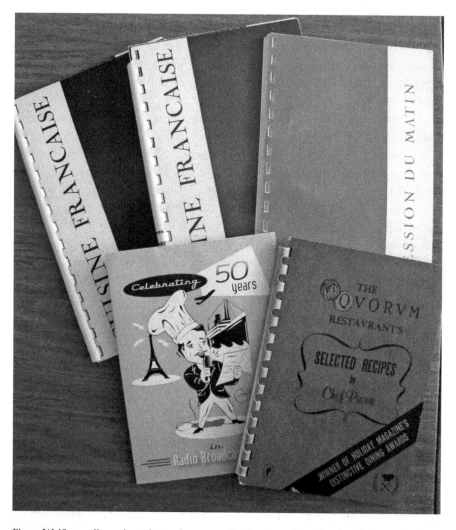

Pierre Wolfe, a culinary icon, has written countless books and cookbooks. *From the collection of Pierre and Jean Wolfe; author photo.*

This was the same year that Pierre met a beautiful and witty young schoolteacher who was working part time at Centennial Race Tracks. The young lady frequented the tony restaurant across the street for her lunches. Pierre and Jean began their enduring love story at the Patio. The couple was married in 1960, and Pierre took his new bride on a whirlwind, thirty-day honeymoon tour of nearly every country in Europe. All the while, he was building his dream restaurant in a run-down coffee shop that he found in the Argonaut Hotel across from the state capitol building. In 1959, Pierre

Pierre cookbook with photo. *From the collection of Pierre and Jean Wolfe; author photo.*

Cuisine Française cookbook, Frog Legs Provençale & Escargots Maison Luxembourg. *From the collection of Pierre and Jean Wolfe; author photo.*

convinced the hotel owners to renovate the space and hired architect Richard Crowther to spearhead the project. With an eye on his future, professionally and personally, Pierre returned to Denver ready to change his world. When the Wolfes returned from their honeymoon in late spring, Pierre set to work in his new restaurant, christening it the Quorum. Pierre enlisted the help of a cousin, wine vendor Heinz Gerstle, who went on to partner with him on later restaurant projects as well. The Quorum met with much early success, due to the fact that after languishing during the war era, Denver was longing for a return to fine dining and elegance, a delicious meal and a wonderful night on the town. The Quorum soon became popular with politicians, newsmen, sports figures and celebrities. Lined with red leather banquettes, polished dark wood furniture, white tablecloths and flowers, the Quorum was sophisticated without being stuffy, as the Palace Arms was deemed in the late 1950s.

One evening, Pierre hosted an engagement party at the Quorum for broadcasting entrepreneur Bill Daniels, the owner of 94.5 FM. The party was a huge success, and in a surprising turn of events, Pierre was subsequently offered a chance to bring his unique talent to the airwaves. Pierre began his broadcasting career in Colorado in 1957 on KFML Radio and branched out into television in 1961. Since those years, Pierre Wolfe has been involved with radio and television on a continuous basis. In fact, Pierre is the longest culinary and tourism radio broadcaster in the business. Pierre's nationally syndicated show, *America's Dining and Travel Guide*, has been continuously aired since 1988, including fifteen years on TalkRadio.net. His work as a talk show host led him to local stations KOA, KDEN, KNUS and KVOD in Denver, and he left those stations only due to changes in programming and or management. His tremendous success on radio prompted television appearance offers as well.

In the early 1960s, Pierre officially ventured into television with a prime time slot opposite medical drama *Dr. Ben Casey*. For his first night, Pierre decided to spoof on that theme by showing up to the production set in a surgical gown and gloves. Quite to the amazement of the producers, Pierre proceeded to "operate" on a beef heart by deftly opening, stuffing and sewing it up. He then baked, expertly sliced, garnished and served the culinary delicacy to the audience. In a matter of days, the television station had more than three thousand requests for the recipe, and Pierre was a hit and an original culinary television star. In subsequent episodes, Pierre demonstrated Crêpes Suzette with full flambé and his claim to gustatory fame, the iconic Steak Diane, which he drenched in a lush lobster sauce.

Culinary legends Pierre Wolfe and Julia Childs. *From the collection of Pierre and Jean Wolfe; author photo.*

As an early pioneer of the television cooking show format, Pierre brought professional cooking and fine dining into focus across the city and the country. Even though Pierre enjoyed the process of creating television episodes and the notoriety that came along with it, he missed his freedom, his wife and his restaurant. Eventually, Pierre gave up on television, amid tremendous success. Ultimately, he found it an imposition on the frequent global travels he and Jean enjoyed.

Essentially, Pierre paved the way for the emergence of French cuisine and fine dining in Denver and across the nation. Pierre Wolfe and legendary cookbook author and culinary television personality Julia Childs joined forces in the kitchen one day in 1979. At the time, both were iconic veterans of the hospitality and broadcasting industries and both were authors of various cookbooks. One can only imagine what that incredible conversation went like. Julia Child came to fame when she partnered with French chefs Simone Beck and Louisette Bertholle to write their French culinary tome *Mastering the Art of French Cooking* in 1961. International stardom followed when PBS first aired the instant television hit *The French Chef*, starring Julia, in 1962, and a new era of haute cuisine was christened. By the time she met Pierre, Julia enjoyed tremendous success as a culinary television host,

often working alongside fellow iconic chef Jacques Pépin. She was living in Boston at the time and graced Pierre's radio broadcast with an interview. A Denver-based media and public relations person decided to host a private event, inviting Julia and thirty-five guests to be privately wined and dined in Denver and Pierre was hired as the chef for the day. He served lamb noisette accompanied by celery carved into the shape of olives and sautéed in a sauce of saffron and balsamic vinegar. The room ate the innovative meal in hushed tones, looking toward Julia and her reaction for guidance. Julia loved it, particularly the creativity of the faux olives, and went on to praise the chef and meal on her own television show.

By the time Pierre joined BizTalk Radio in 1988, presenting his shows, *The Good Life* and *America's Dining and Travel Guide*, his program reached 285 stations around the country. Pierre has a very large cadre of guests who call into his shows, including major, renowned international guests in the travel and culinary industries. Today, Pierre and Jean still travel regularly, opting for cruises and venturing around the world. Pierre totes his broadcasting studio with him and broadcasts his show from aboard ship. In 2016, Pierre regularly broadcasted from Holland America's Westerdam Caribbean Cruise. In the recent past, he has broadcasted from countries as varied as Morocco, Italy, Vietnam, China and Tunisia.[39] Over his lifespan, Pierre has frequently traveled the world with Jean. He has been a broadcaster and guest chef on many of the leading cruise lines, including Crystal, Cunard, Seabourn, Windstar and Radisson Seven Seas. During his travels, Pierre has broadcast live from all parts of the globe and from all continents, with the exception of Antarctica and the Arctic Circle. "There is still time," he said, eyes glistening.

Although Pierre found a new passion in radio, his first love is still fine dining. In 1964, *Holiday Magazine* shone a light on Pierre's Denver efforts. The magazine awarded an annual accolade to the best restaurant in the country; the prestigious national award predated the modern *Food & Wine* magazine and James Beard Foundation praises. The story goes that *Holiday's* critic, Silas Spitzer, caught wind of the work Pierre was doing in Denver and decided to pay a visit and see what all of the fuss was about. Spitzer was more than pleased with what he found at the Quorum and said as much in a review of the restaurant. In 1970, *Holiday Magazine* honored Pierre by bestowing on him its prestigious Holiday Dine Award. Pierre was astounded and humbled by the attention. Always a brilliant self-promoter and gracious gentleman, Pierre seized the opportunity and went on to organize a weeklong reunion and conference bringing together past winners. The event commenced

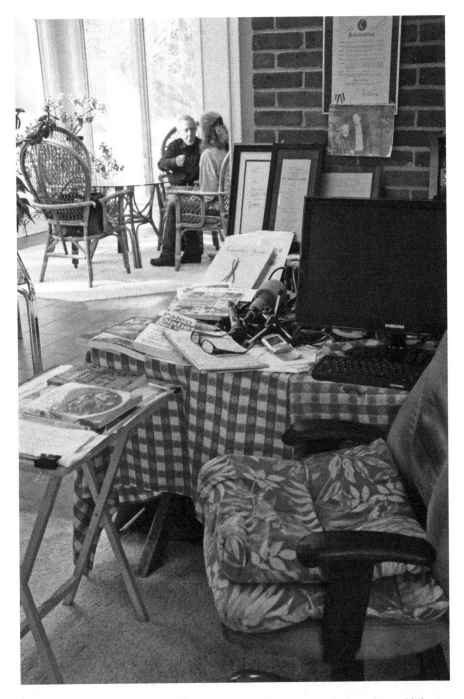

Pierre Wolfe sharing memories with Colleen E. McKenna, the author's mother, at his home in Cherry Creek. *Author photo.*

on Friday, October 23, 1970, at the tony AAA Five Diamond Broadmoor Hotel in Colorado Springs, long considered the most luxurious hotel in the entire state. Pierre planned and executed every step flawlessly. According to Wolfe, "Victor Borge, the exceptionally talented and equally famous Danish classical musician was contracted to entertain the guests. The festivities were sponsored by Diner's Club and American Express, and had an entrance fee of $500, which was a lot of money in 1970." Events always have issues behind the scenes, and the issue at this event was due to a piano. Borge was under contract with Steinway, and the only piano available at the Broadmoor was a Yamaha, so he refused to play unless a replacement could be found and in the eleventh hour, a Steinway was brought in, unbeknownst to the guests and the press. The *Rocky Mountain News* created a special section to cover the event, and photos were splashed on the front page. The Quorum Restaurant received recognition and national publicity along with a new group of fans in the conference attendees.

Pierre was the owner of five award-winning restaurants in Colorado over the years: the Patio, the Quorum, Chez Michelle, the Normandy and Tante Louise. Wolfe officially retired from the competitive restaurant scene in 1990. With more than fifty years of experience in the restaurant industry, Wolfe has plenty of juicy stories to tell from his former eateries, many of

Médaillons de Veau Pyrénéenne
Slices of Veal with Foie Gras and Onion Sauce

1/2 lb. sweet onions (sliced)
1 cup Bechamel sauce
2 tablespoons melted butter
2 egg yolks
1/4 cup light cream or milk
salt and white pepper
8 thin, round slices of veal
flour
2 tablespoons butter or cooking oil
1 tin, imported paté de foie gras
2 tablespoons chopped chives
2 sliced truffles

Saute the sweet onion slices in the 2 Tbs. melted butter. Add the Bechamel sauce and heat over a low fire, blending the onion with the sauce. Remove from the fire and beat in the egg yolks that have been mixed with the light cream. Salt and pepper to tast. Heat the 2 Tbs. butter or cooking oil in a heavy skillet. Dust the veal medaillons with flour and brown quickly on both sides. Sandwich the medaillons with slices of foie gras in the centers. Arange the veal on an oven proof serving dish surrounded with sauteed mushrooms. Pour the onion sauce over the veal and top with slices of truffle. Place under the broiler and glaze quickly to a golden brown. Serves 4.

10

Gratin De Champignons Luxembourg
Gratin of Mushrooms with Pate de Foie Gras

1 lb. large, white, fresh mushrooms
juice of one lemon
1 tablespoon butter
1 shallot
pinch of salt
5 tablespoons minced, smoked tongue
1 cup dry white wine
1 tin, imported pate de foie gras
1 1/4 cups Bechamel sauce
1/4 cup grated Parmesan cheese

Remove the stems from the mushrooms and wash the caps and stems. Place the caps in a saucepan and cover with one cup boiling water. Add the lemon juice, butter, and salt. Boil for 3-5 minutes. Drain the caps and arrange upside down in a shallow baking dish. Saute the shallot, finely minced, with the tongue. Chop the mushroom stems and add to the shallot mixture. Cook over a fast fire for 5 minutes and add the white wine. Simmer for about 20 minutes or until the mixture is reduced to a pulp. Fill each mushroom cap with this pulp and top with a slice of foie gras. Cover the mushrooms with the Bechamel sauce and top with a sprinkle of the Parmesan cheese. Place in a 375 degree oven until heated through and the cheese is browned on top. Serves 6-8

7

From the Patio & the Quorum (1)

STEAK DIANE Quorum.

(1) Have your butcher cut strips of sirloin into 1/2 high thick slices and remove all the fat and sinew resulting in small steaks weighing about 3 1/2 oz. each (2 steaks per person)

2 - 4 oz trimmed sirloin strips about 1/2 inch thick	1/4 tsp shallots chopped
1/2 tsp. poupon mustard	1/4 tsp garlic chopped
Worcestershire sauce	1/2 cup sliced mushrooms
Fresh ground pepper	1/4 cup finely chopped green onion tops
olive oil or butter	1 cup of brown sauce or demi glace

Prepare to sauté steaks by slightly covering each strip with mustard, a few drops of Worcestershire

(2) sauce, and fresh ground pepper. (set aside) Sauté garlic & shallots mixture, mushrooms, and onion lightly, add steaks to the ingredients already cooked, cook to desired doneness and flame with brandy or cognac. Add brown sauce heated and serve at once, spooning sauce and other ingredients over the steaks

* P.S. Buy the brown sauce from your favorite Restaurant or the super market

Above: Pierre Wolfe's renowned Quorum Restaurant Steak Diane recipe, written for me by his wife. *From the collection of Pierre and Jean Wolfe; author photo.*

Opposite: Medallions recipe, Cuisine Française cookbook, Médaillions de Veau Pyrénéenne Gratin de Champignons. *From the collection of Pierre and Jean Wolfe; author photo.*

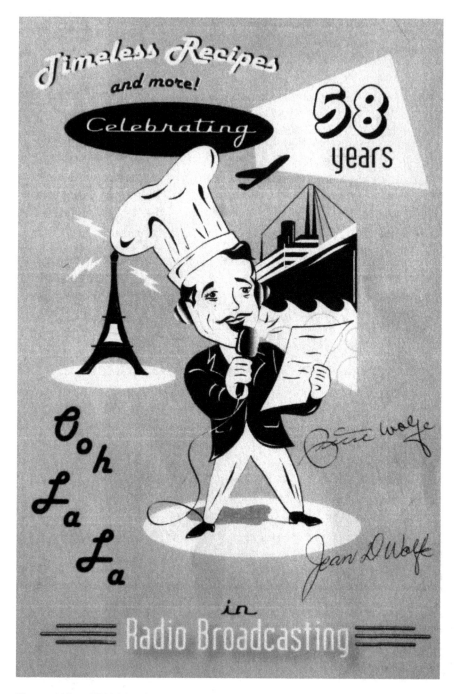

Pierre and Jean Wolfe's latest culinary contribution in written word. *From the collection of Pierre and Jean Wolfe; author photo.*

Pierre Wolfe hosts the longest-running culinary radio show from his home every week. Pierre broadcasted his first show in 1956. *Author photo.*

which can be found in his 2001 book *Tastefully Yours,* in one of his many cookbooks, on his website or on his continuing radio broadcasts. In 2001, after Pierre published *Tastefully Yours,* he met with *Denver Business Journal* staff writer Patrick Sweeney to dish on his more than fifty years in the Colorado restaurant business:

> *The restaurant business is one of the most competitive businesses and more prone to failure than any other. It's a very volatile business and you have to be dedicated. In today's restaurant market you have to have patience, talent, dedication and money. If you can fit into that category of advice then be my guest and venture out there....Regardless of what I say people will still open a restaurant....The restaurant business can be very rewarding. If I'm reincarnated, I'm going to do it one more time.*[40]

Author's Note

In 2016, I met Jean and Pierre Wolfe on a blustery early autumn evening at Racines, another iconic yet more casual Denver restaurant, with a large and loyal following. Every Thursday evening, at 6:30 p.m. sharp, they can be

found sharing a roasted half chicken with vegetables and mashed potatoes. He takes the breast, and she dines on the leg. Our order taker was a young woman forcing a smile. I couldn't even call her a server, as she lacked all of the professional qualities of one. Jean and Pierre did little to hide their disgust but were polite, nevertheless. The place was expectantly packed and on its usual twenty-minute wait, and the new server was clearly in the weeds. Near the end of our conversation, Pierre lamented,

> *The elegance of dining has vanished. Fine dining is performing at the highest level, but formality isn't valued anymore. Everyone has become too laid back, too casual. People don't even understand how to properly use silverware. Nobody cultivates etiquette, manners, or social graces anymore. I took Jean to dinner for her birthday a few months ago, at a famous place, really fancy.* [He mentioned the name, I will not.] *There was no service, no special attention to detail, no flowers on the table, no candle, no birthday dessert. There was a napkin lying on the floor the entire time. What happened to fine dining?*[41]

Like so many others, Pierre and Jean long for a restaurant like the Quorum in Denver. The couple dines out nightly and feels like their choices have become limited, as new restaurants are more like noisy and crowded nightclubs that cater to the young and trendy. Older people have disposable income to spend and are nostalgic for a touch of elegance and service that were once honored traditions. "If a restaurant like this [the Quorum Restaurant] existed in Denver, it would have its place in the community—the older people would love it. Fine dining is a matter of respect, it makes you feel good."[42]

Places like Racine's have been around for decades serving quality food and a lot of it at reasonable prices in a toned down environment. I first became acquainted with Racine's as a ballet dancer with a sweet tooth in the late 1980s. The restaurant, then in the Golden Triangle off of Speer Boulevard and Bannock, was adjacent to the ballet studio and company where I studied for hours every day. On breaks between classes, many of us would venture next door because at that time, Racine's had a pastry and coffee counter that was unsurpassed in that section of town. I was mesmerized by the largest walnut brownies I'd ever seen. Low on cash and on energy, I would savor half with a tiny cup of black coffee in the early afternoon, saving the other half for my long drive home to Boulder where I was at the University of Colorado.

Speaking of sweet offerings, I met Brad and Kathleen late in my dance career when they arrived in one of my Pilates classes. It was 1999, and back then, Pilates was the best-kept secret in fitness, before the celebrities and athletes exploited and bastardized it. My classes attracted professional dancers and a few local residents aware of its benefits. I don't remember how Brad and Kathleen found out about the class, but I am sure happy they did. They went on to own arguably the best bakery in Denver, Gateaux, which has long been my go to for all things perfectly confected. Known for their beautifully glazed, decorated and highly addictive tea cookies and the most beautiful petit fours I'd ever seen, I fell in love with their cakes, sweet muffins, zucchini and pumpkin breads, cookies and croissants. The pair opened up their tiny gilded sweets shop on 1190 North Speer Boulevard in 1999, just blocks from my dance and Pilates studio. While Brad has long since moved on, searching for other opportunities, Kathleen still graces the shop most days. Once a week, she also donates all leftovers to Father Woody's at the Denver Rescue Mission. Rumor has it Kathleen is opening a second location in the gentrified Stapleton neighborhood in the spring of 2019. They should be so very lucky.

Crab legs, flown in fresh daily. The Kitchen, Denver. *Courtesy of The Kitchen; author photo.*

6

THE TRANSITIONAL DECADES

The 1980s and 1990s brought a new wave of talented culinary professionals to Denver. Creative chefs working under the tutelage of Wolfgang Puck, Alice Waters, Thomas Keller and other industry greats began seeking out a new frontier. Denver has always been known for its pioneering spirit. It was around this time that national ethnic fusion cuisine themes hit Denver in a big way. Also, the year 2000 was culturally and economically pivotal for Denver, as the city installed several professional sports franchises in the downtown area, boosting the economy and driving rapid gentrification. The Rockies baseball team found a home at the newly constructed Coors Field; the Avalanche hockey team and Nuggets basketball organization both play just blocks away at the Pepsi Center; and McNichols Events Arena was torn down along with the aging Mile High Stadium to make way for the shiny new Sports Authority Field at Mile High, home to the Broncos football club. Even the Denver Center for the Performing Arts began to slowly update, modernize and remodel its structures to meet the increasing capacity of the culture and arts season.

By the time Mel and Janie Master moved to Denver from England by way of France, Denver, along with most of America, had fallen into what James Beard and Judith Jones referred to as an epidemic of "The Quick and Easy Crowd." Bland, salty and often unhealthy packaged food offering convenience had come into prominence, and fine, fresh, healthy ingredients were nonexistent and considered exotic fare. Forgotten even were grandmothers' recipes and any form of sophistication. Mel and Janie had a plan to change all of that.

MEL AND JANIE MASTER

How cutting edge can one really be nowadays? The important thing is doing whatever it is [that you do] *and doing it really, really well. Teaching young chefs that less is often more, like farm to table, there's too much going on, on the plate.*
—*Mel Master, 2016*

Mel and Janie were never really local success stories; their tale has always been global. They are internationally known and nationally renowned. Mel and Janie Master met as kids in Surrey, England, in 1964. He was a guitar player, and she was a pianist. Something about their upbringing and culture infused a sense of wandering troubadour in their personalities. The couple married in 1969 and moved to the south of France. While living and working in Provence, the couple developed an affinity for French food and wine and decided to open a wine-exporting business called Master Wines, importing wine to the United States. Soon after, the 1973 oil embargo hit and hit them hard; they lost nearly everything. Looking for fresh horizons and a place to raise their young family, the Masters moved to Denver in 1975. In Denver, the Masters founded a fine wine distribution company called Dionysus, for the Greek god of wine. Dionysus is now owned by the imposing Republic National Distribution Company. In those early days, Mel hired two young and eager hospitality professionals to help him sell his wines: Blair Taylor, now formerly of the iconic Barolo Grill and Enotec Italian Wine Imports fame, and Denver rock star wine representative Vince Goggins. With Mel focused on selling wine, Janie started a cooking school out of their home. She studied culinary arts in France and worked for Le Jardin, running the kitchen before the family made the move to Colorado. Within a few years, the couple opened a French restaurant called Fleurie, after the famed Cru Beaujolais wine subregion in Burgundy, France.

In 1980, Mel and Janie met Tom and Sally Jordan. The Jordans had started their acclaimed winery and label Jordan Wine in 1972 in the Alexander Valley of Sonoma County, California. Their focus was on classic Bordeaux varietals like Cabernet Sauvignon, Merlot, Cabernet Franc and Sauvignon Blanc along with Burgundian grape and Chardonnay. Tom and Sally also started a luxury chateau and winery with guest suites and a restaurant to play host to the budding winery tourism industry. Mel and Janie took it upon themselves to provide public relations along with sales and marketing support for the budding brand. The Masters were largely responsible for Jordan Wine's initial success and in return, Tom and Sally Jordan invested

$20,000 into Mel and Janie's new restaurant concept on Sixth Avenue just north of Cherry Creek. The new restaurant was to be called Dudley's, after longtime colleague Blair Dudley Taylor. Janie ran the kitchen, created an innovative menu and hung her own clothes on the walls to enhance the décor. Dudley's quickly received national praise from the *Washington Post* and *Food & Wine* magazine and was included on the "Where to Eat in America" list by the *Chicago Tribune*.

As if they didn't have enough to do, raising a family, importing and distributing wine, running restaurants in Denver, the Masters also produced a string of major culinary events and started restaurants across the country: most notably in 1977, when the pair produced a Nouvelle Cuisine event in Denver with legendary French chef Paul Bocuse. In 1978, Mel partnered with *Food & Wine* magazine and Tavern on the Green in New York City to present budding locavore now superstar Chef Alice Waters in one of the first farm-to-table events in American culinary history.

By 1981, the Masters were ready for another change, and they sold their interest in Dudley's to Blair Taylor. After eight years, he transformed the space into Chives restaurant. Around this time, Mel and Janie looked to other markets and found interesting opportunities and partners on each coast. They collaborated with Jonathan Waxman to open Michael's at the Jordan Winery and on JAMS, a pioneering California cuisine/locavore restaurant in New York City. They went on to open a JAMS in London and a restaurant called Buds on the West Side in New York City. Soon thereafter, the relationship with Waxman had run its course, and the Masters found themselves moving back to France to focus on their wine business. While in France, the couple started their first wine label and named it Les Jammelles, fusing the names Mel and Janie. The wine was one of the first in Europe to introduce grape varietal labeling to the consumer, changing the wine business forever. Eventually, the Masters moved back to Denver and were once again drawn into the restaurant business.

The year was 1991, and the Masters were back in Denver just in time for Blair Taylor to open the much celebrated Barolo Grill Denver in Cherry Creek North. Local phenom Chef Sean Kelly was hired as the first chef. Barolo Grill Denver has gone on to become one of the most beautiful spaces and respected restaurants in the city. The restaurant is decked out in paneled wood walls and exposed brick accents and has a cozy fireplace in the corner. The walls are adorned with beautifully painted Italian landscapes and framed vintage spirit and wine posters. The main dining room faces a carved wooden bar, and with near floor-to-ceiling

windows lining one wall, the ambient light from the street view of the old neighborhood is idyllic. Barolo Grill is known for its delectable, northern Italian, Piemontese-focused cuisine and its extensive and well-curated wine list thanks largely to Taylor's association with Enotec Imports. In 2015, Taylor, hoping to focus more time and energy on this Italian wine–importing business, quietly handed over the keys to general manager/wine director Ryan Fletter in an unsurprising yet hushed deal. In his twenty-one-year tenure with Barolo Grill, Fletter was one of the most dedicated and devoted employees. He started out as a waiter and worked his way up to wine director and general manager. In Taylor's mind, Fletter was the only choice. Tremendously talented Chef Darrel Truett is at the helm, and few things have changed about the menu. Quality is critical to success, but in the end, customers remember service. Barolo Grill has always focused on impeccable service in everything. The management cares about service so much that the restaurant subsidizes an annual employee pilgrimage to northern Italy so the staff can learn about the wine, cuisine and culture through full immersion. Flawless restaurant service is a hot-button issue, and Denver's casual approach to service may be one of the contributing factors to its slow path toward national and international praise. Only a handful of restaurants in Colorado are known or rewarded for their exceptional service, and Barolo Grill is at the top of that short list.

Back to Mel and Janie: in 1993, the couple found the perfect space for their new restaurant, Mel's, in Cherry Creek North, at 235 Fillmore Street. The room was elegant, and the feeling was upscale casual. While the cuisine was French-focused, it had elements of farm-to-table before it was the thing to do in Denver. Under the creative guidance of local superstar Chef Goose Sorenson, Mel's quickly went on to become one of the best restaurants on the Front Range and was named one of *Esquire*'s Top Ten Restaurants in the USA. Within a few years, real estate developers in Cherry Creek North decided that it was time to transform the district, and Mel's was an unfortunate casualty of this rapid growth. The Masters went on to open and partner on a string of other restaurants in Denver, including Bruno's Italian Bistro, Café Promenade, Starfish, Montalcino's and Top Hat. When they opened Top Hat, the Masters hired a young and green chef named Frank Bonanno as the sous chef. According to legend, Bonanno didn't have the finesse in his culinary skill yet. Mel sent Bonanno to Piedmont, Italy, to immerse himself in Italian culinary technique for three weeks, and he came back transformed, with a new passion for haute Italian cuisine. Chef Sorenson invested his talent and time into his own nationally acclaimed

restaurant, Solera, which closed in the spring of 2018 after many successful years serving the Denver public with much well-deserved fanfare.

Mel and Janie have partnered with, employed, mentored and nurtured the talent and careers of many of Denver's shining culinary stars, "that includes professionals such as restaurateur Blair Taylor of Barolo Grill, chef and owner Frank Bonanno of Mizuna and Luca d'Italia, chef and owner Goose Sorensen of Solera, chefs Tyler Wiard and Corey Treadway of Elway's, chef Don Gragg of Radda Trattoria in Boulder, and Ben Davis, owner of the Passionate Palette cooking school in Englewood, to name just a few."[43] On the heels of the most recent economic crash, Mel and Janie liquidated and moved back to Connecticut. Their wine business, Master Wine, is flourishing, largely due to the dedicated work of their son, Charlie. Janie is writing a culinary-driven memoir called *Caviar & Hemlock*. Married for over fifty years, through all of the ups and downs, they were and are partners in life, in wine and in cuisine.

LE CENTRAL AFFORDABLE FRENCH RESTAURANT

September 13, 2015, was a gloomy day for Denver diners. That was the day Robert Tournier decided to shutter his wildly popular restaurant. Tournier, an immigrant from Toulon, France, opened Le Central Restaurant on the corner of Eighth Avenue and Lincoln Street in 1981 on a shoestring budget and a big American dream. Back in those days, Tournier and his wife ran the kitchen and dining room together. The team created a casual Francophile environment and a simple menu offering classic French bistro fare that quickly expanded to feature French classics like onion soup, eight different types of moules and frites, Coquilles St. Jacques, savory and sweet crêpes, Trout Almondine and delectable omelettes, all served with crusty, warm French bread and followed by some of the the most beautiful desserts in town. Le Central boasted an expansive French wine list with many wines by the glass. The restaurant had a casual ambiance and lacked the white tablecloth fine-dining feeling of Barolo Grill or Mel's, but the food and the experience were no less impressive. Soon, the restaurant expanded into adjacent space to accommodate hungry Denverites looking for an affordable, well executed, yet non-pretentious meal. By the late 1990s, Le Central employed between forty and fifty regular staff and requisite Francophone servers. The ambiance evolved to resemble a sun-soaked, bright-blue and

pale-yellow Provençal seaside bistro, transporting diners to the south of France with every bite. This was a place where you could find traditional French bistro fare such as escargots or lobster for a price that couldn't be beat. For many young Denverites, myself included, this was an introduction to authentic French cuisine prepared and presented in a way that it became something we could understand, afford and enjoy over and over again. The menu was written in French, and oftentimes, college students would work as waiters at Le Central to practice their budding French language skills. "Back in 1981, I just wanted to make the simple, basic food that I grew up eating, like Moules et Frites, steamed with white wine, butter, garlic, and shallots… being a chef is a blue-collar job, but now, everyone thought they'd become movie stars," quipped Tournier toward the end of his run.[44] Saddled with difficult parking in an ever growing downtown and plagued by two busy main corridors, Le Central Affordable French Restaurant succumbed to closure like so many other iconic Denver restaurants have in the last few years. After thirty-four years, Tournier received a very generous offer to sell the building. Considering his options, he decided to retire. He left behind a tremendous legacy of delightful meals, celebrations and an indelible mark on the hearts and stomachs of his legions of fans.

KEVIN TAYLOR

Denver native Chef Kevin Taylor is a self-taught culinary wizard with nothing more than a high school diploma. Taylor was only twenty-five years old in 1987 when he launched his freshman endeavor, Zenith American Grill. Within six months of its opening, southwestern cuisine–inspired Zenith was garnering accolades as a top-rated Denver restaurant, even gaining national notoriety. According to his personal website biography, within a few years, Taylor and Zenith earned a four-star rating and sealed his fate as a future Denver culinary icon.[45] In the years following Zenith's glorious success, Kevin Taylor opened a string of spectacular restaurants, venturing into Italian themes with now defunct Prima in the Hotel Teatro, along with classic American cuisine restaurants, including Kevin Taylor's Restaurant, Kevin Taylor's Opera House and Palettes Contemporary Cuisine in the original Denver Art Museum building; the Limelight Supper Club & Lounge at the Denver Performing Arts Complex; and Rouge in Central City. "Although each restaurant's menu and style offers diners a singular

experience, Taylor's belief in fresh ingredients and beautiful presentation is a common thread throughout all...appealing to those with a sophisticated palette, as well as a love for the arts."[46] Dining in a Kevin Taylor restaurant is more than just a meal; it is an aesthetic affair to be remembered and often unrivaled by any other experience to be found in Denver. "When I cook, the first and foremost thought in my mind is that each guest needs to be wowed," said Taylor. "I take perfection seriously and am constantly looking for ways to improve myself as a chef, the food, the ambiance and setting, and how people feel when they dine in any of our restaurants. Food is just a portion of the overall guest experience; I often ask myself how contemporary cuisine can be better, and go from there."[47]

The city lamented the surprise closing of Restaurant Kevin Taylor at Denver's Hotel Teatro in 2014 after fifteen years of operation. It was one of the city's most celebrated spaces. Taylor made it easy for people to understand cuisine. He is an everyman chef, not a hot-headed tyrant, but every bit exacting. People I talked with for this book who spent time under his tutelage have warm memories and are fiercely loyal to the charismatic, perpetually youthful figure. I met Kevin when I invited him to be a guest chef for an event I co-produced in Denver called *SOMM: A Evening with the Masters*. For the party, thirteen Colorado-based chefs and ten master (wine) sommeliers were gathered for an interactive culinary event including two wine dinners, a tasting and cocktail hour, the movie premiere of the illuminating wine docufilm *SOMM*, a master sommelier panel–led group discussion of the film and after-party extravaganza at the Four Seasons hotel in LoDo. Kevin partnered with two master sommeliers to expertly execute a five-course meal accompanied with perfectly paired wines for fifty of the more than two hundred guests. He was most gracious, professional and charming. He executed his task with the passion and precision of any classically trained chef and the humanity of a humble man in his kitchen.

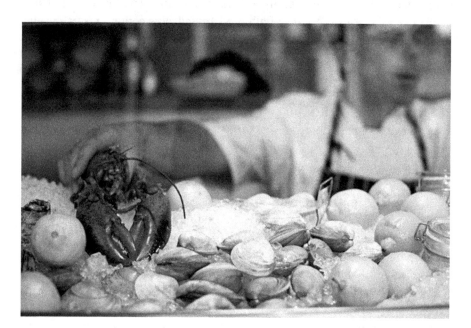

The raw seafood bar at The Kitchen, Denver. *Courtesy of The Kitchen.*

MODERN BEFORE THEIR TIME

P re-gentrification lower downtown (LoDo) Denver was a much simpler, much seedier and much more savory place in many ways. It was a place in time when lofts were still called apartments and were rent controlled at that. Those of us who lived in and loved downtown in the 1990s found our post dancing 'til dawn at Rock Island under the Fifteenth Street Viaduct breakfasts and strong espresso-based coffees at the Market on Larimer Square and our dinners in casual spots like the Front Bar at McCormick's Fish House & Bar, home of the best valued happy hour in town. Ethnic fusion themes already hit Denver in a big way as chefs scrambled to carve out an identity for the city. Daring, new approaches to cuisine in Denver during the late 1990s and early 2000s applied a global focus, including surprises like Scandinavian, Brazilian, Russian and Cuban influenced fare along with Northern Italian, Spanish and Northern Californian slow food movement themes, cuisines and techniques. Many of these new restaurants struggled to gain traction and buckled, but some have since become iconic hot spots. Denver wasn't ready when Adega Restaurant & Wine Bar opened on Seventeenth and Wynkoop. We still missed shooting pool all night long at Calvin's, the dank and fabulous pool hall (that occupied the space that later became P.F. Chang's). Sure, there was dining downtown, mostly stoic steakhouses like Morton's, Marlow's, Sullivan's, Ruth's Chris, McCormick's Fish House & Bar, which thrived alongside Dixon's American Restaurant, Wazee Supper Club, Josephina's Italian Restaurant, the Mexicali Café, Champion's Brewery and Trios Enoteca Wine Bar. As of 2016, all but two

of these LoDo mainstays had closed to make way for a new generation of culinary hot spots. Looking back on some of these restaurants, they were truly modern before their time.

TRILLIUM, DENVER

After decades of worshipping all things Mediterranean, the culinary world is shining its light on northern European latitudes for inspiration and new ideas. Scandinavian culinary culture exemplifies a certain sturdy, industrious minimalism that is cozy, warm and comforting, at the same time. Known for regionally sourced, locally foraged, seasonal food like puckery sweet berries, fresh cold-water fish, cabbage, root vegetables, tangy pickles, new potatoes, wild mushrooms, langoustines, fresh briny seaweed, smoked oily fish and fresh or cured meats and all kinds of clever preservation methods, traditional Scandinavian cuisine defines what is necessary to sustain the population through their long, dark, brutally cold winters. Modern Scandinavians sip on espresso coffee drinks and aromatic aquavit liquor while dining on delectable flaky pastries and open-faced Smørrebrød sandwiches that are similar to Spanish tapas yet made with locally sourced ingredients.

The rest of the world has slowly moved past molecular gastronomy, and the best chefs are currently enthralled with Scandinavia and its parallel Iberian cousin, San Sebastian, Spain. New Nordic cuisine is at the height of its popularity across the country. The movement is inspired by the work of Claus Meyer and René Redzepi, who together essentially created the New Nordic cuisine phenomenon. The partners opened their illustrious restaurant Noma in Copenhagen, Denmark, in 2005. Noma, known for its artistically plated locally sourced ingredients, fermented foods, naturally flavored vinegars and abundance of fish, was soon crowned the best restaurant in the world for 2010, 2011 and 2012. Meyer and Redzepi even wrote this manifesto for the New Nordic Kitchen, which was heavily influential for culinary professionals as well as aficionados and home cooks.

New Nordic Kitchen Manifesto

1) To express the purity, freshness, simplicity and ethics we wish to associate to our region.

2) To reflect the changes of the seasons in the meal we make.

3) To base our cooking on ingredients and produce whose characteristics are particularly in our climates, landscapes and waters.

4) To combine the demand for good taste with modern knowledge of health and well-being.

5) To promote Nordic products and the variety of Nordic producers—and to spread the word about their underlying cultures.

6) To promote animal welfare and a sound production process in our seas, on our farmland and in the wild.

7) To develop potentially new applications of traditional Nordic food products.

8) To combine the best in Nordic cookery and culinary traditions with impulses from abroad.

9) To combine local self-sufficiency with regional sharing of high-quality products.

10) To join forces with consumer representatives, other cooking craftsmen, agriculture, fishing, food, retail and whole-sales industries, researchers, teachers, politicians and authorities on this project for the benefit and advantage of everyone in the Nordic countries.

In 2013, New Nordic Food also launched the Nordic Children's Kitchen Manifesto, stating that "Every Nordic child has the right to learn how to cook good and healthy food."[48] Now, if we could find a way to apply that to American school lunches, think of how content American children and their parents would be every day.

Denver-based Chef Ryan Leinonen was immersed in the New Nordic trend a decade ago when he opened Trillium Restaurant. The place soon became an industry favorite because of its unique, fresh, creative offerings and its carefully crafted cocktails. I met Ryan Leinonen for a little lunch at Alex Seidel's Mercantile Dining & Provision to discuss his personal culinary evolution. Ryan was born and raised in the Great Lakes region of Michigan. He grew up eating his grandmother's Finnish-inspired cuisine and developed an early affinity for fermented and smoked foods and cold-water fish. His family hasn't returned to Finland but kept their roots close to their home. In college, Ryan met and fell in love with another Scandinavian. His wife is Swedish and has close ties to her Swedish lineage. Ryan was already a successful chef, working in the kitchens of Root Down, Colt & Gray and The Kitchen, Boulder, when he and his wife attended a family reunion in Sweden. The couple made their way through Finnish and Swedish Baltic seaside farmer's markets, food halls and fish smokers, nibbling along the

way. Ryan fell in love with cuisine all over again. He always had respect for the Noma crowd and was professionally inspired by the slow food movement spearheaded by James Beard and Alice Waters: "Trillium was an expansion on the concepts presented by Waters. The Moosewood Restaurant in New York and Mollie Katzen's hand-penned Moosewood hippy cookbook played a role as did Scandinavian Marcus Samuelsson at Aquavit in New York City in inspiring me."[49]

Ryan came back to Denver enthused to take on global fusion cuisine by incorporating Scandinavian themes into classic American fare. He opened Trillium at 2134 Larimer Street toward the end of 2011. Noma was all the rage and chefs on both coasts were embracing Scandinavian influences in their restaurants. Nobody was doing it in Denver. Ryan passionately stepped up to the challenge. He selected a historic building with a story in the up-and-coming Ball Park section of downtown Denver. After two long months of lease negotiations, a strenuous interior buildout and a lot of industry buzz, Trillium opened to instant fanfare. The space exemplified modern Scandinavian design with whitewashed and exposed brick walls, cobalt-blue tiles, decorative glass features, exposed ceiling ductwork and a stainless steel–bedazzled exposed kitchen where patrons could watch their meals being crafted. Ryan employed his culinary heritage honed at the feet of his Finnish grandmother and parlayed it into greatness. His offerings included in-house smoked meats and fish, house-crafted pickled vegetables, tangy berry and rhubarb delicacies, infused aquavit and specialty mulled wines.

Chef Ryan Leinonen's Scandinavian cuisine dream closed in September 2015, after just four years. Ryan and all of the eateries opening around him expected more foot traffic, more consistency and more understanding from their greedy landlords. Many of his contemporaries were also edged out because of skyrocketing property values and excruciating parking issues. In the end, there were just too many insurmountable problems with the location. "I was living my dream, and I had a ton of fun doing it," Leinonen said at the time of closing. Denver will forever miss his Nordic-influenced global fusion fare. Trillium's departure left a tremendous void on the culinary landscape of Denver that has yet to be filled by anyone worthy of the praise and affection that Chef Ryan Leinonen and Trillium garnered.

Since Trillium's opening in late 2011, chef and owner Ryan Leinonen has received praises for his modern Scandinavian yet approachable concept. The biggest honor has been the opportunity to cook at the James Beard House come this fall. On Tuesday, November 11, Leinonen will take four

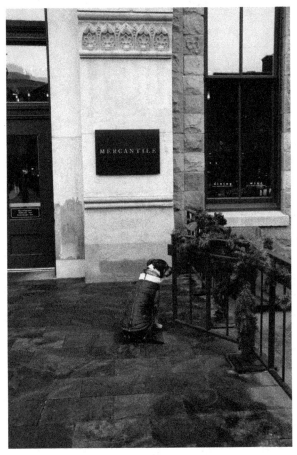

Above: Lobster, lemons and clams at the raw seafood bar at The Kitchen, Denver. *Courtesy of The Kitchen.*

Left: Denver loves dogs. This beautiful guy is a frequent visitor of the Mercantile Dining & Provisions patio at Union Station. *Author photo.*

Famous Colorado peaches at Union Station Farmers Market. *Author photo.*

Sunflowers and green plants at Union Station Farmers Market. *Author photo.*

Cherry tomatoes and strawberries at Union Station Farmers Market. *Author photo*.

Radishes and string beans at Union Station Farmers Market. *Author photo*.

Left: Peppers in three colors at Union Station Farmers Market. *Author photo.*

Below: Haystack Mountain Cheese, founded in 1989 in Longmont, Colorado, focuses on goat milk cheeses and product, Union Station Farmers Market. *Author photo.*

Right: Eggplant, Union Station Farmers Market. *Author photo*.

Below: Black Cat Restaurant farm stand at Union Station Farmers Market. *Author photo*.

Union Station Farmers Market, established 2016. *Author photo*.

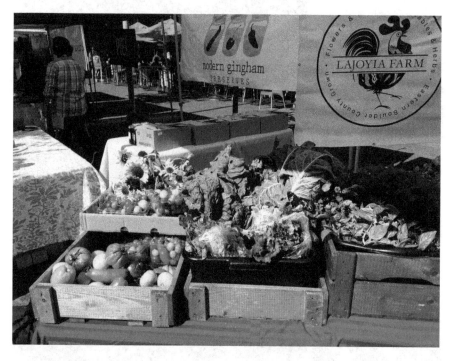

LaJoyia Farm rooster sign, La Joya Farms, Union Station Farmers Market. *Author photo*.

Squash and eggs at Union Station Farmers Market. *Author photo.*

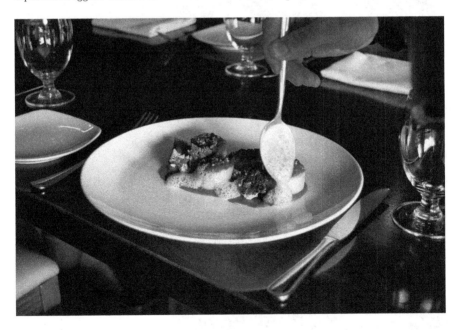

Scallops from Fruition, Alex Seidel's original restaurant on Sixth Avenue in Denver. *Courtesy of John Poplin.*

Above: Wooden platter of salumi, Il Porcellino Salumi. *Courtesy of John Poplin.*

Left: Meat curing room, Il Porcellino Salumi. *Courtesy of John Poplin.*

Right: Brian Albano and Bill Miner, owners, Il Porcellino Salumi. *Courtesy of John Poplin.*

Below: Mercantile Dining & Provision. *Courtesy of John Poplin.*

Mercantile Dining & Provision's famous croissants. *Courtesy of John Poplin.*

Mercantile Dining & Provision, Union Station, LoDo, Denver. *Courtesy of John Poplin.*

Left: Prepping carrots, Fruition Restaurant, Sixth Avenue and Clarkson, Denver. *Courtesy of John Poplin.*

Right: Chef Alex Seidel, owner of Mercantile Dining & Provision, Fruition, Fruition Farms and FüdMill. *Courtesy of John Poplin.*

Fruition Restaurant. *Courtesy of John Poplin.*

Salumi on platter, Old Major Restaurant, 3316 Tejon Street, LoHi, Denver. *Courtesy of John Poplin.*

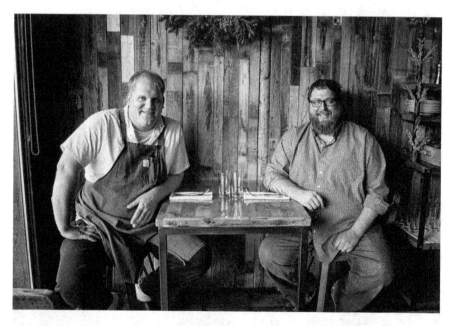

Chef Amos Watts and Chef Justin Brunson of Old Major, Masterpiece Deli, Culture and Royal Rooster fame. *Courtesy of John Poplin.*

The Fort Restaurant in Morrison. *Courtesy of John Poplin.*

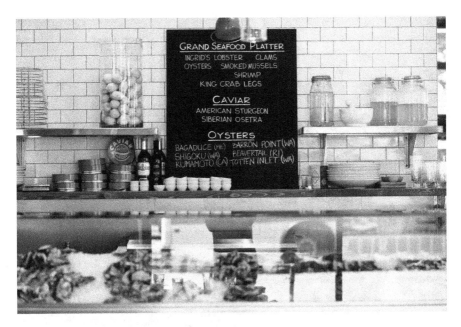

The Kitchen seafood case. *Courtesy of The Kitchen.*

Bistro Vendôme, the most beautiful patio in Denver, is hidden from view. Walk through the Kettle Arcade archway just off Larimer Square, and you're in Paris. *Author photo.*

The Kitchen dining room. *Courtesy of The Kitchen.*

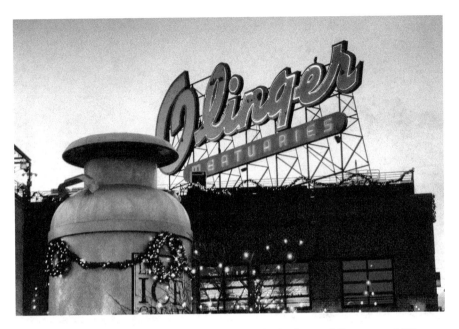

Linger Restaurant, owned by Justin Cucci, is located in the former, fully renovated Olinger Mortuary building in the happening LoHi neighborhood. *Courtesy of John Poplin.*

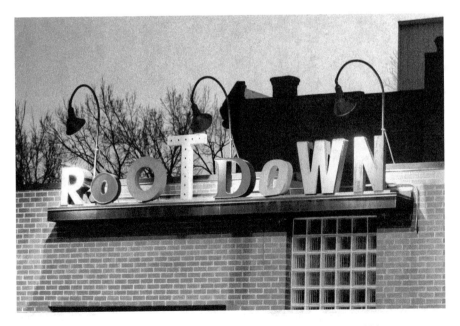

Root Down is one of the original Justin Cucci restaurants. Justin Cucci and his restaurants had a major impact on the culinary evolution in Denver. *Courtesy of John Poplin.*

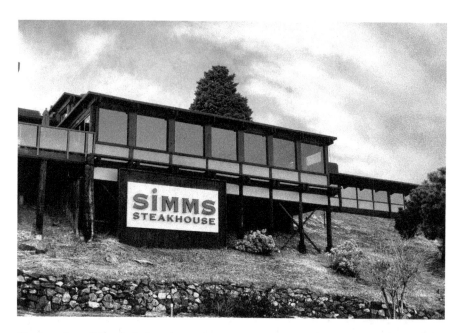

The best view of the city is from Simms Steak House, on Sixth Avenue and Simms/Union Boulevard in Lakewood, to the west of downtown. *Courtesy of John Poplin.*

Cooper's Lounge is a hidden gem of a wine and cocktail bar located on the mezzanine of Union Station. *Courtesy of John Poplin.*

to six lucky staff members to New York City to cook a meal of a lifetime and he couldn't be more excited. Being invited to cook at the James Beard House is a pretty big honor. How did the opportunity come about? In order to be invited to cook at the Beard House, a chef must meet certain selection criteria. Most importantly, the Beard Foundation wants chefs and restaurants that are new and notable, but doing different stuff. I think Trillium was selected because no one else in Denver is doing approachable Scandinavian and Nordic cuisine.[50]

Chef Ryan Leinonen and his inspirations Claus Meyer and René Redzepi taught us that Scandinavian cuisine is more than healthy eating. Scandinavian cuisine is peaceful, being at peace with your world and community; it exemplifies humanity, it incorporates the Danish concept of *hygge* with a modern, culinary twist. Often Denver is a decade behind, but with Ryan, it was right on trend, and what a trend it was. Scandinavian-influenced cuisine and culture are still going strong across the country and globe. In 2016, Claus Meyer opened Nordic-focused Agern in the Grand Central Food Hall in Union Station in New York City. René opened a pop-up restaurant in Tulum, Mexico, in part to hone his skills learning about new ingredients and techniques, while Noma was undergoing extensive renovations. "Unlike the other two extended pop-ups Mr. Redzepi has overseen—the first in Tokyo in 2015, the second in Sydney, Australia, the new, opened-air project in Tulum was a joint enterprise. His creative partner was Rosio Sanchez, who worked as Noma's pastry chef and, later, in the restaurant's test kitchen."

Z Cuisine

In another tragic loss for the city, Z Cuisine & Á Côte Wine Bar closed late summer of 2016, and in its truly remarkable eleven-year stretch, it filled an incredible need for a true Parisian immersion experience in Denver. When Patrick Dupay opened Z Cuisine on an out-of-the-way, tree-lined, historic street in a run-down section of town, he had no idea that little corner of Denver would become the hottest up-and-coming and expensive dining and living destination in Denver proper. Z Cuisine was tiny and beautiful, in ways that only Francophiles would appreciate and love. With its gilded edges, sparkling chandeliers, Parisian zinc bar and handful of bistro-style tables, walking into Z Cuisine was like walking into a Belle Époque Parisian

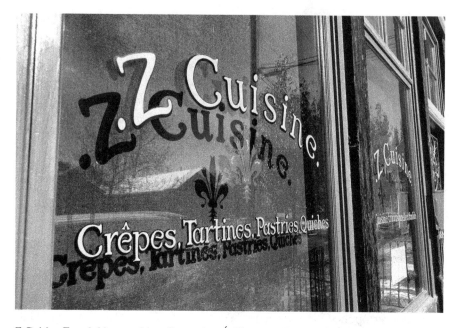

Z Cuisine French bistro and its adjacent bar Á Côte were Denver culinary darlings before their unexpected closing in 2016. *Courtesy of John Poplin.*

café. Daily features and standard menu items were illegibly scrawled on a chalkboard menu along with culinary sketches. Dried flowers and herbs hung on the wall before this aesthetic was popular. Patrick Dupay focused strictly on organic, seasonal, farm-to-table cuisine before it was all the rage in Denver. Z Cuisine offered a genuine French experience along with its sister space, À Côté, an authentic absinthe and wine bar. French comfort food like cassoulet, coq au vin, gratineed vegetables, steaming onion soups, stews, pâtés, marche salads and some of the most delectable desserts found anywhere in the city. Z Cuisine will be missed.

POWER TEAM BETH AND JEN: BETH GRUITCH AND JEN JASINSKI

Jen Jasinski is a Denver-based celebrity chef with a familiar story. She developed a love for cooking at a very young age in her California home, and her passion for the creative art led her to study at Santa Barbara Collage and the Culinary Institute of America. Jasinski landed a coveted

spot apprenticing at the legendary Rainbow Room in New York City where a chance meeting with Wolfgang Puck changed her life and career, leading her back to southern California. Jasinksi went to work in the kitchen at the Hotel Bel Air, and Puck took her under his culinary wing, serving as her mentor and, at times, her boss. Puck helped mold and shape Jasinski's career, offering her positions at Postrio in San Francisco, Spago in Las Vegas and Ledoyan in Paris. By 2000, Jasinski began looking for a change in scenery and in pace, which brought her to Denver as the executive chef at Panzano, an Italian restaurant in the trendy Kimpton chain Hotel Monaco. It was at Panzano that Jasinski met her future business partner Beth Gruitch. Gruitch, a Colorado native with generations of restaurateurs behind her, trained in restaurant hospitality and management at the University of Nevada in Las Vegas. After brief stints at Las Vegas mainstays like Dive and Boogies, Gruitch joined Levy Restaurants in Chicago and immersed herself in high-end restaurant concepts. Moving back to Denver in the late 1990s, Gruitch became the general manager of Panzano. Gruitch is known for her attention to detail and exacting standards, demanding as much from her front-of-house staff as Jasinski does in the kitchen. Both hire the best people in town and generously mentor them, often into opening up their own restaurants. By 2003, Beth and Jen had become a professional power couple and began plotting their inevitable future of massive success.

Rioja opened in the repurposed dining room of Josephina's on Larimer Square in 2004, serving up haute Mediterranean cuisine with an American twist to the long lines of people waiting for a table. With its modern look and feel and locally sourced ingredients, Rioja was a pioneer in the Denver locavore movement. Rioja quickly became a press darling, receiving local and national praise, awards and accolades. I was lucky enough to be a part of their early front-of-house team, working as a dinner hostess. I had never seen anything in Denver quite like the mind-bending lines of people reaching halfway down the street waiting for hours for a table, night after night. The pace, the presentation and the professionalism taught me lessons that I still carry with me today.

By 2006, Beth and Jen were ready for an expansion and took over a restaurant space across the street hidden in a beautiful historic courtyard. Bistro Vendôme is a classic French bistro concept with one of the prettiest dining rooms in the city. Known for classics like beef tartare, coq au vin, duck confit and a traditionally French wine list, Bistro Vendôme is a quiet force to be reckoned with. Bistro Vendôme has always been a personal favorite for weekend brunches and celebration dinners. The seasonally influenced food

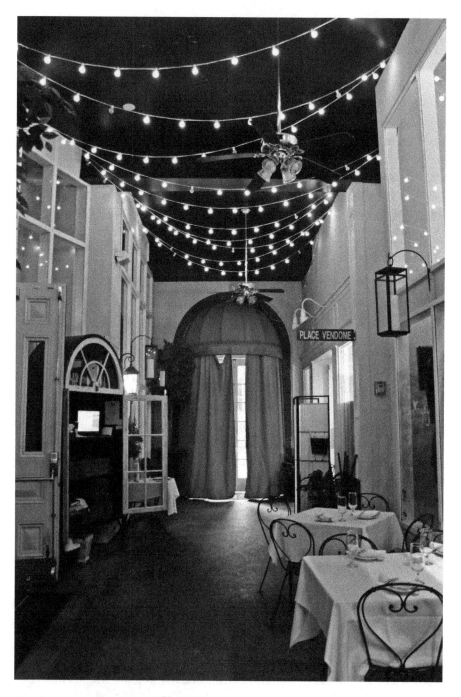

The elegant entrance of Bistro Vendôme, owned by Jen Jasinski and Beth Gruitch, of Rioja fame. *Author's photo.*

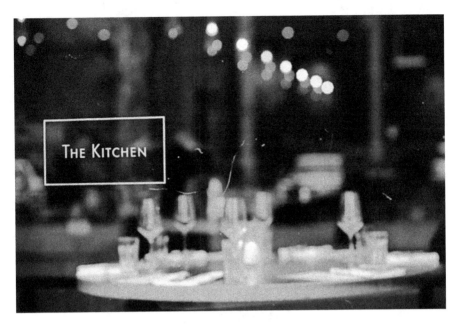

The Denver location for The Kitchen, based on the iconic Boulder restaurant, Sixteenth and Wazee Street. *Courtesy of The Kitchen.*

The Kitchen, Denver. *Courtesy of The Kitchen.*

is exquisite, and the service is relaxed but attentive. The music and ambient noise never drown out my conversation or my solitary thoughts.

Most evenings, Jen can be seen in her chef whites, wine glass in hand, triumphantly walking across Larimer Street to Bistro Vendôme after working the room at Rioja. By 2017, Beth and Jen had added Euclid Hall, an American tavern with its take on German and Alsatian cuisine and beer; and Stoic & Genuine, an upscale fish house and a raw bar at Union Station, to their growing empire. Ultreia, a take on Iberian peninsula and Basque pintxo and tapas, sherry wines and pungent gins, recently opened to instant success in Union Station. After more than a decade in the Denver culinary scene, Rioja is still one of the most popular and consistently outstanding restaurants around, but Beth and Jen continue to surprise and amaze Denver diners with each new venture.

THE KITCHEN

Kimbal Musk and Jen Lewin had just moved to Colorado when they met Hugo Matheson while walking down Pearl Street in Boulder, Colorado, in 2002. With a shared love of world-class food, the trio partnered to open the casual meets fine dining restaurant called The Kitchen American Bistro in Boulder in 2004. Musk, Lewin and Matheson hoped their restaurant would be a comfortable center of community and conversation just like home kitchens all over the world. The Kitchen, Boulder, firmly entrenched in the locavore movement, soon earned national accolades, James Beard attention and a reputation as the place to be seen and to dine. Soon after their original success, the group opened a cocktail bar and food concept called The Kitchen Upstairs in the space above the original restaurant. The group expanded the American bistro concept to Denver in 2012. Denver quickly embraced the elegant interior, casual vibe and haute cuisine. The Kitchen, Denver, took over the former Gumbo's Cajun Restaurant space in the newly renovated Sugar Building on Sixteenth and Wazee Streets. Soon after experiencing a warm welcome from Denver residents and tourists, The Kitchen opened a more casual themed outpost, (The Kitchen) Next Door, at the newly remodeled Union Station, offering up a relaxed menu in a relaxed space. Based on sister restaurant The Kitchen Upstairs in Boulder, Next Door may be less serious but every bit as dedicated to the mission of creating a community dedicated to food security, healthy eating and lifestyle choices

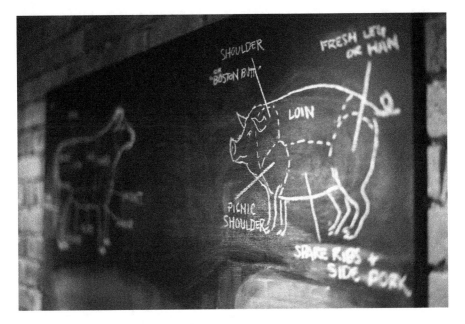

The Kitchen, Denver. *Courtesy of The Kitchen.*

and environmentally friendly business practices. With a slogan "Community Through Food," The Kitchen is known for sourcing the finest ingredients from local farmers and ranchers to prepare simple but well-crafted cuisine. The Kitchen American Bistro team is a strong proponent of the snout-to-tail and everything in between philosophy. The group's policy is to use every part of an animal across their various restaurant concepts along with sourcing the highest quality foods from local farmers and food producers. The Kitchen concepts aim for the greatest positive impact on the community with the least waste and destruction. The Kitchen has restaurants in Boulder, Denver, Fort Collins, Chicago and Memphis.

French Culinary Institute–trained Kimbal Musk is the younger brother of tech giant Elon Musk of Tesla and SpaceX fame. Both siblings have a deep love and concern for their fellow man and their planet. According to his website,[51] Kimbal loves what he calls "real food" based on the work and writings of food critic and activist Michael Pollan and has long-term plans to bring nutritious, locally sourced, environmentally friendly restaurants to the masses by opening fifty new Next Door concepts by the year 2020. The Kitchen restaurant group also has a philanthropic side. The Kitchen American Bistros and its sister foundation, Big Green,[52] have worked to establish upward of 350 schoolyard learning gardens across the country

Raw bars are all the rage in Denver. *Courtesy of The Kitchen.*

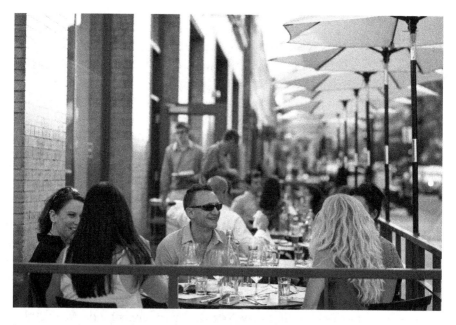

Dining al fresco in Denver at The Kitchen. *Courtesy of The Kitchen.*

focused on educating children about nutrition and introducing them to gardening, with the purpose of growing healthy food for their families. Musk laments that "people have lost the skill of cooking" and wants to change that—one garden and one restaurant at a time. Kimbal Musk and his partner Hugo Matheson are ambitious humanitarians who understand that healthy, well-fed, well-supported children and adults are the most important elements in the health and success of our neighborhoods, cities, the country and the globe. The Kitchen Community 501c3 has connected schoolchildren to real food in meaningful, interactive ways in Boulder, Denver, Los Angeles, Chicago, Brooklyn and Memphis.

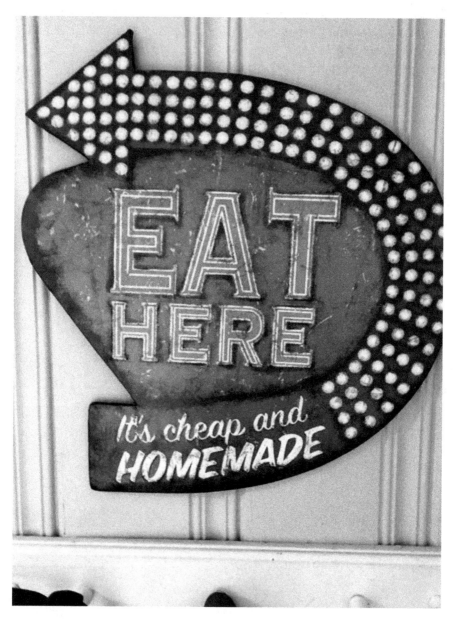

Eat Here. *Courtesy of John Poplin.*

8

SOPHISTICATED COMFORT FOOD

Largely driven by the local agricultural and beverage industries, a third wave of culinary innovation blossomed during the late 2000s and early 2010s. Chefs, restaurant front-of-house and managers, caterers and culinary public relations/event strategists continue the evolution of Denver cuisine. Americans began looking for healthier versions of American cuisine, and chefs like Jeremiah Tower, Thomas Keller, Alice Waters, José Andres, Grant Achatz and Eric Ripart were spreading their creativity and influence nationwide. The rise of Food Network and its celebrity chefs like Bobby Flay and Emeril Lagasse inspired professional and at-home kitchens in every corner of America. The rise of the everyman foodie, blogging, vlogging and food competitions brought a newfound love of all things American to cuisine, often influenced by Mom's cooking, back into prominence. Denver was no different and actually in line with the trend. American nuanced culinary creativity in Denver began to take off at a rapid pace because the city wasn't quite ready to embrace haute cuisine, and sophisticated takes on comfort food became all the rage.

Every city has that restaurant that stands out as an industry favorite. It is the place where chefs and servers go on their rare nights off to gather and dine on incredible food among their peers and other culinary sensualists. For the last decade in Denver, that restaurant has been nestled just off Corona Street on Capitol Hill. That restaurant, owned by Aaron Forman, is Table 6.

TABLE 6

Aaron Forman went to work in restaurants for the flexibility and quick cash that could support his adventurous lifestyle. He landed in Jackson Hole, Wyoming, in 1998 after being a professional dog musher for three years. Aaron enjoyed the athleticism of the area, particularly the skiing and the hiking. He started out as a busser, working for Ken Fredrickson at the iconic Terroir restaurant, a wine-driven dining experience nestled in the ski resort town. He worked his way up to expediter, became a server and then rose to manager.

When Aaron does something, he goes all in, and he quickly recognized his talent for the business and for wine. Working under Fredrickson, a master sommelier, Aaron was able to access an exalted learning experience and learned something new every day. Within three years, he eventually worked every position at Terroir and learned the flow necessary for success in restaurants. Aaron worked alongside an ambitious and daring group of entrepreneurial-minded restaurant staffers, including Ryan Guadin, Mike Young and Chris Gregory, all now well established in the restaurant scene in Denver. Before opening internationally renowned Frasca Food & Wine in Boulder, master sommelier Bobby Stuckey worked the floor at Terroir, as did master sommelier Keith Goldstein.

Aaron was quite comfy in Jackson Hole, living life on his terms, skiing by day and turning tables by night, but eventually, this talented group of men began looking for something new. One thing that I have learned in researching this book is that restaurant people love new and exciting challenges. So, in 2002, Chef Brian Moscatelo, Aaron, Ryan, Mike and Chris ventured to Denver looking for their next best thing; Aaron decided to look even farther west. He was "itching to do another project" and partnered with a friend who wanted to open something in Honolulu, Hawaii. There were consecutive research trips to New York City on private jets decked out with vintage Taittinger champagne, beluga caviar and mean girls. It didn't take long for Aaron to realize that this wasn't the scene for him, so on Christmas Day, he traveled back to Denver. He felt defeated, sitting in a middle seat at the back of the airplane on an economy flight, with his tail between his legs.

Desperate for work, he looked up his former group of colleagues, now ensconced nicely at Adega Restaurant & Wine Bar, located on the corner of Seventeenth and Wynkoop Streets in the quickly gentrifying LoDo neighborhood of Denver. Adega, Portuguese for "above ground wine cellar," was an exceptionally beautiful restaurant housed in an old red-brick Historic

Register building. Known for its centerpiece, an enormous glass-walled wine cellar, Adega was light-years ahead of its time in Denver. Denverites loved the food and the wine, but the restaurant suffered from New York City attitudes toward service and big-city prices. As Denver was not quite ready to shell out for that kind of experience, Adega was a dream that was short-lived. Adega wanted Denver to be a grown-up city, but it simply wasn't. The owners expected Denverites to pay fourteen dollars for a glass of wine in 2002, but Denverites weren't ready for that on a basis consistent enough for survival. Adega wanted diners to dress up, appreciate the ambiance, the service standards and food presentation and, most of all, appreciate the delightful cuisine. Adega was haute couture designer dining before Denver even knew what that was. "Adega was like a new and shiny penny, but it was hard to sustain. It was elaborate and amazing."[53]

Ryan Guadin was working as the Adega general manager and hired Aaron as a cocktail waiter. The position was supposed to be temporary until a server position became available. On his first night at pre-service lineup, Aaron couldn't help but notice that he was the only man standing in a line of beautiful women. How was he going to make this work? Well, work it did. On his first night, he sold enough wine to contribute $800 to the pool of tips. At the same time, Mike Huff, the owner, was expanding his operation and looking for new locations to play with other restaurant concepts. He already had opened Mirepoix in Cherry Creek and came across a house-turned restaurant on 6th Avenue called Beehive. Huff was able to purchase Beehive, christening the tiny space Table 6 around the same time. Aaron was recruited to run Table 6. He became the general manager of the new restaurant on his thirtieth birthday, April 5, 2004. He has been there since.

Table 6 has always been a labor of love and an industry favorite. Ahead of the trend, Aaron took the refinement of Adega for the front-of-house operation, focusing on flawless service and generous hospitality. He combined this with incredibly thoughtful representations of simple home cooking. Aaron was greatly inspired by his mother's cooking in his 1980s suburban Chicago home. Known for his take on tater tots, duck confit and beignets, Forman adheres to seasonality for his menu. On any given night, Table 6 is always one of the greatest meals to be found in Denver. The ambiance is warm and welcoming; the service is never stuffy, with tremendous attention paid to detail and an extraordinary knowledge of all things wine. Known for an exceptionally curated wine list that keeps up with trends but focuses on taste and price, Aaron still does most of the wine buying himself. Aaron considers his wine list to be a wide-ranging historical document representing

the life of the restaurant. It is representative of relationships he has built over the years with wine reps, producers, importers and guests. His wine program is drenched with niche wines that the adventurous seek out and the well-trained staff can sell to even the most traditional of palates.

Table 6 was an early press darling, earning national accolades from *Esquire* and *Food & Wine* and frequently appeared in local magazines and newspapers, all showering praise. Over the years, and with rapid changes in the market, national praise has dropped off, as Aaron no longer employs a PR agent, nor does he feel the need for one. His product has been solid for over thirteen years, and he doesn't have any plans to change his concept in the future. When it is this good, why deviate? He is busier than ever before, and the continued population boom brings new diners looking for an exceptional meal, even if it is slightly off the beaten track.

I asked Aaron why he thought Denver is so hot right now. He pondered this and considered his words carefully:

> *It is a very exciting and very scary time to be in restaurants in Denver right now. The secret is out: the weather is amazing, the sun, athleticism, it is a beautiful place to live, and the people are interested in life. The influxes of marijuana and technology industries are bringing floods of people. In 2002, there were just a handful of Indy restaurants: Barolo Grill, Mizuna, Mel's and Rioja, just to name a few. Over the last six years, the Indy restaurant scene has exploded, and it continues to be well-focused, thought out, and it shows.*

Forman also cited the rapidly increasing cost of living as a detriment. "It wasn't bad then, but now, now I wonder." He said that people ask him about Denver and moving to Denver a lot. He isn't as positive with them as he was in the past. "People coming for New York, Washington D.C., Chicago, Seattle and Los Angeles, look at Denver and think that this is easy: the cost of living, the congestion, they think that it is approachable and accessible." But for long-term Denver residents, nothing could be further from the truth. Many are shocked at the rapid growth and are struggling to adjust to all of the changes around them.

Aaron acknowledged that Denver may be land locked, but asserted, "Yes, we can get fresh fish flown in, and this is an amazing place to grow produce and raise quality livestock. We have [access to] the best products available." He hates the term *farm-to-table*, but that is what many of the restaurants in Denver provide. "We support locally sourced produce food;

seasonality is important." Forman recognizes the collaborative nature of the restaurant scene in Denver. He likes it. This style of hospitality happens elsewhere, in Portland and Seattle, and on some scale in New York City. Great food scenes depend on the collective whole for inspiration and evolution. "Creativity is booming. I will do whatever I can to help anybody, the restaurant community is a tight knit group; we stick together, supporting each other." When Alex Seidel opened his similar concept, Fruition, a few blocks away, Aaron welcomed this addition. He wasn't threatened at all. He realizes that this is a hard business and that restaurateurs need to look out for each other. It is almost as if he was saying that the success of his independent restaurant is linked and dependent on the success of all independent restaurants in the city.

So many of the people who I talked to for this book mention inadequate service as the main thing holding Denver back, and Aaron agreed, to an extent. His servers are some of the best in town. Forman realizes that service isn't a lifelong profession for most servers in Denver as it is in other cities and countries. They are here to ski, hike or go to school. They aren't lifers. They aren't pros. Many are working two or three other jobs and have another focus. Many industry insiders agree with him that front of house has an obligation to provide more training and higher standards of service in Denver restaurants in order to take things up to the next level.

So, what does Forman do to balance out his life? He is a marathon runner. He loves to hate the marathons but welcomes the travel it provides. He loves to cruise around in new cities, exploring the cuisine. When we talked, he was preparing for his ninth marathon, in Montreal. Now that is a food city. He keeps his life simple, his friends and family close, and admits that exercise is the key to his lifestyle and profession. He knows that he has to have an active life outside of the business, talk about other things and maintain outside interests. And what is his favorite meal? "I have always been a meat and potatoes kind of kid, my mom's cooking, dad was a great cook, too. They gave me a lot of exposure to great but simple food. I have a lot of exposure to the best food in the world. We play, but let ingredients do the talking, or it can get disjointed and lost."

When asked who among his peers is truly succeeding, Aaron, mulling over the question, ruminated that

> the most interesting projects in the city include Alex Seidel's Mercantile Dining & Provision, and Jen Jasinski's Rioja, Stoic & Genuine, along with Cart Driver, Z Cuisine, Acorn, Max's Place, and Mr. Tuna by Troy

Guard, noting that Guard is a machine and is growing so quickly. Troy Guard, who owns Tag, Guard & Grace, and a handful of burger joints, is growing so quickly that you can't keep up!…[Denver] *is so dynamic right now! Older places like mine are still bringing it. I feel like a proud papa in a way: if little Table 6 had a little influence, then that makes me happy.*[54]

Café Prague

Sometimes chefs are like lead singers in rock bands. You can change the other players, but people identify the vocals with the sound and identity of the band. Executive Chef Ales Zabilansky lends his voice to Café Prague. Known for classic and modern Eastern European–themed cuisine and brusque Old World service, Café Prague is without a doubt one of the best restaurants in the Denver vicinity and one of the best kept secrets. Don't bother asking for substitutions, special preparations or even separate checks because your requests will be flatly refused. Zabilansky considers himself an artist, and if you don't like his creations his way, don't bother ordering them. Zabilansky offers classic European dishes like Bohemian sauerbraten, schnitzels, goulash and roast pork bedecked with sauerkraut and sweet and sour red cabbage alongside chicken Marsala, veal Martiniquais and juicy filets. The café offers a global wine list and plenty of specialty beers with a full bar near the back of the narrow old storefront. On warm evenings and most days, Café Prague makes use of a sunny courtyard patio set just off the main street running through the town.

Tomas and Yvona Stibral first opened Café Prague in 1999, in the old Victorian mountain town called Georgetown, Colorado, but moved to its current location in Morrison just five years later. Tomas explained the early years to the *Denver Post* in 2013:

Our first restaurant was in Georgetown. We purchased The Full Circle Cafe from the ex-husband of Roseanne Barr. The cafe was featured in "America's Most Haunted Places" on TV. No surprise, we had to do the tours in the basement for a lot of customers after remodeling and renaming the place Cafe Prague. Another interesting thing to mention is that Madeleine Albright dined at our restaurant several times. She enjoyed our Czech cuisine as well as the opportunity to carry on a conversation in Czech. She visited our place during her term as secretary of state, so even our kitchen got a visit

from the Secret Service. The Café Prague in Georgetown, as well as our building in Morrison, were originally built as hardware stores.[55]

In the past few years, the Stibrals opened a smaller version called Prague in Evergreen to much acclaim, but the place failed to thrive and closed its doors in late 2016. The couple also exited their original concept in Morrison, home to world-famous Red Rocks Amphitheater. Under new ownership, the service has lightened up, but the flavors and voice of Chef Ales Zabilansky remain firmly in place. On a recent visit, no substitutions or separate checks were allowed.

FRANK BONANNO

Much has been written about New Jersey native Frank Bonanno. He is arguably one of the best chefs in Denver and as famous for his arduous and frosty reputation as he is for his exceptional cuisine. He is exacting and demands the best from his staff. He firmly believes that he can do anything in his kitchens better than anyone else. Rave reviews year after year have given Frank a slightly inflated sense of self, but his food is worth every bit of it. As with many great chefs in Denver, however, his front of house is consistently lacking. He steadfastly focuses his attention on the kitchen and neglects the front-of-house operations across his many restaurant concepts.

Bonanno worked in kitchens to support himself while attending the University of Denver, earning a degree in finance. Yet his mounting passion for food called him into the kitchen like so many chefs before him. Soon after he graduated from the Culinary Institute of America in Hyde Park, New York, Bonanno followed his girlfriend back to Denver and landed a coveted position working at Mel's Restaurant in Cherry Creek. Legend has it that Mel Master saw something in Frank's unrefined skill and encouraged a stint in an Italian culinary school, where his skills were honed into a definite talent. Frank left Mel's after five years of learning in the kitchen along with then general manager Doug Fleishman. The pair soon partnered to found Mizuna in the up-and-coming Governor's Park neighborhood, taking over the Aubergine space in 2001. Mizuna quickly positioned itself as a premier dining establishment complete with white tablecloths and freshly made-to-order cuisine. In no time, Mizuna became a top attraction and, fifteen years later, an icon. Mizuna's culinary claim to fame is a dish of to-die-

for macaroni and cheese laced with succulently sweet lobster. It is the only mainstay on the ever-evolving menu. "Bonanno claims that he can produce a menu never repeating a single ingredient…Bonanno took it upon himself to push the boundaries of pricing in Denver restaurants. When confronted with critics claiming Denverites wouldn't pay more than thirty dollars for an entrée, Bonanno brushed them off and ventured forward and upward, positioning Mizuna as one of the most expensive and sought after meals on the Front Range."[56] After all of these years and numerous other concepts, Mizuna still offers one of the most well-crafted meals in Denver.

Tragically, Fleishman died in an automobile accident in 2003; Bonanno was shaken but powered on to forge one of the strongest and most diverse restaurant conglomerates the city has ever known. Frank and his wife, Jacqueline, have gone on to open eleven restaurants under the Bonanno Concepts LLC. No two restaurants are the same, and few even have a common thread other than the proprietor's touch. It is a restaurant empire unrivaled by any other in the city. "At Bonanno Concepts, we strive to throw love as best we know—through food and drink and more. We aim to be a chef-driven restaurant family dedicated to satisfying meals, outstanding service, education, and community."[57] Bonanno opened Italian-themed Luca D'Italia in 2003 and followed with another Italian concept, Osteria Marco, in 2007. Osteria Marco, taking over the Larimer Square mainstay Mexicali Café, smartly offered homemade salumi and cheeses long before the trend hit Denver. Bonanno has had many partners along the way, including Ryan Gaudin of Adega fame and Jean-Phillippe Failyau of Park Burger. Recently, Adam Hodak became the beverage director and sometimes partner with Bonanno Concepts. Other restaurants in the Bonanno stable include Asian-focused Bones (2008); Green Russell and Russell's Smokehouse barbeque and Wednesday's Pie Shop; Vesper Lounge and Russel's Smoke House, both opened in 2012; followed by an homage to Bonanno's New Jersey roots, Salt & Grinder, which opened in 2014. Most interesting, perhaps, is Green Russell/Russell's Smokehouse, a basement cocktail bar cum barbeque holed up in an old time speakeasy complete with tunnels, passages, hidden rooms and low ceilings. Wednesday's Pie Shop serves as an enticing entrance to the hidden dining room:

Frank and Tyler Wiard (Elway's) were joint chefs at Mel's and Doug Fleishman was the general manager. Doug and Frank wanted to do their own thing and Sean Kelly wanted to sell his concept Aubergine on 7th avenue in Governor's Park, I strategized a meeting for Doug and Frank to

take over the space which became Mizuna. The first of the many Bonanno concept restaurants. Tragically, Doug was killed in a car crash just two years later. Bonanno went on. Janie and I gave a young, enthusiastic, but slightly unrefined Frank Bonanno a lesson in life when we sent him to Italy for a month of cultural and culinary immersion. He came back to Denver reformed and ready to make his indelible mark on the culinary landscape and that is exactly what he did.—Mel Master[58]

At the time of this writing, Frank and Jacqueline are putting the finishing touches on their latest culinary adventure, Milk Market, which is an eighteen-stall[59] shopping and dining—food, wine, beer and cocktails—collective in the freshly renovated old Dairy Block building on Eighteenth and Wazee Streets.[60]

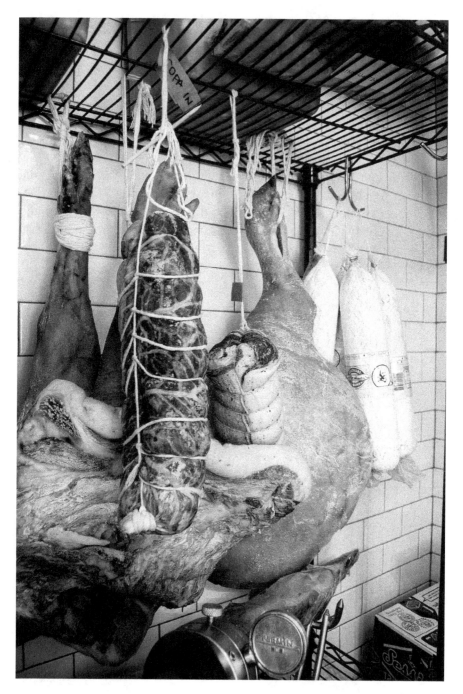

Meat curing room, Il Porcellino Salumi. *Courtesy of John Poplin.*

9

HAIL THE MIGHTY PIG

The pig has assumed an exalted place of importance among foodies and culinary professionals unlike any other ingredient. Artisanal butchers and sausage makers are devoted to crafting, curing, smoking and cooking with every inch of the pig from snout to tail. It seems as though every menu, regardless of food style, has a pork belly focus. Gourmands in America have fallen in love with the pig to the point of fanatical obsession. Pork is everywhere. Bacon has been fetishized, glorified, glamorized, chocolate dipped and sugar glazed. It can be found in the most unusual places, like dessert, chocolate bars, ice cream and even gum. Pork is accessible, flavorful and diverse. Celebrity chefs like Anthony Bourdain and Andrew Zimmer wax poetic about swine. Why? What is it about the pig that makes it so tasty, so sought after, so coveted?

Since the pig's domestication some seven thousand years ago, pork has been wildly popular. According to pork.org, pork is the most consumed protein in the world and is the fastest growing protein in the USA, with Americans consuming more than 9.8 billion pounds of the stuff for breakfast, lunch and dinner, every day, without fail. That is up from 8.78 billion pounds in 2011. That is a lot of pig![61] Pork went through one hell of a marketing campaign with the Other White Meat, deemed healthier than red meats, but how healthy can it be when you are eating slabs of fat with scant meat?

Throughout history, most meat was consumed in autumn and winter. Young animals were fattened and ready for slaughter. Autumn harvest feasts and festivals celebrated abundance across the civilized world. Human beings

struggled with food security before the invention of refrigeration, particularly in cooler climates such as Northern Europe and Scandinavia. Peoples all over the world engaged in food preservation techniques, many of which are still in practice today. The advent of brining, salt curing and smoking techniques changed dining habits with the invention of preserved fish and meats, including charcuterie. Charcuterie is the branch of cooking devoted to prepared meat products such as bacon, ham, sausage, terrines, galantines, pâtés, salumi, saucisson, rillettes (pork butter), gratin, mousseline and confit, primarily from pork. Originally intended as a way to preserve meats before the advent of refrigeration, these preparations are celebrated today for the flavors that are derived from the preservation processes.[62] Charcuterie is beloved among Americans and Europeans and prized in foodie culture.

There are four basic styles of forcemeat:

STRAIGHT
Produced by progressively grinding equal parts pork and pork fat with a third ingredient, a dominant meat, which can be pork or another meat. The proteins are cubed and then seasoned, cured, rested, ground and finally placed into the desired vessel.

COUNTRY-STYLE
A combination of pork and pork fat, often with the addition of pork liver and garnish ingredients. The texture of this finished product is coarse.

GRATIN
Has a portion of the main protein browned.

MOUSSELINE
Very light in texture, utilizing lean cuts of meat usually from veal, poultry, fish, or shellfish. The resulting texture comes from the addition of eggs and cream to this forcemeat.[63]

I believe that the main reason the pig is wildly popular is because of this versatility. The meat acts like a blank canvas for all kinds of spices, rubs, marinades and preparation techniques. People all over the world, including Americans, have a love affair with charcuterie: prosciutto, chorizo, serrano, jamón ibérico, cured and uncured, nitrate laden and non-nitrated. According to *Pork Be Inspired*, the consumption of carnitas and pulled pork has doubled in two years. And with so much that can be done with the pig; is it any wonder that chefs love this little darling?

Meat curing room, Mercantile Dining & Provision. *Courtesy of John Poplin.*

DOZENS OF WAYS TO PREPARE THE PIG

Pork Chops
Crown Roasts
Rib Roasts
Short Ribs
Shanks
Sausages and more
 Sausages
Hot Dogs
Bacon
Canadian Bacon
Honeyed Ham
Soppressata
Spam
'Nduja

Ciauscolo
Prosciutto
Prosciutto di Parma
Prosciutto di San
 Daniele
Jamón Ibérico
Serrano Jambon
Speck
Danish Ham
Strolghino
Culatello
Culaccia/Culatta
Prosciutto cotto (ham)
Coppa or Capicola

Bresaola
Cotechino/Zampone
Guanciale
Lardo
Mortadella
Pancetta
Salame
Salame Genovese di
 Sant'Olcese
Salame di Felino
The king of all
 experiences: the
 Whole Pig Roast[64]

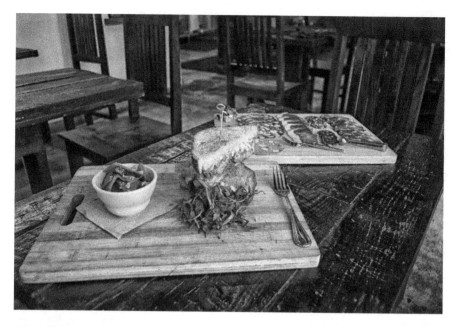

Il Porcellino Salumi, Forty-First and Tennyson, northwest Denver. *Courtesy of John Poplin.*

Porcellino chalkboard, Il Porcellino Salumi. *Courtesy of John Poplin.*

Each breed of pig presents different qualities and flavors to their meats. Their feed makes a difference in flavor, texture and fat content. Heritage hogs such as Red Wattles and Berkshires are tremendously popular with chefs and foodies across the United States, while in Europe, it is all about the Spanish breeds. The Black Ibérico pig is one of the most prized agricultural animals in the world.

> *Immediately after weaning, the piglets are fattened on barley and maize for several weeks. The pigs are then allowed to roam in pasture and oak groves to feed naturally on grass, herbs, acorns, and roots, until the slaughtering time approaches. At that point, the diet may be strictly limited to olives or acorns for the best quality jamón ibérico, or may be a mix of acorns and commercial feed for lesser qualities. The hams from the slaughtered pigs are salted and left to begin drying for two weeks, after which they are rinsed and left to dry for another four to six weeks. The curing process then takes at least twelve months, although some producers cure their jamones ibéricos for up to 48 months.*[65]

Spanish Jamón Ibérico and Bellota were illegal in the United States until 2007 and still garner a hefty price tag—upward of seventy-five dollars a pound. A small taste of this rich ham, served with olives, fresh nuts, a sliver of aged manchego and a cold glass of Albariño wine, makes a tremendously satisfying meal.

Il Porcellino Salumi

Il Porcellino Salumi is the only traditional salumeria in Denver. Founded in late 2015 by two longtime Denver chefs looking for the perfect andouille sausage, Il Porcellino Salumi produces some of the finest cured meats I have ever tasted. I came across them at Union Station Farmers Market selling their wares by sampling tidbits. The crowd was so dense; wading through took strategy and skill. But it was worth it. Owners Brian Albano and Bill Miner, who had a lengthy history of circling around each other on various lines and in kitchens scattered across Colorado, came together out of necessity. While working together at a catering company called Relish, their search for the perfect andouille sausage

led to a collective collaboration quest for perfectly crafted charcuterie. The pair partnered to create the needed andouille, quickly followed by a specialty bacon. As their interest grew, gaining confidence through praise and encouragement, they next tackled Copa. For three years, they researched and developed their recipes, style and production methods. Brian and Bill told me that they "quickly saw a need for a place like this in Denver, and we are the first of its kind."

They are still learning every day and enjoying the trial and error. Mistakes along the way, such as having to throw out an entire prosciutto, can be a bit wrenching, but for the most part, every experience has taught them something valuable and led to an exquisite group of products. "We are still learning and figuring it out, understanding the process and the product, understanding the business takes work." When asked what is the one thing holding the Denver culinary scene back from greatness, Brian commented, "Denver wants to be Aspen or San Francisco, but doesn't want to pay for it."[66] I took that to mean Denver wants to be a fine-dining mecca but doesn't want to invest the time—the blood, sweat and tears, so to speak—in order to make that transition.

Walking through their production facility and restaurant on Forty-First and Tennyson in the hip Berkley area reminded me of the charcuteries of some ancient European city, drying room in full view, plumb full of encrusted salami, copa, ham, lanza and bresaola, hanging seductively in the window. Chalkboard menus are seen from the door, inviting you in. Il Porcellino Salumi's drying room is kept at a constant sixty degrees Fahrenheit and 80 percent humidity and has finally developed its own lacter-bacteria culture, which inoculates the cured meats, creating the signature white, penicillin crust. All of the meats are locally sourced from farms and ranches practicing humane and sustainable animal husbandry and raising heritage breeds like Berkshire and Red Wattles hogs, specific cattle and bison. "Different breeds are good for different styles of salumi." They also work with cheese producer Ugly Goat Milk Company and Farm near Brighton. "Terroir for pigs is very important, more than any other animal, what they eat affects their flavor and quality....That's why it is impossible to recreate true Jamón ibérico in America, without the Spanish black hogs and the acorns that they eat, the meat doesn't react or taste the same."[67]

Bill and Brian have a small but talented staff, including a butcher and salumiere named Cory Nead from the Bay Area. He brought his butchery skills and passion to Il Porcellino Salumi in 2016. Cory is so dedicated

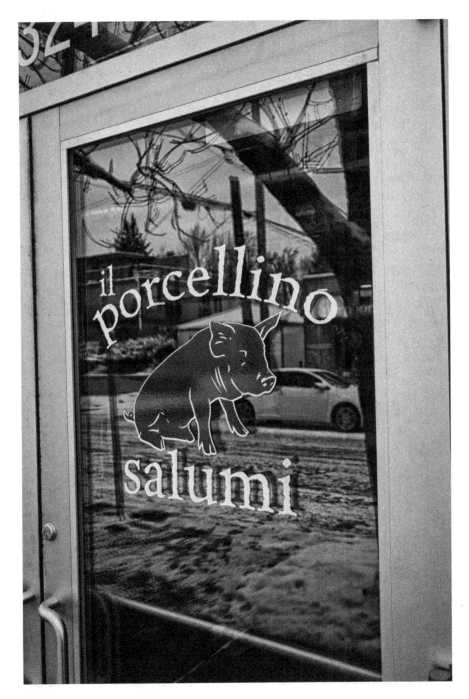

Il Porcellino Salumi offers some of the city's best cured meats, located on Forty-First and Tennyson. *Courtesy of John Poplin.*

to his craft that he has a tattoo on his arm of the proper cuts of the pig. He came to butchery after spending ten years in biotech followed by a life-changing segue into the culinary arts. Cory worked as a sous chef for eleven years, learning to make sausage at Nopa in San Francisco. He began cutting meat at 4505 and moved to the Local Butcher Shop, where he really honed his knife skills. After a move to Denver, he spent a few years cutting fish for Shamrock when he stumbled across a Craigslist ad for a butcher. Cory relayed that industry standards on cutting meat for regular consumption are much different than for curing meats, and after just a few months on the job, he was finally beginning to read the animal to determine the best use, as fat content and meat ratio dictate the cuts. "Prime cuts for a restaurant or home cook aren't the same as prime cuts for charcuterie. Making cured and dried meats is time consuming, labor intensive, and can be quite expensive. One false move results in expensive losses."[68]

Il Porcellino Salumi is interested in education, offering classes about butchery and charcuterie. The owners hope to dispel myths and misconceptions about cured meats, which get a bad wrap in the press. The consumer is leaning toward uncured and alternatives to nitrates found in

Sliced meat on platter, Old Major Restaurant. *Courtesy of John Poplin.*

most cured meats. I learned that nitrates aren't as bad and much more common than I thought. Nitrates are naturally found in celery and beet powder, common preservation ingredients for processed meats. Bill and Brian explained that these nitrates are less stable and more difficult to control. Nitrates, derived from sodium nitrate and potassium nitrate, add that classic ham flavor; maintain color and texture; and act as an antioxidant, antimicrobial and preservative for ground meats in particular. They are less important for whole muscle cuts of meat. Nitrates convert to nitric oxide, which is actually good for the blood:

> *The use of nitrites in food preservation is controversial due to the potential for the formation of nitrosamines when nitrites are present in high concentrations and the product is cooked at high temperatures. The effect is seen for red or processed meat, but not for white meat or fish. The production of carcinogenic nitrosamines can be potently inhibited by the use of the antioxidants Vitamin C and the alpha-tocopherol form of Vitamin E during curing. Under simulated gastric conditions, nitrosothiols rather than nitrosamines are the main nitroso species being formed. The use of either compound is therefore regulated; for example, in the United States, the concentration of nitrates and nitrites is generally limited to 200 ppm or lower. They are considered irreplaceable in the prevention of botulism from consumption of cured dry sausages by preventing spore germination.*[69]

BRUNSON & CO.

Justin Brunson was raised in a farming community near Cedar Rapids, Iowa. Brunson still owns a forty-acre farm near Washington, Iowa, where he raises pigs, among other things, while renting out some of the land to other farmers. Because of his fondness for all things swine, Brunson, one of the nicest guys working in the restaurant scene in Denver, is fondly nicknamed "The Meat Guy." Justin came to Denver from Iowa nearly fifteen years ago after a stint working in luxury kitchens in Scottsdale, Arizona, like Le Cordon Bleu and Michael's at the Citadel, honing his culinary technique. It was there that he met Ed Sabol, an American filmmaker and the founder of NFL Films. Sabol loved to fly and took Brunson along as a personal chef on many of his trips. It was a mutually beneficial relationship and a formative time for young Brunson.

Old Major menus, 3316 Tejon Street, LoHi, Denver. *Author photo.*

Old Major Restaurant. *Courtesy of John Poplin.*

He arrived in Denver at the tender age of twenty-three and quickly landed a job as a line cook at Adega working under Brian Moscatelo. He worked there for just one week before making his way to Richard Sandoval's popular River Front Park mainstay Zengo. Justin landed the position of lead line cook. Within a month, he was promoted to sous chef, his first management job. He stayed with Zengo for a year and a half. As he developed his skill and confidence, Justin was drawn into the world of higher end cuisine. Justin decided to transition his career by going to work for the exacting Frank Bonanno, landing at Mizuna around the same time as Alex Seidel. Bonanno was opening Luca, and Justin took on more responsibility at Mizuna. Between Alex Seidel and Justin Brunson, Frank Bonanno's little empire of fine dining began to flourish. Justin worked for Frank for just over three and a half years before he decided to venture out onto his own. In 2008, Justin and Steve Allee, the pasta cook at Luca, decided to start a gourmet delivery sandwich shop in the back room of the seedy Lancer Lounge located just down the block from Mizuna in Governor's Park off of Seventh Avenue and Broadway. It was here that Masterpiece Sandwich was born. It wasn't too long before the Lancer Lounge space became too shady for Brunson's new business, so he decided to move to the gentrifying LoHi region just west of downtown on the I-25 frontage road, Twentieth Street. Masterpiece Deli found tremendous success in this new location.

In 2013, Justin opened Old Major on West Thirty-Third Avenue and Tejon Street. Old Major focuses on snout to tail and locally sourced business practices. Justin sources and serves wild game, game birds and seafood. He partners with Aspen Ridge Co-op on the Western Slope (of the Colorado Rockies) for his prime ribeye cuts and ground beef. He raises pigs in Iowa to butcher and uses the whole pig for his cured, smoked, pâté and fresh pork offerings. Justin is a fan of Josh Applestone, the founder of the Heritage Pig movement, not only for the quality of the pig, but for the practices that insure nothing goes to waste. Justin spent a lot of time and resources learning butchery and meat processing and is comfortable making and selling sausages, cured meats, smoked meats and forced meats in his restaurant and in his shops. And while Justin loves to make charcuterie, he rarely eats it anymore. He loves really great fried chicken but opts for fish and salad most nights.

His time in the kitchen taught him that people love to dine out, and they love the idea of eating locally sourced, sustainable, healthy foods until they see how expensive it is. He has gotten pushback on

Chef Amos Watts and Chef Justin Brunson of Old Major, Masterpiece Deli, Culture and Royal Rooster fame. *Courtesy of John Poplin.*

his pricing. Justin is the first to admit that there isn't much money in restaurants anymore, especially as Denver becomes more popular and crowded. These days, Justin is the owner of Brunson & Co., which is a collection of Denver chef/owner restaurants, including Masterpiece Delicatessen, Denver Bacon Company, Old Major, Royal Rooster @ Old Major, Masterpiece Kitchen and Culture Meat & Cheese.[70] Brunson & Co. opened Masterpiece Deli Uptown in 2014, followed by Masterpiece Kitchen at Lowery and Culture in Denver Central Market in 2016. Justin's 2011 Denver Bacon Company announced plans for expansion in the spring of 2017 after buying an old warehouse just north of downtown. The city can't wait.

Justin Brunson is a force to be reckoned with. He has cooked at the James Beard House three times and travels nationally to cook and give demonstrations at food and wine festivals around the country. He even cooked with French icon Chef Jacques Pépin for ninety people at the 2015 Aspen Food & Wine Festival, being named the Best Food at Aspen. "That one made me cry." He has cooked for and appears in videos for the Pork Board. He was one of six chefs to cook for the Pork Board's first event in Napa a few years ago, where he and the team cooked for sixty of the most

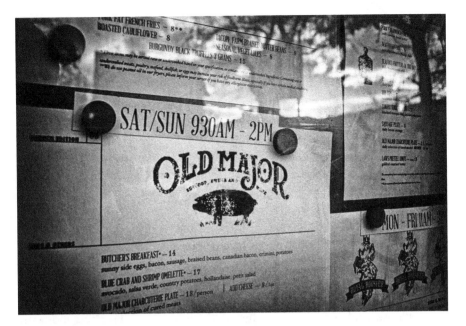

Old Major Restaurant. *Courtesy of John Poplin.*

Old Major Restaurant, a view of the neighborhood from the dining room. *Courtesy of John Poplin.*

prominent chefs from around the globe. The next thing he wants to do is "Chef's Night Out" by Vice Video and *Munchies* magazine because "it's the coolest thing out there."

When asked about the Denver food scene and what, if anything, is holding it back from stardom, Justin agreed with many other people interviewed for this book. He commented that "there's not a lot of great service in Denver. Chefs go out and learn, they go from restaurant to restaurant, but front of house (managers and staff) don't really look at it as a profession, a long term career. There are not a lot of pro servers in Denver. What we need is more Danny Meyer* style service....I would love to take front of house and take it more seriously." Justin lamented that the hipster bartender thing is "the worst," because "they just don't have the skill and flair of the old bartenders: the old guys...who are just calm and easy about their jobs. They have the know-how, the patience, the calm and the cool." Justin said that in many ways, white tablecloth fine dining is a dying industry. People like quick and convenient; they want it now, and they want it cheap. "I cook classic French food with American ingredients, I always wanted my food to be whimsical, but if I took the ham and biscuits off the menu, I would be murdered." Essentially, cooking is about pleasing people; feeding people is nurturing them, and Justin likes his role in that. Justin is opinionated about the future generation of culinary professionals coming out of school and applying for jobs in Denver. He is disappointed that the young kids don't seem to have a level of competition driving them to be the best at what they do and admits that he can be a bit of a slave driver. On the other hand, the kitchen culture of the past is unacceptable; you can't yell at them anymore, you can't throw plates and pans, you can't berate them into being better, to try to get them to perform. It just doesn't work anymore. He tells applicants and new hires looking for a break into the highly competitive culinary world, "Don't work here because it's easy, work here because it's great!" Justin is an eternal student; he still writes everything down—notes, plans, recipes and personal commentary—by hand in notebooks he has collected over the years. "To me, it's like you always have to be studying, reading, learning and striving to be the best." This dedication to perfection paid off in 2017 when Food Network came calling. Justin Brunson landed his own touring food show pilot called *SEARious Meats*, which debuted in October 2017:

Renowned carnivore and chef, Justin Brunson, ditches his restaurants for the road and a mouthwatering mission. Join him city-by-city as he steps into the protein-rich kitchens of some SEARious meat savants, to taste and celebrate their savory creations.[71]

*New York City–based James Beard Award–winning, internationally acclaimed Union Square restaurant and hospitality group owner Danny Meyer wrote the book on service standards, literally; it's called *Setting the Table*.

Fruition Restaurant, Sixth Avenue and Clarkson, Denver. *Courtesy of John Poplin.*

10

SLOW FOOD AND LOCAVORE COLORADO

nce upon a time, people grew their own food. They foraged for mushrooms, berries and wild herbs and flowers. They hunted birds and game. Some people raised goats, sheep and cattle for milk to make cheese and for meat. It was common to have a few chickens or a duck or two. People lived in small towns and rural communities with yards and land devoted to gardens rather than lush, green landscapes. Often they shared their abundant bounty and their peasant-style food with their neighbors.

Early urban dwellers visited markets and produce stands daily to supply their cupboards and tables. There have always been inns and bistros where these people could find a warm meal or simple sustenance. As restaurants grew in popularity and food production became a global phenomenon, we lost touch with the land and the source of our food. Prepackaged cereals, pastas, canned goods and eventually frozen meals replaced homegrown and prepared food. People have forgotten what seasonality means and what a truly ripe peach smells and tastes like. In our efforts to be ever more efficient, fast food is getting faster, cheaper and nearly unrecognizable as food.

But in modern America and Western Europe, there is a subset of retro-focused people who are demanding more from their food and culinary experiences. They are seeking out healthier choices, supporting local producers and their communities by subscribing to the slow food, farm-to-table movement. As Americans and people all over the world embrace the foodie trend, food diversity, organics, seasonally focused, locally sourced

produce and agriculture are again becoming a mainstay on the tables of city dwellers, just like it was for our grandparents and theirs.

Micro farms are cropping up in front and back yards all over the country. Urban gardens provide highly coveted, long-term rental plots of land to those who can afford them. People will remain on waiting lists for years for the best plots. Urban balconies are peppered with container herb and vegetable gardens. Farmers' markets have become the hip and showy, prestigious places to shop for those in the know. It is not uncommon to see open-air market attendants with an air of superiority, their Louis Vuitton totes and designer dogs in tow. They know that this is where the best, freshest, most beautiful fruits, vegetables, herbs and flowers can be found, and they can rub shoulders with celebrity chefs all in an afternoon. Union Station hosts the only 100 percent, producer-driven market in Denver. It is teaming with gorgeous displays, pregnant with ripe peppers, tiny Japanese aubergines, juicy heirloom tomatoes in all shapes, sizes and colors, lovely edible flowers, salad greens and squash blossoms. You can find locally produced salumi, creamy and pungent cheeses, locally roasted coffee, teas, homemade jams, local honey, farm-fresh eggs and still warm, crusty breads. It is not uncommon to see local celebrity chefs culling through the displays for the best of the best, and later in the day, their bounty becomes the specialty of the house.

ALEX SEIDEL

I cook because I like making people happy. It hurts in my soul when it's not right.
—Alex Seidel

Alex Seidel's story is a love story that could and should fill the pages of his own book. Alex is a chef for the city, for the people, because of his humility and heart of gold. His laid-back presence and boyish smile permeate his restaurants and reflect throughout his genuinely happy staff. He cares about you, and you can feel it. Alex Seidel was born in Racine, Wisconsin, and was raised by a single mother and heavily influenced by his aunt. He has a younger brother twelve years his junior and was always a bit of the man of the house. At fourteen, he began working in the restaurant business as a self-proclaimed "badass" dishwasher, and he liked the work and scene. He had an affinity for the detailed, meticulous work in the kitchen. Alex was a skilled soccer player and played through college, with professional prospects

knocking at his door. When he was just seventeen and living on his own, Seidel headed back to the kitchen, abandoning his promising soccer career because the NCAA rules wouldn't allow him to have a job. It is easy to say that he was a culinary natural, and maybe it is true. But Alex was never afraid of hard work, and in the kitchen, that is just what he found. In his first cooking job, he made sauces for a Cajun restaurant in Milwaukee. He had an eccentric boss who liked to host cigar dinners at the restaurant. Alex met a girl who was a server at the hottest trattoria in the city, and he followed her there. At just eighteen, he landed a garde manger and sauté position, which led into the wood-fired pizza maker position. He was never demoted and learned that exacting standards would be the secret to his success. While others were sloppy or careless, Alex took a painstaking approach to his work. From his earliest days in the kitchen, he always wanted to produce balanced, elevated, consistent cuisine—cuisine that he could be proud of. It was in those early days at restaurants like Main Street Bistro that Alex encountered freshly grown herbs and exotic mushrooms for the first time. His curiosity was piqued, and he realized that there was a fascinating and complex world of food in front of him. Executive chefs Paul Katz and Adam Medina were out of California and they saw something in the young Alex. Adam took it upon himself to train Alex as a sous chef. Adam saddled Alex with a series of increasingly difficult and structured tasks and recipes, which Alex executed with skill, fervor and passion. By the end of the summer, Alex realized that he had passed the test. He went home and had a heart-to-heart talk with his mom before he quit college to enroll at Western Culinary Institute in Portland, Oregon. He packed four boxes and his mountain bike and boarded a westbound Amtrak train.

It was 1995, and Alex landed a job working for the Kimpton Hotel in the best Italian restaurant he could find. He appreciated that the ingredients were incredibly fresh and abundant. While in Oregon, Alex embraced the coastal lifestyle, the ocean and its bounty, by learning about crabbing and casting oyster beds. He took time out to visit regional wine country, food festivals and farmers' markets and supported local food culture. The quality of ingredients available in Oregon went on to inform and define Alex's culinary career and life. He rode that old mountain bike everywhere in his exploration. He rode to and from work, in the sun and in the rain. It was a great way to learn about the city and the culture in and around Portland. Alex graduated at the top of his class.

After culinary school, in need of a change, Alex decided to move to California to work on his next chapter. Alex found the region and its

abundance of fresh and fragrant foods "pretty heavenly." He looked at San Francisco but knew that he couldn't afford to live there. Alex settled in Monterey and found an internship at Hubert Keller's Club XIX at Pebble Beach Resort. Working for Chef Keller was formative and challenging for the budding talent. Alex related a story about one incident that he will never forget: he was to make an artichoke filling for a soup garnish using three cases of fresh artichokes. It took hours of tedious work to clean and prepare the artichokes, and to cut time, he decided to take the batch to the catering department and run them through the buffalo chopper, turning the artichokes into a purée. Upon discovering Alex with the mush, Keller quipped, "What do we have here, son?" before promptly throwing it all away. Alex was crushed but learned a valuable lesson about cutting corners and the importance of perfecting his knife skills. To say that working for Keller was difficult is an understatement, and knowing that it was an unpaid internship is a revelation. For six weeks, Alex toiled alongside Keller, cooking for events and often working twenty-hour day after twenty-hour day. He was so broke that he camped at a campground before getting kicked out; he slept on friends' floors, and even resorted to renting a cheap motel room for a day or two. "In one week, I worked more than I had ever worked in my life." At one point, a frustrated and exhausted Alex tentatively confronted Keller, looking him dead on and stating, "We never referenced pay…" To which Keller interrupted in his reply; "Go home and think about it." Realizing the value of the training, Alex decided to stay on. At the end of his final and particularly grueling internship, Keller presented Alex with the largest paycheck he had ever received. A gesture and lesson he carries with him to this day. Alex learned a lot about restaurants from Keller but also learned that hotels weren't for him. He left a few months later. He went on to become sous chef at Antoine Michelle, then chef de cuisine at Carmel Valley Ranch.

It was during a trip to Colorado's Vail Valley that Alex fell in love with the mountains and soon found a home as chef de cuisine in one of Vail, Colorado's most renowned restaurants, Sweet Basil. Decisively, he went back to California to quit his job, pack his bags and mountain bike, and move to Colorado's Rocky Mountains. Working with Chef de Cuisine Brian Menas, Alex was impressed with his quality, standards and vision. "It was the first, really great, well organized, high end restaurant I was a part of.… It was an eye opener for me." Along the way, Alex fell in love with a girl. In 2002, Alex and his new bride, Melissa, moved to Denver, where Alex went to work as the executive chef at Mizuna. Working alongside owner and chef Frank Bonanno, Justin Brunson and a handful of Denver's other

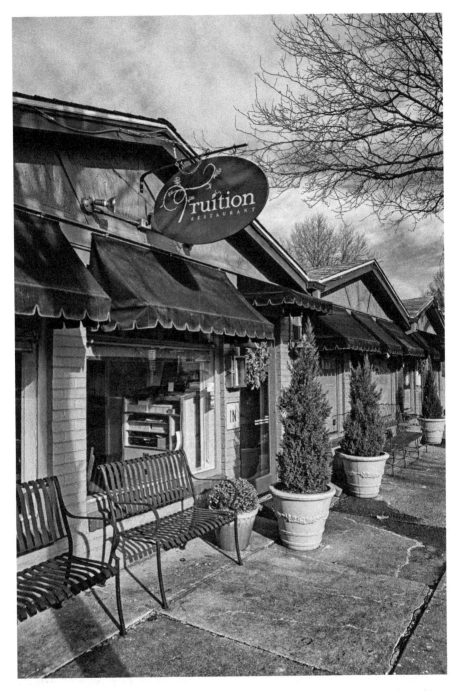

Fruition, Alex Seidel's original restaurant on Sixth Avenue in Denver. *Courtesy of John Poplin.*

culinary greats, Alex continued to hone his culinary craft and business acumen. Alex eventually left Mizuna to take the leap and venture out on his own. Alex opened Fruition Restaurant on February 5, 2007, to much fanfare and acclaim. Fruition Restaurant assumed Chef Sean Kelly's Clair de Lune space on Sixth Avenue and Marion Streets.

> *Fruition was and is one of the hottest tickets in town. Showered with accolades and praise, Fruition Restaurant was dubbed one of the top 10 new restaurants in the U.S by gayot.com; and Zagat has christened it the number one restaurant in Colorado, an honor it has held every year since opening; and* 5280 *magazine has included Fruition in its list of 25 Best Restaurants every year the ranking has run. Seidel himself has been the recipient of even more accolades, earning one of the most celebrated nods in the industry when* Food & Wine *magazine named him a Best New Chef in 2010. In addition,* Denver Magazine *called him Chef of the Year in 2009,* 5280 *gave him that title in 2008, and he has been a semi-finalist for the James Beard Foundation's "Best Chef Southwest" honor numerous times. Seidel cooked at the 20th Anniversary of "Dinners Across America" and was an opening chef of Aspen's Chefs Club by Food & Wine.*[72]

On the heels of his success at Fruition Restaurant, Alex bought a small farm and named it Fruition Farms & Dairy. He raises sheep and heritage hogs, toyed around with bees and sources some of the fruits and vegetables for his restaurants from the land. Alex actively participates in the tending and milking of the sheep. He produces a variety of cheeses from their milk, including award-winning ricotta; a bloomy-rind, soft-ripened cheese called Shepherd's Halo; a hard aged farmstead cheese called Cacio Pecora; and the newest addition, a sheep's milk yogurt called Skyr.

As if that wasn't enough, Alex opened a second restaurant called Mercantile Dining & Provision late in 2014. Mercantile is a minimalistic open-format room with tall ceilings, floor–to–near ceiling windows and an open-view kitchen. It provides a casual, counter service restaurant during the daytime with its own European-style coffee bar and food market, perfect for a morning coffee and pastry or light but luscious lunch and a full restaurant service experience in the evening both indoors and on its busy patio. The restaurant has a well-curated wine list to accompany the exceptionally crafted cuisine. The bar stocks craft beers and craft liquors, some of which are locally produced. Mercantile Dining & Provision is smartly positioned within the north corridor of Denver's Historic Union Station and is adjacent

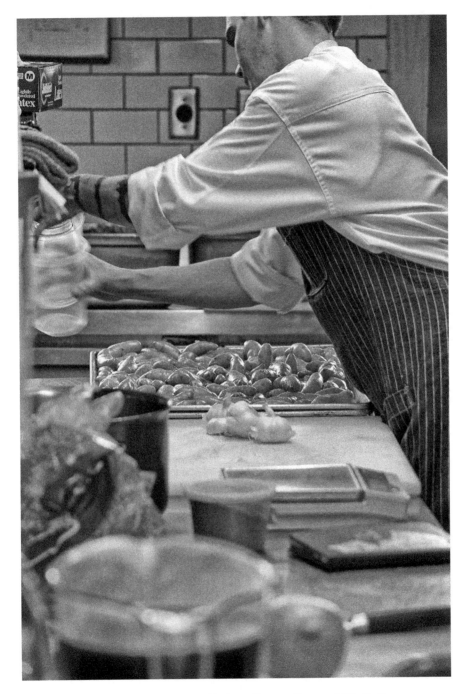

Fruition Restaurant, Sixth Avenue and Clarkson, Denver. *Courtesy of John Poplin.*

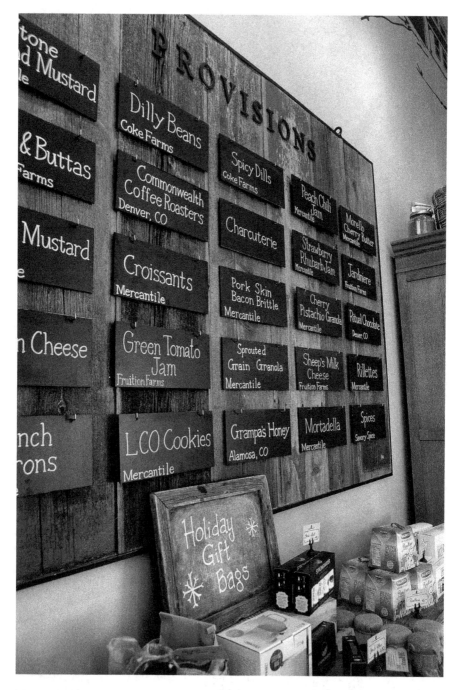

Mercantile Dining & Provision. *Courtesy of John Poplin.*

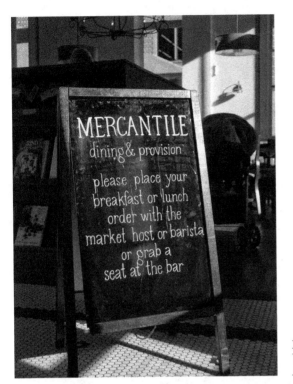

Mercantile Dining & Provision, Union Station. *Courtesy of John Poplin.*

Mercantile salami case, Mercantile Dining & Provision. *Courtesy of John Poplin.*

to the Crawford Hotel.[73] It has become a culinary hub for Denverites and tourists visiting Union Station by rail or on foot.

The year 2016 brought an opportunity for Alex to collaborate with the Boulder County Farmer's Market to start Union Station Farmers Market, a uniquely producer-driven, chef-inspired weekend experience taking place every weekend June through October. The next year, brought the opening of Seidel's Füd Mill commissary, which he designed to supply each of his restaurants with all house created and produced baked goods and foodstuff. Along with running Mercantile, Fruition and Fruition Farms, Alex feels like he is experiencing a culmination of his career: "We all like the spotlight, it is addicting." He doesn't feel the need to have a dozen restaurants under his tutelage—he would rather perfect what he has going and be the best he can in those ventures and in his personal life. Alex believes in lifelong bonds and nurtures his relationships. His partner in Mercantile is a college friend and soccer affiliate. In 2004, in the midst of building his phenomenal career, he married the love of his life and biggest supporter. He was exploding with ideas and creativity, and Melissa served to ground him. "I am trying to deliver really accessible food—iconic classics from the freshest quality ingredients I can find. Not too frou frou, not the most expensive. I want to make food approachable to everyone with the same quality and less pretension, and no table cloths!" This dedication and perfectionism has paid off, evidenced by his loyal following and by his recognition by the national and international press he continues to receive and by his 2018 James Beard Foundation Best Chef South West Region award.

THE BEST BOWL OF SOUP ON THE PLANET

Potato & Ramp Soup

2 tablespoons butter
16 fresh ramp bulbs, removed from leaves and sliced
1 yellow onion, peeled and sliced
2 russet potatoes, peeled and slice
Kosher salt
White pepper
3 cups chicken stock/broth
2 cups heavy cream

3 cups sherry wine, reduced to a syrup
8 slices prosciutto

In a large stockpot over medium heat, melt butter and sweat ramp bulbs, onion and potato. Season heavily with salt and pepper.

Once the onions and ramps are fully sweated and translucent add the chicken stock and gently simmer. Cook until potato slices are fork tender and add cream and bring to a simmer for five minutes. Blend soup in a high-powered blender on high until smooth and creamy.

Adjust seasoning and serve immediately hot or store and serve hot later. Serve soup with a drizzle of reduced sherry wine and sliced prosciutto.

Yield 6 portions

*A special thanks to Alex Seidel for generously sharing this recipe with me. So-Yum!

Little Owl is an independent coffee shop serving European-style espresso-based coffee drinks like this cortado. *Author photo.*

THE THIRD WAVE OF CULINARY ACCOMPANIMENTS

COCKTAILS, COFFEE, BEER AND WINE

C oloradoans are known for their work hard–play hard lifestyle, which often finds them dining or sipping on something luscious at the end of a ride, run, hike or workday. We take our adult beverage culture seriously. Colorado is home to more than 115 wineries and many more vineyards; several are urban wineries along the Front Range. Two wine regions have gained American Viticulture Area (AVA) status: Grand Valley AVA and West Elks AVA. AVAs are designated based on distinguished, specific geographical features unique to a region that impart certain attributes to the wines produced there. We have nearly 70 distilleries, many of which produce world-class spirits. The most prestigious and celebrated adult beverage category for Colorado is craft beer. It seems that there is a brewery on every corner in every region of the state. At last count, Colorado is home to more than 230 breweries, just over 10 percent of all of the breweries in the nation. Endless blogs, articles and books have been written about Colorado beer. Colorado rivals Washington, California and Oregon for the sheer number of breweries and bottles produced annually. According to an article on Thrillist, top five states in number of craft breweries were as follows: California with 431, Washington with 256, Colorado with 235, Oregon with 216, followed by New York with 181.

Sure, Colorado is home to Coors Brewery and Budweiser/Anheuser-Busch but also to Breckenridge Brewery, Strange Brew, Fresh Craft, Oskar Blues, Wynkoop Brewery, Prost, Fat Tire Brewery and hundreds of others

as far flung as Durango, Grand Junction, Colorado Springs, Fort Collins, Boulder and nearly every mountain town speckled across the state. Every October, the Denver Convention Center plays host to the Great American Beer Festival. The legendary debaucherous event is put on by the Brewers Association, a nonprofit devoted to the education and advancement of the craft brewery trade in the United States. Established in 1982, the Great American Beer Festival features four hundred–plus breweries showcasing more than 1,800 brews. In 2016, an estimated sixty thousand patrons visited the festival, flooding the streets, bars, restaurants and hotels with a gluttonous energy and feelings of merriment and revelry.

Beer lovers interested in learning more about the Denver and greater Colorado craft brew scene should check out *Fort Collins Beer: The History of Brewing on the Front Range*, by Brea D. Hoffman, and *Mountain Brew: A Guide to Colorado's Breweries*, by Ed Sealover, two beer aficionados more in the know than me.

As if wine, spirits and beer aren't enough, Colorado is also a major producer of hard cider, with twenty cideries along the Front Range and across Colorado.

The first record of cider consumption and production dates back to 55 BC and the Roman invasion of southern England. It is said that upon arriving in the village of Kent, the Roman soldiers observed the locals making and drinking fermented beverages out of apples and pears. Roman soldiers, famous for planting wine grape vines from Italy to England and in nearly every country in between, must have been pleased to find something delicious to sip on after their fraughtful battles. Across the British Isles and Northern Europe, cider production and consumption rivaled that of wine during the medieval period. Water was unsafe, and wine production was controlled by the monasteries. Common folk could grow and make their own ciders. After the Battle of Hastings and the Norman Conquest in AD 1066, cider became the drink of choice in England, Basque country, Brittany and Normandy in France and, surprisingly, across what is now northern Italy and Switzerland.[74] Cider is still among the most popular beverages in these European locales. It tends to be a bit lower in alcohol content than wine, more in line with beer. Cider is made bone dry to semi sweet, still and sparkling, with the most popular and widely consumed of the dry and sparkling variety. It has a tangy, earthy, almost savory flavor and sings of autumn. England is still the largest producer of cider—57 percent of the entire annual apple crop is devoted to creating 600 million liters of the stuff. It was the English immigrants to the New World who brought their ciders

with them, establishing a booming cider business in the colonies. In fact, cider was the signature drink of early America, holding a special place of importance with the revolutionary Patriots. Along with Madeira, having a mug of cider in a pub signaled your political status to others without saying a word.[75]

Centuries later, the cider industry is booming again. The drink is becoming increasingly popular, and with the reintroduction of craft cideries, there is no end in sight. Sadly, in the United States, mass-produced, commercial hard ciders are required to contain only 50 percent real apple juice and often have more than five teaspoons of sugar per pint. That is more than the World Health Organization's recommended daily allowance for adults. Any variety of apple can be made into cider, but there are specific cider apples that produce the best of the good stuff. Colorado is home to seventeen cideries, with several urban cideries in the heart of Denver: C Squared Ciders, Clear Fork Cider, Colorado Cider Company, Infinite Monkey Theorem Urban Winery and Stem Ciders.

Stem Ciders

Stem Cidery is nestled in the rapidly gentrifying River North/RiNo district just north of downtown Denver. RiNo has branded itself as the new center of art in Denver with the slogan "Where Art Is Made." It is home to some of the best restaurants, breweries, pubs, bars and artist co-ops and galleries to be found anywhere in Denver. Once an industrial and warehouse district, RiNo is also becoming one of the most expensive and densely populated residential/pedestrian centers in Denver. Stem Cidery is tucked away from street traffic along Twenty-Eighth and Walnut Streets. Stem serves up some of the city's best flights of varied cider in its cozy tasting room, adjacent to its fermentation facility. The room is a vision in blonde wood from its paneled walls to its furniture. Even the flight serving trays, which carry between four and six tiny glasses filled with an assortment of flavors, are carved out of blonde wood. The aesthetic of the room matches the flavors in the glasses: ever so delicately earthy.

Owners Eric Foster and Phil Kao opened Stem Ciders in 2013 after tinkering around with their craft since 2011, when the pair produced their first cider and dubbed it Real Dry Apple Cider. Foster and Kao are purists and appreciate classic cider traditions developed long ago in

Europe. "Stem produces cider founded on three principles: quality, style, and tradition." Foster and Kao source the best apples from Washington, Michigan and even from the western slope of the Colorado Rockies, often seeking out nearly lost heritage varieties. They press apple juice from whole apples, crafting their dry ciders in small batches. Stem Cider partners with local producers to source crabapple, and encourage growers in the Pacific Northwest and northern Midwest to cultivate and distribute heirloom cider apples specifically to be used in producing traditional styles of cider. Foster and Kao realized that it was time for a major expansion for their business after brewing 3,500 barrels of traditional dry cider in 2015. Foster and Kao are clever entrepreneurs, and thanks to their vision of tradition, 2017 was their year. They opened a $7 million two-story restaurant, tap room and fermentation facility on eight acres of land in the town of Lafayette, northwest of Denver, on the road to Boulder. One more, very important note: Stem Cider is Denver dog friendly.[76]

URBAN WINERIES

Denver is home to two urban wineries offering vastly different experiences. Infinite Monkey Theorem Urban Winery is an edgy, graffitied, urban warehouse winery located in the hip RiNo arts district, while Carboy is a suburban winery featuring a full restaurant, landscaped grounds in a golf club atmosphere.

Winemaker Ben Parsons founded Infinite Monkey Theorem Winery in an alley just off of the Santa Fe Arts District in 2008. His wine-drenched journey to Denver began in his home country, the United Kingdom, where he sold and schlepped high-end Bordeaux and Burgundy to wealthy celebrity clients. After a few seasons spent "doing harvest" in New Zealand learning the ins and outs of vineyard and winery work, Parsons applied for a Rotary International scholarship to attend oenology school in Australia. In 2001, Parsons, freshly graduated and eager, sought work in the United States and landed in Palisade wine country, located in the southwest region of Colorado. Palisade and its closest city, Grand Junction, are roughly four hours west of Denver on the other side of the Rocky Mountains. Parsons became a winemaker for Canyon Wine Cellars and a consultant for many other Colorado wineries at a time when Colorado wines were lackluster and novel. After half a dozen years, Parsons was ready for something new. He

decided to move to Denver and start an urban winery. He sources his grapes from Palisade and California, making recognizable varieties, including Chardonnay, Riesling, Sauvignon Blanc, Cabernet Franc, Merlot, Syrah and white and red blends.

In 2010, Parsons pioneered the wine in a can movement, realizing that outdoorsy Coloradoans not only like the convenience but also appreciate great wine in great packaging. Infinite Monkey Theorem offered a chardonnay, moscato, merlot and rosé in 250-milliliter cans conveniently boxed in four-pack carriers. The Infinite Monkey Theorem winery rebranded itself as the go-to wine for camping, hiking, biking and skiing. Soon, the wine in a can concept landed Parsons a very lucrative deal with Frontier Airlines, providing the wines for domestic in-flight service. Since those early days of producing just 24,000 bottles of wine annually, Infinite Monkey Theorem now produces the equivalent of 960,000 bottles sold as bottles, cans and kegs of wine in forty-four states across the country. Infinite Monkey Theorem recently expanded to Austin, Texas, opening another innovative urban winery in the heart of the music district there.

In contrast to the hip urban vibe of Infinite Monkey Theorem Urban Winery in Denver, Carboy Winery opened in late summer of 2016 in a distant suburb just south of the city. Carboy Winery looks like an expertly xeriscaped country club decked out in steel beams and honey-blonde reclaimed barn wood. It has dozens of tables, a full bar with kegs of wine on tap and a sun-drenched patio. Carboy is adjacent to its sister restaurant, Angelo's Taverna. The original Angelo's Taverna is a stained-glass and white stuccoed Italian red sauce icon cum oyster bar located downtown on Sixth Avenue. Business partners Craig Jones and Eric Hyatt took over the aging Angelo's Pizza in 2013 with dreams of transforming the old restaurant into a happening hot spot by brewing up jars and jars of homemade limoncello and adding a raw oyster bar and Mollusk Monday happy hour features. Angelo's quickly became the place for slurping on briny goodness in downtown Denver. The duo already had plans for expansion and their eye on undeveloped open space along South Santa Fe Drive in Littleton. The new Angelo's Taverna pays homage to the original with a similar décor, menu, raw bar and jars and jars of their signature limoncello. Carboy's Winery sources its juice from vineyards around the country and, at times, across the globe. It ferments and blends more than a dozen white, red and rosé wines, most of which are available on tap and by the glass.

Coffee

Denver is home to a thriving independent coffee scene. There is a rich network of coffee bean roasters like Kaladi Brothers and independent purveyors such as Paris on the Platte, Common Grounds, St. Mark's and the Mercury Café, all founded in the late 1970s and 1980s. Soon, entrepreneurs caught on to the coffee craze, opening coffee shops like Backstage Coffee, Pablo's, Crema, Avanti and Little Owl. The independent coffee shop definitely rules Denver. Sure there is a Starbucks on every corner, but people flock to the indie scene. It all started with the Market on Larimer Square in 1983.

The Market

A city favorite, The Market proudly occupies a prominent storefront on Larimer Square. It is the city's oldest and best old-school coffee house and deli. Iconic land developer Dana Crawford opened The Market on Larimer Street in 1978 as a grocery store serving the brave few residents of

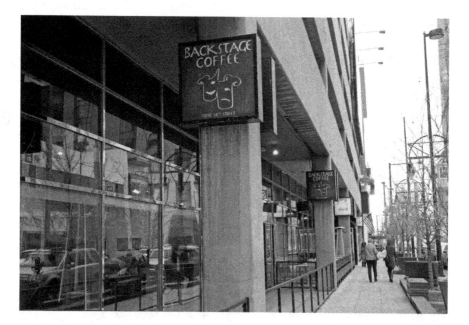

Backstage, located at the Denver Center of the Performing Arts, in the former space of the Scene & Screen Book Store. *Author photo.*

downtown Denver. At the time, downtown Denver was severely degraded, and trendy LoDo had yet to be conceptualized. The Market struggled to gain a foothold in the sparsely populated city center. Downtown Denver was struggling with the rise in suburbanization, and The Market relied on day workers for its survival. Eventually, Crawford sold the establishment to a pair of brothers from New Jersey in 1983. The last bastion of Denver's historic past was kept intact between Fourteenth and Fifteenth Streets on Larimer Street. Denver transplants Mark and Gary Greenberg transformed the struggling grocery store into downtown Denver's only classic deli and espresso bar. Modeled on memories from their East Coast upbringing, the Greenberg brothers infused The Market with their New Jersey culture and Jewish heritage. The Market claims that it was the first espresso bar between New York and Los Angeles, two decades before it became trendy to open a coffee house on every corner. When The Market opened on Larimer, the street was home to a newsstand, a handful of restaurants and bars, a boutique or two and a fantastic shoe shop called Garbarini's. Larimer Square is a block from Denver's Auraria Campus, two colleges and two universities servicing thousands of students annually.

Perfectly situated and styled, The Market satisfied sleepy college kids and local residents with novelty espresso drinks, Italian sodas and specialty teas many years before Starbucks took over the newsstand down the street. For many years, The Market boasted a large selection of cheeses and pâtés, as well as an extensive selection of crackers and specialty cooking items, long before the trendy natural/organic grocery chains. Since 1983, Mark and Gary Greenberg have transformed that fledgling grocery into Denver's most recognizable deli and espresso bar. The prolonged success of the business is directly attributed to the brothers' emphasis on freshly prepared foods made and served on the premises as well as the preservation of the locally owned downtown grocer and local meeting place atmosphere.

The Market boasts a fresh salad bar and a picnic salad bar with a variety of sweet and savory pasta salads, shrimp and tuna salad, chicken salad, tabbouleh, hummus, Greek salad and a wide variety of other cold dishes; a sandwich menu featuring traditional deli-style hot and cold sandwiches; a hot entrée bar with dishes ranging from creamy quiche, fried chicken, turkey with stuffing, enchiladas, pot roast, brats and kraut and calzones to many other offerings. It also offers a full menu of super-sized pastries, desserts, cakes and cupcakes. The Market also has a candy counter featuring candy, truffles, chocolates and beautiful hand-painted marzipan from around the world.

Spring Fling

Our signature cake, made with zucchini bread, cream cheese frosting and assorted fresh fruit. If you had it at a party or gathering, this is the cake you're probably looking for. Serves 12 to 14

2½ cups shredded zucchini
5 eggs
1¼ cups sugar
¼ cup vegetable oil
1 cup sour cream
½ tablespoon plus ½ teaspoon vanilla extract (for frosting)
3½ cups all-purpose flour
½ teaspoon baking soda (increase to 2 teaspoons at sea level)
½ teaspoon baking powder (increase to 1 teaspoon at sea level)
Pinch of salt

For frosting:
¾ cup cream cheese
¼ cup butter
2 cups powdered sugar
½ cup heavy cream

Fruit for cake:
1 pint strawberries, cleaned, stemmed and sliced
4 kiwi fruit, peeled and sliced
2 mangoes, peeled and sliced
1 pint blackberries or black grapes
1 can mandarin oranges, drained (optional)
Apricot glaze, or apricot jelly thinned out with a bit of warm water (optional)

Preheat oven to 350 degrees. Grease and flour a round 10-inch cake pan. Shred the zucchini in a food processor. In a large mixing bowl, combine zucchini, eggs, sugar, oil, sour cream and ½ tablespoon vanilla. When thoroughly mixed, combine all dry ingredients and add to bowl; mix well. Batter should be fairly wet and easy to pour. Pour in the batter and bake for 50 to 70 minutes, testing with a toothpick in center. Cool finished cake on a rack for 10 minutes, then remove it from the pan and allow it to cool completely. (You can make the cake a day

ahead and refrigerate.) To prepare frosting, whip room-temperature cream cheese and butter until smooth. Gradually add the powdered sugar, mixing until well combined. In a separate bowl, whip the cream until stiff, and then fold it and the vanilla into the frosting. Do not over mix. (I think the frosting resembles sweetened condensed milk.)

Cut the cooled cake in half lengthwise, making two layers. (The Market cuts the cake into three layers, which you may do if desired.) Spread an even layer of frosting over the first layer, and add a layer of the various fruit pieces (repeat if three layers). Put on the top layer of cake and evenly frost. The sides of the cake are not frosted; use extra to fill in, as needed. Arrange the fruit in circles all over the top of the cake, slightly overlapping. Spread the apricot glaze over fruit on top of the cake with a pastry brush.

Walking through the patio and into the front doors, one is accosted by the aroma of freshly brewed coffee, baking croissants and cinnamon buns and a noisy crowd of hungry students and urbanites. In the center is a large island featuring three main counters and dozens of hot and cold deli offerings.

One of the city's best coffee spots offers one of the worst cups of joe in the city. The Starbucks at REI is situated in the REI building at the confluence of Cherry Creek and the South Platte Rivers, where Denver was founded in the 1850s. This beautiful redbrick landmark once housed the Forney Train Museum. While the coffee at Starbucks is marginal at best, the chain coffee vendor is housed in this amazing space complete with charm and a view of Confluence Park and the rivers flowing through it. It happens to be one of the city's most popular and packed coffee shops. REI transformed the old museum into a mecca of outdoor living, complete with rock walls, a bike shop, camping world and an impressive class schedule, offering up a corner to coffee. As one of the most alluring coffee shops in Denver, it is a shame that a craft roaster didn't happen upon the spot first. The commercialism of Starbucks taints the flavor and offers up subpar iced mocha sugar bombs rather than a beautifully crafted cup of coffee. The overly roasted bitter brew screams for milk, sugar and flavorings just to make it mildly palatable. The crowd doesn't seem to mind because this coffee shop isn't about quality; it is all about the scene. Good luck finding a seat; this is *the* patio for the athletic subculture. It is the place to be seen strutting with your branded, sweat-soaked sports attire and clunky bike cleats. REI and the Starbucks are a gathering spot for athletic types of all ages. The adjacent park is not only a confluence of rivers but also of several major bike paths that reach to the ends of the

Avanti Coffee started in Boulder and expanded across the Front Range. *Author photo.*

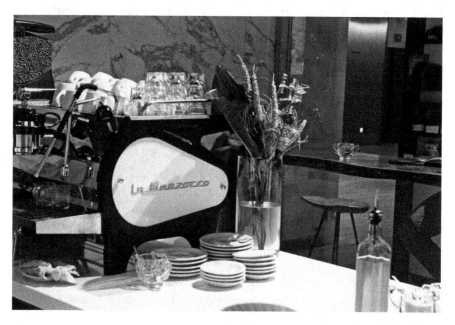

Little Owl Coffee, located at Sixteenth and Blake in the luxury residential Sugar Cube Building. *Author photo.*

St. Mark's Coffeehouse, one of the city's oldest coffee shops, on east Seventeenth Avenue, in Uptown. *Author photo.*

St. Mark's Coffeehouse, a classic, independent, patron-driven coffee shop set on pleasing and serving its neighborhood residents. *Author photo.*

city and beyond. In the summer, throngs of families splash around in the water, cooling off after picnicking in the park. On most weekends, kayakers can be found honing their craft in the rushing waters. As for the coffee shop, there should be stacks of dusty books, crumpled newspapers, classical music low in the background and customers conversing at the tables. Instead there are sanitized, faux cappuccinos devoid of personality or barista art; the place is always filthy, with zero standards, but packed to the rim with Spandex-clad weekend warriors.

For the true coffee lover, you only need to ride a block away. True, the views aren't as enchanting, but the coffee is. Carbon, housed in the space that was the legendary Paris on the Platte late-night coffee and weekend breakfast joint, is serious about caffeine. Aware of every trend and ultra-modern to the point of retro, Carbon offers ultra-smooth paleo coffee laden with coconut oil alongside Habit Dispensary donuts. Go there for the trendy healthy late-night menu or just for a cup of delicious joe. Speaking of exceptional coffee, Little Owl Coffee is a micro shop located in the Sugar Cube building just off of Sixteenth and Blake Streets. Little Owl serves up outstanding coffee. The tiny space has fewer than ten seats, so there isn't room for setting up shop. Locals sip on espresso drinks like my favorite, the cortado (equal parts espresso and steamed, frothy milk), while standing at the bar or sitting on the patio, even in the winter.

Cortados can't be found everywhere in the city. For years, it was only available at a purist coffee shop, Aviano, in Cherry Creek, but now you can sip on one at Little Owl and Mercantile Dining & Provision in LoDo.

PARIS ON THE PLATTE AND ST. MARK'S COFFEEHOUSE

Paris on the Platte Coffeehouse boasted the longest history for a classic coffee house in Denver when it closed early in 2015 after a twenty-eight-year run. Paris was a classic artists' den, complete with evolving art instillations, terrible service, amazing coffee, a small breakfast and lunch menu, a few wines by the glass and a European cigarette menu. A few years before its demise, Paris opened a wine bar in the adjacent room, but the concept struggled to succeed. It would be easy to blame the terrible, slow and bitchy service for the closing. Paris on the Platte had a loyal crowd until the bitter end, but even regulars often got fed up with the poor treatment and found libations and nibbles elsewhere. That said, the food was good, the coffee was great

and it was one of the only places in Denver where you could grab a cup of coffee and sit with your dog on the patio, reading a book and smoking cigarettes, as you watched the world go by. Just like in Paris.

St. Mark's Coffeehouse began serving morning inspiration to the uptown crowd near City Park around 1992. It is a facsimile of a Greenwich Village coffee house from late sixties New York City or San Francisco. The coffee isn't the best in Denver, but the place is always packed. Once upon a time, the customers would be reading books and newspapers or passionately engaged in debate or chess games. Now, even though the place looks the same but with more of a patina of age, the crowd is a bit younger and only engaged with their cellphones and laptops.

Third-wave craft coffee roasting and post-modern coffee shops brimming with shiny silver computers and hipsters are springing up alongside packed neighborhood breweries, cider houses and urban wineries. Spandex-clad cyclers with dogs in tow sip on everything, all under the shining Denver sun. Every weekend, cyclers clank across finished concrete floors to retrieve their rewards for workouts completed. Looking for a thirst-quenching libation, they flock in droves to the multitude of beverage purveyors with patios sprinkled across the metropolitan area. Craft coffee and craft beer offer welcoming, sunny views of the comings and goings of athletic Denverites, most with a dog or two in tow. Many of these hot spots are strategically located along the bike and pedestrian paths in the city. Denver is a bike-friendly outdoorsy city, with twenty thousand acres of urban, rural and mountainous parks managed by Denver Parks and Recreation, which was founded in 1868 to protect and preserve open green space and wild lands throughout the Denver metropolitan region.[77] The Denver metropolitan area has hundreds of miles of walking and bike paths snaking around the city along rivers, parks and major thoroughfares. The city of Denver alone has more than 100 miles of multiuse trails, 130 miles of bike lanes and almost 400 miles of signed bike routes. The city's popular B-cycle Program, managed primarily by Public Works and Parks and Recreation, supports the city's multi-modal transportation goals with a growing network of innovative infrastructure throughout the city.[78] You don't even need to own your own bike to visit a local coffee shop or brew pub thanks to Denver's B-cycle.[79]

The best coffee bar in LoDo's at Mercantile Dining & Provision. *Courtesy of John Poplin.*

The Amtrak and local RTD train tracks adjacent to freshly renovated Union Station and Crawford Hotel, Denver's new living room. *Author photo.*

12

ENTER THE WORLD STAGE

enver is receiving mostly positive national and international attention for its culinary scene and attempts at evolution, diversity and modernization. With the recent James Beard attention and *Food & Wine* magazine mentions, write-ups in *Travel & Leisure, Conde Nast, Zagat* and even the *New York Times* travel section showering praise on Denver twice in the last few years, Denver is on fire. Celebrity chefs are looking at Denver for vanity restaurant projects. Food Network hosts Bobby Flay of *Boy Meets Grill* and Guy Fieri of *Diners, Drive-Ins and Dives* have featured Denver on their shows. Travel Channel's Anthony Bourdain visited twice with *No Reservations* but not with CNN's *Parts Unknown*. I have no doubts that more positive attention is coming our way. Denver continues to be one of the fastest growing metropolitan areas in the country. In his 2016 "State of the State" address, Governor John Hickenlooper flatly stated that one thousand people migrated to Denver every week and had for the last eighteen months. By his estimations, this growth would continue for at least another year. These numbers tapered off in late 2017 and into early 2018. You can't drive down the street without running into major construction; cranes dot the skyline like birds on a wire soaking up the Colorado sun. Where are these people coming from? What are their culinary expectations? How are our restaurants going to adapt to the constant flow and change?

New people are arriving from Los Angeles, San Francisco, Chicago, Washington, D.C., Silicon Valley, Dallas, Atlanta, as well as far-flung international locales. They are arriving with the expectation that Denver

is going to provide them with familiar and fantastic culinary options. They demand diversity, depth and delightful dining experiences. They revel in our craft beer and cocktail scene. Denver's light-rail system brims with the culinary curious flooding into the city and peppering the streets downtown. Restaurant-packed Union Station has become the first stop on a culinary journey. Collaborative creativity sets Denver apart from its culinary siblings. No other city seems to have a force working together in quite the same way to achieve collective greatness. It isn't one man for himself but every chef for the city. Competition is defined by camaraderie and a collective vision focused on success. Restaurants will at times share staff, expertise and accolades, all for the betterment of the culinary scene in Denver.

BACCHANALIAN CELEBRATIONS

What is it about food and wine that fascinates? Wine and food festivals are a great way to explore the diverse and wonderful world of elite food and wine while rubbing shoulders with celebrity chefs and winemakers. Throw a little amazing live music in the mix, and the week can be an incredible bacchanalian festival. Colorado plays host to dozens of festivals, including the world-renowned Aspen Food & Wine Festival, where the crème de la crème of international wineries and elite celebrity chefs celebrate their professions for a week each June. Chefs have an opportunity to showcase their craft and creations to throngs of foodies and fans. Wineries sample their wares to crowds of oenophiles. Industry professionals network with their colleagues, promoting product portfolios to proprietors and the public alike. Aspen Food & Wine is like a debaucherously delicious playground for gourmands, wine industry and culinary professionals and the people who adore them. Each year, metropolitan Denver hosts dozens of festivals, with the Denver International Wine Festival and Denver Food & Wine ranking at the very top.

DENVER INTERNATIONAL WINE FESTIVAL

Christopher and Darcy Davies arrived in Denver in 2001 shortly after 9/11 with a newly founded magazine, *Wine Country International Magazine*, and

a few connections in the global wine industry. Christopher came to wine by way of the entertainment business, which seems to be a theme for so many of us. In college, he trained as a photographer and filmmaker who photographed rock-and-roll bands for Concerts East in the 1980s in New York and New Jersey. Davies still loves his camera but prefers to photograph Denver's ever-changing skyline and growing architecture along the Front Range or the vineyards and wineries he visits in his travels. Davies founded *Wine Country International Magazine* in 2001, focusing on Long Island wine country and promoting his winery tour business. The first issue went to print just as Christopher and Darcy arrived in Colorado.

It was on a winery tour trip in Chile that Davies was challenged with the idea of a Denver wine festival. A winemaker queried, "Why are all of the festivals in the mountains when all of my wine is sold in the city?" Perplexed to the point of being inspired, Davies and his wife came back to Denver and promptly began work on the Denver International Wine Festival, now in its eleventh year. In 2005, the first festival took place in the grand ballroom of the Oxford Hotel and saw more than 350 wines and 800 people at the grand tasting. Then Denver mayor John Hickenlooper, now Colorado governor, declared the week of the Denver International Wine Festival, Denver Wine Week. Always searching for the perfect venue to host the ever-growing tasting event, Denver International Wine Festival has bounced around from the Oxford Hotel to the Grand Hyatt downtown, Mile High Station, the University of Denver, Wings Over the Rockies Air & Space Museum and now the brand-new Westin Hotel at Denver International Airport.

Perhaps one of the most differentiating points separating the Denver International Wine Festival from other fêtes across the state is the Pairsine competition the night before the grand tasting. The Pairsine Chefs Fine Wine & Food Pairing event started in the second year as a way to add a second date to the festival. Originally called A Taste of Elegance, the competition pairs the city's greatest chefs with the award winning wines from the blind tasting competition. In a live culinary competition, each chef is given one red and one white wine and proceeds to create a unique dish to accompany each wine, hoping to win the grand prize of best chef pairing at the event. Former winners include three-time champion and Top Chef Hosea Rosenberg and Top Chef Contestant Kelly Liken. The lineup for the 2016 festival included Fruition, Range, Grill & Vine, Blue Moon Brewery, Lime and Oceanaire with judges John Moeller; former White House chef and author Barrie Lynn; the Cheese Impresario; and Elena Pozzolini, winemaker and president of Tenuta Sette Ciele in Tuscany, Italy. Each year, the Denver International

Wine Festival supports a deserving charitable foundation, including the Foundation for Sight & Sound, Help America Hear Program and There With Care, through silent auctions.

In 2005, when Christopher and Darcy founded their parent company, Wine Country Network, to produce the original Denver International Wine Festival, they had their eye on the future. Per Davies, "It's time to scale up or close up....Wine Country Network is on the verge of mass expansion into more national and international markets, founding and partnering with beverage festivals, competitions and enticing (the) media." In just over a decade, Christopher and Darcy have extended their magazine and festival concept into a festival-focused empire with six beverage competitions and as many festivals appearing in culinary hot spots across the country with an eye on Prowein, Vin Expo and Vin Italy. Events include Denver International Beer Competition, Denver International Spirits Competition, New Orleans Bourbon & Whiskey Competition and Drink Pink Rosé Festival & Competition. Spirits are the hot new thing in the beverage industry. In 2014, there were approximately 1,000 distilleries in the United States, and by the end of 2015, there were 2,085 and counting. The Davies have plans to collaborate with Tales of the Cocktail at the North American Bourbon & Whiskey festival in New Orleans.

No longer active in wine tourism after closing that sector of Wine Country Network, Davies is still interested in the growing culinary tourism sector, often writing about it for his magazine. After eleven years in print, *Wine Country International* went completely digital in 2013 and claims more than 500,000 readers. Davies is planning to hire more writers, editors, advertising and marketing staff to expand the magazine's offering and global presence. The magazine mantra is: "Your attitude-free passport to great wine and delicious food." For the first three years, the print edition included a Wine 101 Guide collectible pull-out that was three-hole punched and illustrated by a cartoonist. The idea was to collect the guides in a wine-focused binder.

Christopher Davies mused over a glass of wine, "It's a really good life.... It's been a long way, coming to this point, feast and famine." As for what's next for Christopher and Darcy? Well, they are looking longingly at Tuscany like so many other oenophiles and foodies. Tuscany is a dream retirement destination for so many people and wine people in particular. Davies has plans for semi-retirement entrepreneurial projects to keep himself busy in Italy, creating a place in the beverage world and carving out yet another niche. Rumor has it that there will be spirited beverages involved; the world will just have to wait.[80]

DENVER FOOD & WINE FESTIVAL

Every September, just after Labor Day weekend, Denver Food & Wine Festival partners with the Colorado Restaurant Association, Southern Glazers Wine & Spirits of Colorado and the Metropolitan State University of Denver's Hospitality Department to mark the end of summer with a decadent celebration of all things food and wine. The five-day event was once held in the grassy open spaces of downtown Denver's largest academic campus, Auraria Campus. Auraria is home to four institutes of higher learning, including the University of Colorado at Denver, but only Metropolitan State University of Denver participates in Denver Food & Wine. Metro, as it is affectionately called, provides classroom space in its Hospitality Learning Center for various demonstrations and seminars while the remaining public festival is now held off campus at the neighboring Pepsi Center. In September 2018, the Fourteenth Annual

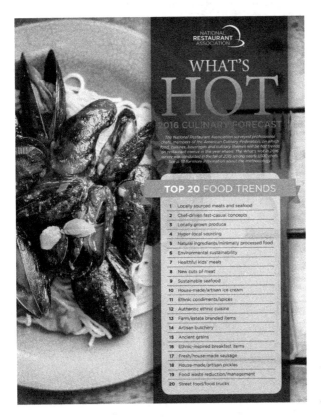

What's Hot in Food and Dining, 2016. *Courtesy of National Restaurant Association.*

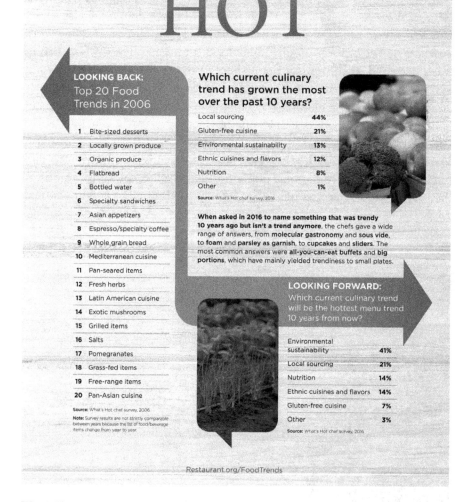

10 YEARS OF

WHAT'S

HOT

NATIONAL
RESTAURANT
ASSOCIATION

LOOKING BACK:
Top 20 Food
Trends in 2006

Which current culinary trend has grown the most over the past 10 years?

Local sourcing	**44%**
Gluten-free cuisine	**21%**
Environmental sustainability	**13%**
Ethnic cuisines and flavors	**12%**
Nutrition	**8%**
Other	**1%**

Source: What's Hot chef survey, 2016

1 Bite-sized desserts
2 Locally grown produce
3 Organic produce
4 Flatbread
5 Bottled water
6 Specialty sandwiches
7 Asian appetizers
8 Espresso/specialty coffee
9 Whole grain bread
10 Mediterranean cuisine
11 Pan-seared items
12 Fresh herbs
13 Latin American cuisine
14 Exotic mushrooms
15 Grilled items
16 Salts
17 Pomegranates
18 Grass-fed items
19 Free-range items
20 Pan-Asian cuisine

Source: What's Hot chef survey, 2006
Note: Survey results are not strictly comparable between years because the list of food/beverage items change from year to year.

When asked in 2016 to name something that was trendy 10 years ago but isn't a trend anymore, the chefs gave a wide range of answers, from **molecular gastronomy** and **sous vide,** to **foam** and **parsley as garnish,** to **cupcakes** and **sliders.** The most common answers were **all-you-can-eat buffets** and **big portions,** which have mainly yielded trendiness to small plates.

LOOKING FORWARD:
Which current culinary trend
will be the hottest menu trend
10 years from now?

Environmental sustainability	**41%**
Local sourcing	**21%**
Nutrition	**14%**
Ethnic cuisines and flavors	**14%**
Gluten-free cuisine	**7%**
Other	**3%**

Source: What's Hot chef survey, 2016

Restaurant.org/FoodTrends

What's Hot in Food and Dining, statistics and trends for this decade. *Author photo.*

Denver Food & Wine Culinary Classic will take place; consisting of five days of chef events, wine and beer seminars, classes and a culinary cinema series. The spectacular culmination is the Grand Tasting featuring forty restaurants and seven hundred beverages, including wine, sake, spirits, beer and specialty water from all over the world. The event is now held on the Pepsi Center parking lot adjacent to Auraria Campus in the heart of downtown Denver, and it is often too hot outdoors to be truly enjoyable. Early September is often still blisteringly hot in Denver, and the fumes wafting up from the asphalt interfering with the delicate aromatics and flavors of the wine and food don't help matters much. Nevertheless, it is still one of the hottest tickets in town, one heck of a party, and nearly sixty thousand people are expected to attend.

James Beard Awards

The James Beard Foundation's mission is to celebrate, nurture, and honor chefs and other leaders making America's food culture more delicious, diverse, and sustainable for everyone.
—James Beard Foundation[81]

James Beard was a renowned cookbook author and culinary educator with a fond spot for the restaurant world. He was always a champion of American cuisine and locally sourced food and endlessly worked to promote his craft. After his death, a foundation was created in his name to continue his work. The James Beard Foundation occasionally shines its coveted spotlight on Colorado. Jen Jasinski of Rioja fame, Alex Seidel from Fruition Restaurant, Hosea Rosenberg with Black Belly Market, Eric Skokan from Black Cat, Steven Redzikowski of Acorn, the Frasca Food & Wine guys and Lachlan Mackinnon-Patterson and Bobby Stuckey in Boulder are frequent names on the short list. Receiving a prestigious James Beard Award not only changes a chef's life, but his or her restaurant(s) also flourish under the international spotlight and glow of adoration and opportunity in the culinary community. Recipients join an elite class of trend-setting culinary professionals whose influence is far reaching. Former winners include Canlis in Seattle, Eleven Madison Park in New York City, Rick Bayless and Topolobampo in Chicago, Eric Ripart and Le Bernardin in New York City and Thomas Keller's Per Se in New York City.

Earlier today, the James Beard Foundation announced its 2017 roster of restaurant and chef semifinalists, four of which are Colorado contenders. Frasca Food and Wine, a perennial favorite of the Foundation and a seven-time nominee and two-time winner in the Best Chef: Southwest and Best Wine Program categories, is vying for this year's Outstanding Restaurant title, a category that trumpets 20 restaurants that zigzag from New York to Chicago.

That nomination is certainly a boon for Boulder, but what about Denver? Despite the city's tremendous growth spurt, seemingly endless avalanche of openings and confetti of chef and restaurant accolades—local and national—the Beard Foundation snubbed the state's culinary talent in just about every other division, save for one: Best Chef: Southwest. Still, a trio of local kitchen magicians made the cut: Steven Redzikowski of Acorn; Eric Skokan of Black Cat Farm-Table-Bistro in Boulder; and Alex Seidel of Mercantile Dining & Provision. Redzikowski, who's also the co-owner and chef of Brider and Boulder's Oak at Fourteenth, along with Seidel, chef-owner of Fruition, were semifinalists in the same category last year, while this marks the first (much-deserved) nomination for Skokan, a cookbook author and farmer who also presides over Bramble & Hare, his second Boulder restaurant.[82]

A James Beard Award is like a Pulitzer, Oscar, Tony or a Grammy and not only solidifies the recipient's greatness but also raises the bar in his or her community. Colleagues strive for more, work harder and inspire one another. As a result, the culinary community produces more interesting, often more complex cuisine. The dining public happily embraces the delicious results of these efforts. As the culinary evolution across the Front Range of Colorado continues, the food will only get better and better. These chefs are constantly working to provide the most interesting and most nutritious food for their fans new and old. A thriving culinary scene positively impacts other critical industries to Colorado, including our flourishing tourism community. Top Chef Masters competitor Jen Jasinski of Rioja, Stoic & Genuine and Euclid Hall fame won the James Beard Best Chef South West Region award (Colorado, Arizona, Texas, Utah, Oklahoma and New Mexico) in 2013, followed five years later by a win for *Top Chef* judge Alex Seidel with Mercantile Dining & Provision in 2018. Seidel has been nominated every year for Fruition and/or Mercantile Dining & Provision for a decade. This places these chefs and their teams in the category of internationally acclaimed chefs Eric Ripart, José Andrés, Thomas Keller, Grant Achatz and

so many other culinary artists in the United States. Unbelievably, Denver food is still largely ignored by industry publications like *Food & Wine*, *Wine Enthusiast*, *Travel & Leisure*, *Bon Appétit*, *Town & Country*, *Conde Nast Traveler* who generally keep their focus firmly bi-coastal. Denver has its own versions of *Thrillist*, *Eater*, *Zagat* and *Dining Out* diligently working to promote the Denver / Boulder culinary scene. When attention is paid, it is well deserved. Restaurants like Baur's, The Fort, Quorum, Mel's, Barolo Grill, Table Six, Rioja, Trillium Denver, Old Major, Stoic & Genuine, Bistro Vendôme, Fruition Restaurant and Mercantile Dining & Provision have in their own time and in their own way influenced and elevated Denver dining. These restaurants and so many others have been stepping stones along the culinary evolution happening in Denver. Without chefs and restaurateurs like Pierre Wolfe, Otto Baur, Alex Seidel, Jen Jasinski, Justin Brunson, Mel and Janie Master, Blair Taylor, Ryan Fletter, Ryan Leinonen, Justin Cucci, Aaron Forman, Brian Moscatelo, Goose Sorenson, Sean Kelly and so many other talented and influential individuals, Denver wouldn't be quite as interesting and delicious. Denver is exploding with growth and possibility, and our talented culinary and hospitality community is up for the challenge. They continue to learn, grow, take risks, collaborate, compete and create, all for the wondrous benefit of lucky Denverites and tourists alike. It is a fantastic time to dine in Denver.

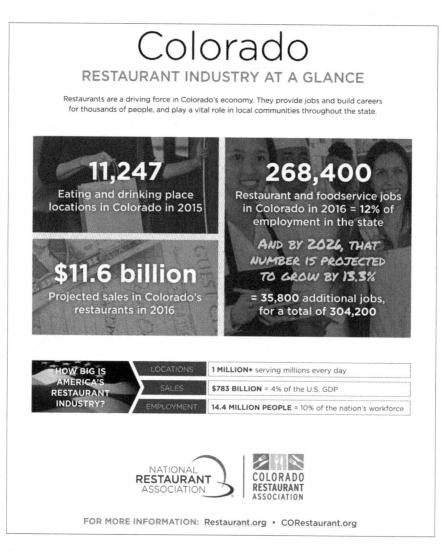

Colorado

RESTAURANT INDUSTRY AT A GLANCE

Restaurants are a driving force in Colorado's economy. They provide jobs and build careers for thousands of people, and play a vital role in local communities throughout the state.

11,247
Eating and drinking place locations in Colorado in 2015

268,400
Restaurant and foodservice jobs in Colorado in 2016 = 12% of employment in the state

$11.6 billion
Projected sales in Colorado's restaurants in 2016

AND BY 2026, THAT NUMBER IS PROJECTED TO GROW BY 13.3%

= **35,800** additional jobs, for a total of **304,200**

HOW BIG IS AMERICA'S RESTAURANT INDUSTRY?

LOCATIONS	**1 MILLION+** serving millions every day
SALES	**$783 BILLION** = 4% of the U.S. GDP
EMPLOYMENT	**14.4 MILLION PEOPLE** = 10% of the nation's workforce

NATIONAL **RESTAURANT** ASSOCIATION

COLORADO RESTAURANT ASSOCIATION

FOR MORE INFORMATION: Restaurant.org • CORestaurant.org

Colorado Restaurants At a Glance, 2016. *Courtesy of Colorado Restaurant Association.*

WHERE DO WE GO FROM HERE?

I t has never been more important to focus efforts on educating people to engage with, grow and cook their own food. The culinary industry is starting to work as a community to help educate the public about the crisis of food insecurity in the United States and around the globe. Talented culinary professionals already inspire home cooks, the next generation of culinary superstars and everyone in between. According to reports in *Forbes* and *Time*, in 2016, Americans spent more money dining out than eating in. Food Institute president and CEO Brian Todd noted:

> *Millennials spend 44 percent of their food dollars—or $2,921 annually—on eating out, according to the Food Institute's analysis of the United States Department of Agriculture's food expenditure data from 2014. That represents a 10.7 percent increase from prior data points in 2010. In contrast, baby boomers in 2014 spent 40 percent of their food dollars on eating out or $2,629 annually....As millennials grow older, they have more expendable income for eating away from home, contributing to that increase in year over year expenditures.* [83]

At the same time, lifestyle and diet-related disease and illnesses such as heart disease, diabetes and obesity are at an all-time high.[84] It is time to find a happy medium between convenience and healthy well-being. People are choosing convenience over health, and convenience often comes at a steep price. Fine dining, fast food and fast casual restaurants

don't always offer healthy choices, nutrition dense foods or even food for that matter. People are quickly forgetting the importance of a well-cooked meal, consumed with family, in the comfort of their own homes. The pace of American life has superseded the need for family dinners, even family dinners in fantastic restaurants.

Those of us who love food, I mean really love food, often live with abundance bordering on waste. I recently read that most Americans throw away 40 percent of their food. According to the United Nations, *133 billion pounds* and *$160 billion* of food goes to waste each year across the United States; 50 percent is produce,[85] and more than 30 million people go hungry in this country each day.[86]

According to a recent report by UNEP and the World Resources Institute (WRI), about one-third of all food produced worldwide, worth around U.S. $1 trillion, gets lost or wasted in food production and consumption systems. When this figure is converted to calories, this means that about one in four calories intended for consumption is never actually eaten. In a world full of hunger, volatile food prices and social unrest, these statistics are more than just shocking: they are environmentally, morally and economically outrageous. Let's start with some basic statistics about food waste in North America and around the world.[87]

Worldwide Food Waste Facts

Every year, consumers in industrialized countries waste almost as much food as the entire net food production of sub-Saharan Africa (222 million vs. 230 million tons)

The amount of food lost and wasted every year is equal to more than half of the world's annual cereals crops (2.3 billion tons in 2009/10)

North American Food Waste Facts

In the USA, organic waste is the second highest component of landfills, which are the largest source of methane emissions

In the USA, 30 to 40 percent of the food supply is wasted, equaling more than 20 pounds of food per person per month[88]

According to the documentary film *Wasted! The Story of Food Waste*, every year, globally, 1.3 billion tons of food are thrown out, a third of which never even makes it to our plates. That's $218 billion—or 1.3 billion tons—of

food annually. Yet at the same time, 800 million people around the globe are starving. It's a problem. The documentary exposes the criminality of food waste and how it's directly contributing to climate change and shows us how each of us can make small changes. Filmmakers explore the reasons for this waste and ways to fix the problem. Starring chefs like Dan Barber, Massimo Bottura and Danny Bowien, it premiered at the Tribeca Film Festival on April 22, 2017, http://www.wastedfilm.com.

Social media platforms like Instagram, Facebook, Twitter and Pinterest, along with culinary-focused blogs, are further impacting wide-scale food waste in the Western world. We have fetishized picture-perfect food and expect every meal to be ready for its close-up.

"If it isn't pretty, we won't eat it: "camera cuisine"...Writing about food waste for the Atlantic *back in 2014, Elizabeth Segran gestured at both the shoppers who refuse to buy imperfect-looking fruit as well as the grocers who refuse to stock the shelves with any wonky-looking wares. "Grocery stores routinely trash produce for being the wrong shape or containing minor blemishes," Doug Rauch, the former president of the Trader Joe's Company, told her.*

But that assumes such produce even reaches the stores. Quoting workers and experts at a variety of vantage points in the food system, the Guardian's *Suzanne Goldenberg also reports that, "Vast quantities of fresh produce grown in the U.S. are left in the field to rot, fed to livestock or hauled directly from the field to landfill, because of unrealistic and unyielding cosmetic standards....In my mind, the desire for perfect produce came about in the 1940s as housewives adapted to widespread refrigeration and new CPG [consumer packaged goods] products," Eve Turow Paul, the author of* A Taste of Generation Yum, *writes in an email. "Suddenly, you could get a pineapple in Chicago in January. Wonder bread hit shelves a decade before. Perfection and manicured foods came to represent safety and new technology."[89]*

"It's easy to see how this obsession might become amplified in an era of high foodie-ism and Instagram where a sort of heirloom airbrushing has taken hold. Writing in the Times *in 2014, Pete Wells christened the extension of this phenomenon in restaurants as "camera cuisine," where dishes are tailored for the patron as well as a "global club whose members, checking out their phones or laptops, constitute an invisible gallery in the dining room."[90]*

We Don't Waste

I first met Arlan Preblud in 2011, just after the 2009 launch of his company We Don't Waste. He visited one of my graduate public-relations courses to tell his tale and ask for help marketing his concept. I have never forgotten the meeting or the disturbing facts he shared about food insecurity in America. Arlan continued with statistics about our starving population of children, elderly, veterans, working poor and the homeless juxtaposed by the tremendous food waste happening. He explained that an average of 40 percent of all food produced becomes waste—not just in the United States, but globally. As he explained that one in five children in Denver, my own city, go hungry every day and that often their only meal is a school lunch, I began to ponder my industry: the wine industry. Those of us in the restaurant world or in proximity to it are so fortunate to dine on elegant and nutritious food as a part of our work. Not everyone is so lucky. We Don't Waste has always had a place in my heart, and it now has a place in this book. In its first decade, We Don't Waste has expanded to a staff of six. They have recovered and repurposed 38 million servings of food benefiting seventy-five organizations, and who knows how many people have been served by this much needed nonprofit organization.

We Don't Waste is one of the largest food-recovery organizations operating in Colorado. It has strategic partnerships with restaurants, caterers, schools and other companies to source food donations. One of the most important partnerships is with Aramark, the company providing food and service for Coors Field, our professional baseball park; the Pepsi Center, home to the Nuggets basketball and Avalanche hockey teams and venue for concerts and other cultural events; the Denver Center of the Performing Arts; and several other cultural and sporting events centers and even hospitals and universities spread across Colorado. The We Don't Waste team focuses on collecting fresh produce, lean proteins, dairy products and other nutritious foods to be repurposed and distributed to organizations in need at no additional cost to the recipients. All of the food it collects and distributes is of high quality and would otherwise end up in landfills. We Don't Waste "allows our recipient organizations to consistently serve the hungry with healthy and wholesome meals without increasing their operating costs." Food recipient organizations spread across Colorado, including schools, food banks, community centers and even the Pine Ridge Indian Reservation in South Dakota, serving children and their families, veterans, the elderly and other food-insecure populations. "Since our inception in 2009, We Don't Waste has recovered

over 11,500,000 meals for the hungry: we have recovered over 38 million servings of food."[91]

Food insecurity is a great tragedy of our society. With so much abundance all around, reintroducing people to cooking and growing their own food is an increasing need. Overly stressed busy people often lean toward instant gratification meals of convenience. Buying fast food takeout is definitely more expensive and much less healthy than cooking a meal at home. Feeding a family of four doesn't have to be time-consuming or labor-intensive and learning the basics of cooking can be gratifying and empowering.

Farmers' Markets, Urban Gardens and Community Supported Agriculture

The home-grown, prepared and preserved foods of our grandparents have become increasingly rare, out of reach and expensive. There was a time when most families had gardens to provide organic, nutritious, healthy, clean foods supplementing what was purchased in markets. Often these gardens were small, and container gardens thrived on many city balconies. Real food, in many ways, has become out of touch for many consumers and even the farmers who grow it. Bourgeois food trends have always dominated the menus in restaurants, from exotic oysters, caviar and confections of the late nineteenth to the twentieth-century height of sophistication: mail-order delicacies from tony vendors like Balducci's, Dean & Deluca and Williams & Sonoma, providing popular holiday gifts of citrus and orchard fruit of the month club. Wealthy people have always paid a premium for their indulgences. Modern trends harken back to simpler times with paleo and gluten-free, fresh vegetable, fruits and lean protein–focused meals. Hot ticket items of the 2010s include providence-designated cocoa, avocados, ancient grains like quinoa, raw foods like sushi, health-enhancing super foods, fruit- and vegetable-based, gluten-free and paleo diets. Real food, as it seems, has become a luxury, and the markets extort the public for them. Food seems to have come full circle.

Micro farming and urban farming are very popular along the Front Range. Walking through downtown and suburban neighborhoods, one can easily spy neighbors congregating around flourishing vegetable gardens in raised beds alongside their beehives, backyard hens and ducks and the occasional little goat. Denver citizens are inspired by sunny days,

Amazing local produce at Union Station Farmers Market. *Author photo.*

the locavore and farm-to-table movement and the work of Denver Urban Gardens and the Denver Botanic Gardens. The best chefs in the city are fans and practitioners of local sourcing and foraging. Most weekends, they can be found at Union Station and Cherry Creek Farmers Markets, thoughtfully considering the produce from their favorite stands. Personal micro farms for the kitchen are all the rage among Denver urban and suburban foodies. The growing season in Denver is short, and at a mile high, the sun is intense, but when zoned right, Denverites can grow fruits and vegetables that rival what can be found in grocery store produce sections. In addition, a movement is underway to provide fresh produce to all levels of consumers across Denver and a broader Colorado. Residents are leasing or donating their front and back yards to Denver Urban Gardens and MicroFarm Colorado to increase local food production and alleviate fresh food deserts in the Denver metropolitan region.

During the summer months of 2016, a new kind of farmers' market sprang up at Denver Union Station. Inspired by European producer markets, Alex Seidel and Boulder Farmers Market partnered to bring the

only 100 percent producer-focused farmers' market to Denver. On weekend mornings, the promenade adjacent to Wynkoop, just outside the doors of Mercantile Dining & Provision, is brimming with chef demonstrations, fresh kombucha stands, coffee roasters, multiple fresh produce stands, Colorado grown flower stands and locally produced specialty food stands. Two unique businesses displaying their wares caught my eye, largely in part to the throngs of people waiting in line to make purchases. Mile High Fungi and Il Porcellino Salumeria present an array of Colorado-grown and produced offerings. Il Porcellino Salumeria factored heavily into the Hail the Mighty Pig chapter, and more on Mile High Fungi can be found later in this chapter.

Denver Urban Gardens

Established in 1985, nonprofit Denver Urban Gardens (DUG) operates its base project, Delaney Community Farm, as well as over 155 community gardens across the Denver metropolitan region, providing the land and the know-how to would-be urban farmers. Among this network of gardens are more than 40 school-based gardens providing education and nutritional support to Denver's youth and their families. DUG produces programming, including master gardener and composter training courses, and a free seed and transplant program for communities in need. DUG works to educate and eradicate food insecurity in Denver and frequently partners with the Denver Botanic Garden to host educational and fundraising events.

DUG and Delaney Community Farm are focused on easy and affordable food access, sustainable agriculture, community development and education with a goal of eradicating food insecurity and fulfilling the natural desire to touch the land and grow one's own food. Historically, human beings have a natural connection to the land and a childlike wonder at watching a seed blossom into a bountiful harvest on the dinner table. Delaney is a 158-acre historic farm located east of Denver in the suburb of Aurora. Members are invited to volunteer in production activities and educational programming. Delaney Community Farm also has a small apiary of working bees that gleefully pollinate the fruits, vegetables, flowers and trees of the farm and produce educational opportunities alongside richly flavored honey, which is sold at the farm.

Delaney Community Farm offers a reasonably priced CSA (Community Supported Agriculture) program supporting local farmers and providing

fresh produce to member families. The annual membership supports the farm's production costs while providing a weekly share of the seasonal harvest to members throughout the local growing season. Partners in the CSA include Mile High Fungi, Eastern Plains Natural Food Cooperative, Ela Family Farms and Western Colorado Honey. These partners make it possible for CSA members to purchase shares of eggs, beef, bison, lamb, yak and chickens along with fruits, vegetables and flowers. Programs like DUG and Delaney Community Farm CSA go a long way to support their communities and help alleviate the growing issue of food insecurity in cities and towns across Colorado and the United States.

MILE HIGH FUNGI

Mushrooms have been recognized as a super food: delicious, nutritious and fibrous, with immune enhancing and cancer fighting properties. In a world of food insecurity juxtaposed with luxury cuisine, the humble mushroom is finding itself growing in popularity in the United States. Already vastly foraged, cultivated and consumed across Asia, Scandinavia and Europe, mushrooms and their tremendous diversity, health benefits and culinary applications are slowly being embraced by Americans.

I encountered Mile High Fungi at the Union Station Farmers Market, intrigued by the display of fresh and fragrant mushrooms. I'd never seen such large oyster mushrooms—pearly white, silvery gray and the palest pink hues, nestled in tiny square crates and showcased under an umbrella to prevent damage from the scorching Colorado sun. Intrigued, I asked for a few boxes and went on my way. Later that day, I took the proprietors' advice and gently sautéed the bounty in a bit of olive oil, dry white wine and garlic and enhanced the flavor with just a hint of herbes de Provence. Wow, what a treat. The meal needed nothing else; it was satisfying and left me mulling it over for days. The following weekend, I went back to the market for a second stash and spent a few hours talking to the knowledgeable pair about all things mushroom.

Mile High Fungi is the brainchild of co-founders and entrepreneurial specialty mushroom farmers Liz and Michael Nail. Liz is from Denver, and Michael is from Maryland. They met at Evergreen State College in the mid-2000s while studying sustainable agriculture, organic farming and agro forestry. They enjoyed learning about wild foraging and mushroom

cultivation and bonded over their love of farming. After graduating, they relocated to the U.S. Virgin Islands to engage in eco-tourism, sailing around on the ocean and practicing organic farming and the local food movement. After three years, even paradise can become dull. Looking for a new challenge, the newly married Nails returned to Denver in 2010. Liz wanted to explore opportunities with the budding cannabis industry, and Michael went to work for Denver Urban Gardens Community Supported Agriculture program. Denver Urban Gardens inspired the Nails to put their educations to use in the food industry. Inspired further by the newly passed Colorado Cottage Food Act (2012), which allows for more lenient regulations on home-based commercial kitchens, the Nails decided to follow their shared passion for mycology. Liz and Michael were inspired by the work of Paul Stamets and other mycologists. Missing the mushrooms of the Pacific Northwest and with limited foraging opportunities in Colorado in comparison to the ripe lands of Oregon, the Nails uncovered their niche market. The couple lived in a historic home in Highlands, just northwest of downtown Denver. They converted sections of their home into a small, urban, organic mushroom farm with plans to sell dehydrated mushrooms. The plan quickly evolved, and now they offer fresh mushrooms to some of the best restaurants in the city. Liz and Mike have been producing mushrooms for nearly two years, learning mostly from trial and error but applying their experience and education and being willing to take risks. The mushroom business is a tricky one as it turns out; mushrooms are delicate, temperamental and even a bit mysterious. Over coffee one afternoon, the pair walked me through the process and the pitfalls of mycology.

Mushrooms are neither plants nor animals, belonging to the fifth kingdom, which includes yeasts, lichens, spores and mushrooms of all types. For the Nails and Mile High Fungi, the entire process begins in a petri dish in a sterile lab in their home. The couple is very careful to maintain a sterile environment, "It's all about managing risks." Mile High Fungi is also innovative in that it adheres to strict organic practices, growing the crop on organic spawn sourced from rye grain and organic millet that has been dried and sterilized. Once the spores activate, they are moved to racks containing a substrate base made from different hardwood shavings, straw and other applicable materials. The substrate is inoculated with the culture. The mycelium, the body of the mushroom, begins to grow in a moist, controlled environment. This mycelium continues to grow, running and spreading along the substrate. Mushrooms, as we know them, are actually the flowers of the plant, providing new spores and new opportunities to grow more

mycelium. Spores can even create different varieties of mushrooms. Each mycelium can produce several crops before it tires.

Liz and Michael explained that "shitake and oyster mushrooms are our bread and butter. We sell most of what we grow to local restaurants who love, love, love, our blue and pearl oysters. We grow other varieties, but these are our mainstays." The couple jumped in head first and believe in failing forward. The entire process has been one of hard lessons, but they are finally at a place where expansion or failure is imminent. They opted for expansion. In 2016, the Nails bought a parcel of land just west of Denver in the mountains near Conifer and built a home and a home for Mile High Fungi. The building is a state-of-the-art mushroom factory engaging in rapid crop rotation to meet ever-growing demand. Liz commented that Americans are behind the times with mushrooms due to long-held misbeliefs and unreasonable fears. Americans are used to tasteless, mushy, grocery store button mushrooms and are just now embracing cremini, portabella and other varieties. Europeans and Asians have been embracing foraging and mushrooming for centuries. Nails also explained that the mushroom business is healthy for the environment because it supports recycling organic materials, generates compost, creates nutritious food and supports the local economy. "It closes the loop, so to speak." The Nails are proud to be a part of the global food chain by supporting their local community in sustainable and organic farm-to-table practices. Since its inception, the Cottage Food Act has been adopted by fifteen states. "Would you rather buy mushrooms from an industrial park in another state, or from an idyllic, mountain farm?" After tasting their oyster mushrooms, definitely from Mile High Fungi.

Liz and Michael have devised a way to be completely sustainable; they source growing medium from local arborists, wood workers, brewers and farmers. Using LED and solar energy sources, the Mile High Fungi is finding creative ways to produce delicious and notorious mushrooms. Mile High Fungi offers shiitakes, lion's mane and blue oyster mushrooms all year round. Specialty mushrooms include king oysters, pearl oysters, pink oysters, maitake, nameko, pioppono and reishi mushrooms. Mile High Fungi vends its bounty at Union Station Farmers Market, Denver Urban Gardens CSA partner farmer shares and the Farmers Market at Highlands Square.

Big City Food Markets and Dining Halls

Cosmopolitan Denverites have always longed for a big-city food market like Takashimaya Times Square in Tokyo, Les Halles or Galeries Lafayette in Paris, Pike Market in Seattle, Reading Terminal Market in Philadelphia, the Ferry Building in San Francisco, Grand Central Market in Los Angeles and Grand Central Terminal at Union Station in Manhattan. A mainstay across Europe and Asia, this trend has quickly become popular with the urban foodie crowd. Americans are finally appreciating the idea of community around food: locally sourced, sustainably grown, diverse, simple and connected. Indoor markets specialize in selling locally sourced artisanal and agricultural goods like groceries alongside imported specialty foods. Most markets have a coffee stand or two, fresh produce stands, a bakery, cheese shops, butchers, a seafood stand and a wine or beer shop. Scattered throughout are smaller stalls vending confections and chocolates, ice cream, local honey, soaps and lotions, candles, greeting cards, city maps and newspapers.

Many markets are housed in repurposed industrial buildings and historic train stations with an eye toward preservation. They serve as a communal gathering space where teens congregate with retirees, toddlers play while their parents sip on coffee and businesspeople grab a quick bite in between meetings. Nearby residents pop in on their way home from busy days to pick up something for dinner, lingering with family on the weekends over breakfast and conversation. Chefs often use the food hall concept to incubate ideas by installing food counter outposts with abbreviated menus, pop-up stands and standalone dining rooms offering tremendous culinary diversity and creativity under one roof. Food halls and dining halls offer an interactive feel, as the consumer can watch the kitchen staff at work preparing recipes, baking bread, cleaning and butchering meats and seafood or roasting and grinding coffee beans. A sign of its recent growth, Denver is following the food market/dining hall trend with the Source, Denver Central Market, Avanti Food & Beverage and Stanley Market Place.

The Source

The Source was on the Denver scene, located in the rapidly growing RiNo Arts District, just north of Denver just after Broadway turns into Brighton Boulevard. The Source is housed in an old foundry building built in the late

The Source, a multiuse market and restaurant, opened in 2013 in the hip RiNo neighborhood, is housed in a repurposed brick foundry building. *Courtesy of John Poplin.*

1880s. It boasts two top-rated restaurants: Comida and Acorn; a coffee bar; Babette's French-style bakery; Mondo Market, selling specialty groceries, cured meats and cheeses; Western Daughter Butcher; along with the Proper Pour liquor and wine store; a flower shop; and the Crooked Stave Artisan Beer Project. A few businesses and a bank also have micro spaces in the building. On any given day, the Source is teaming with people sipping on coffee, tinkering on their laptops or dining in the busy restaurants. Strange though, the space doesn't have that communal vibe that most food markets and dining halls have. It feels isolating and sober under the dimly lit ceilings. The acoustics within the space are aggravating, and at times, the volume is irritating. Nevertheless, as a first attempt at a big-city market, it is a step in the right direction for Denver.

DENVER CENTRAL MARKET

Denver Central Market opened in 2016 on North Larimer Street in the tony Ballpark Neighborhood. Learning what it could from its predecessor,

Denver Central Market is the latest food hall to open in Denver, 2016. *Courtesy of John Poplin.*

the Source, Denver Central Market is a fantastic small-scale big-city market and food hall. The space, in the renovated H.H. Tammen building (circa 1928), a former furniture factory, is elegant. Sunlight floods through ceiling-high panel windows, glossing over exposed brick and shining off the tile floors. The setting transports you to a bygone era in a European city. Jeff Osaka, legendary icon behind Twelve and Osaka Raman restaurants, found the space and instigated the plan for this amazing urban culinary center. Some of the many businesses installed within include Crema Bodega coffee, Culture Meat & Cheese, the Local Butcher, High Point Creamery, Silva's Fish Market, SK Provisions, Temper Chocolates & Confections, Vero Italian Pizza & Pasta, a green grocer and a full-service bar. Long, blonde wood tables with chairs line the center corridor, inviting a sense of community as friends and strangers gather to socialize, dine and shop.

FOOD TRUCKS

Who doesn't love local street food? The convenience, the diversity and the affordable prices attract even the most discerning diners. Street food and food trucks became wildly popular thanks in part to Food Network and Travel Channel shows. Mobile gastronomy is on fire across the United States, and in Denver, it is celebrated with a weekly Thursday festival in Civic Center Park between the capitol and city and county buildings. At the height of the craze, the now defunct DenverStreetFood.com offered schedules for events across the city and links to nearly every food truck driving around. Food trucks have become popular options for nearly every event imaginable: I have seen food trucks catering weddings, conferences, parties, sports events, theatrical performances and political marches and rallies. Food trucks are mainstays on Auraria Campus, the downtown commuter campus housing two universities and two colleges and on the perimeters of Coor's Field; the Pepsi Center; and Mile High Stadium (Sports Authority Field). It seems that every restaurant has a food truck, from Little India and Biker Jim's Gourmet Dogs to Steuben's and R U Cereal offering everything from classic Belgian waffles and French-style crêpes, to street tacos, gourmet hot dogs and sausages, desserts and burgers.

Subscription Food Delivery Systems

Anything can be delivered, pretty much anywhere and anytime. Companies like Amazon, Whole Foods and Trader Joe's are test-marketing grocery delivery. In Denver, King Soopers and Safeway grocery chains engage in delivery. Taking it to the next level, ordering complete meals through food delivery subscriptions is the latest trend in food. In the age of instant gratification, overscheduled lives and kitchen guilt, more and more people are turning to meal delivery systems such as Blue Apron, Plated, Sun Basket, Home Chef and Peach Dish. Consumer favorite Hello Fresh partners with famed British chef and "food in schools" advocate Jamie Oliver. Denver chef Frank Bonanno even provides his own system called Supper Bell. In fact, most of these companies partner with or are founded by successful, well-seasoned chefs. The beauty of the meal-delivery system is that people are going back to their kitchens and having fun doing it. They are increasing their own culinary skills and expanding their food diversity, often selecting meals they might otherwise ignore. Depending on the company and subscription plan, consumers receive a weekly box containing perfectly prepared, packaged and parceled ingredients along with colorfully illustrated recipe cards to ensure foolproof home-cooked meals. The ingredients are high quality, with optimal freshness. Many meals even offer wine or beer pairing suggestions. While these systems simplify efforts, cooks still must know their way around the kitchen. Over time, home cooks will improve their technique, and perhaps their own creativity will begin to shine through.

Subscriptions can be customized for special dietary requests like gluten free, dairy free, vegetarian and vegan. Most systems offer ten to fifteen weekly menu choices. The subscriber selects one, three or five meals a week for two or four persons. Prices are as wildly diverse as the menu options, with individual servings averaging between $10 and $20 a serving and weekly averages ranging from $60 to $100. These costs of convenience add up pretty quickly. Criticisms of these food systems are twofold. Food delivery systems are not eco-friendly due to their excessive, non-recyclable packaging. Every ingredient is individually shrink-wrapped, bottled or packaged in plastic and cardboard right down to tiny bottles of soy sauce, olive oil, salt, pepper and other condiments. The other critique is that the consumer is even further removed from the source of their food. These systems are the antithesis of the locavore movement, though many claim to be locally sourced. Once that package is mailed across the country,

there is nothing local about it. Considering Americans spent more than $70 billion on takeout and delivery meals in 2015, and new food delivery systems are hitting the market every week, it is doubtful that these systems will lose ground any time soon.[92]

Tribally Sourced

Ben Jacobs was just twenty-five years old when he took a chance on his past and partnered with Matt Chandra to open Denver's only Native American owned and operated restaurant featuring Native American cuisine. The restaurant, Tocabe, arrived on the scene late in 2008 in the emerging LoHi section of the city. Jacobs wasn't a stranger to the restaurant business, growing up around his family's Denver-based Grayhorse: An American Indian Eatery, dating back to 1989. Jacobs is a familial member of the Osage Nation, a tribe that has recent roots in Colorado. Drawing from his heritage, Grayhorse and his youth, Jacobs and Chandra took Native American dining into the modern era by establishing a fast-casual theme steeped in traditional Osage recipes and culture. Tocabe offers a glimpse into the original signature cuisine of Denver and Colorado.

The duo was drawn to the fast-casual concept of upfront transparency in a kitchen where the crew and consumer interact. Jacobs explained in a recent interview with Danny Klein of *QSR Magazine*, "When you say hominy salsa or shredded bison or butternut squash relish, people have no idea what that is, and we didn't want to have pictures of food on the menus or anything like that," Jacobs said. "We wanted to have the food visible up front so you could see the quality. You could see the freshness. You could see that everything is prepared in front of you."[93] Tocabe gained an early abundant and loyal following, but diner dollars became scarce during the Great Recession and the culinary boom of the early 2010s. Tocabe took every catering gig it could land just to enrich the brand and reach. Guy Fieri of Food Network fame visited Tocabe in 2010. The restaurant was featured in 2011 on Fieri's *Diners, Drive-Ins, and Dives* series. The newfound notoriety forced Jacobs and Chandra to rethink their concept, double their staff and make plans for expansion. In 2014, the pair opened their second location in conservative Greenwood Village, and they added a prolific food truck to their model in 2016.

Tocabe takes the locavore movement to the next level by engaging in what the owners call tribally sourced ingredients. Jacobs and Chandra work to source ingredients from Native American owned and operated farmers and producers, listing their partners prominently on their menus and website. "We've been working on that diligently for the last two years and really building partnerships with people....That's another part of the native community: supporting and stabilizing one another."[94] Native American cuisine is based on locavore and slow food principles. It has always been responsibly sourced, sustainable, fresh, seasonal and well balanced. The use of robust flavors and quality ingredients is the pinnacle of fine dining in Denver today. Native American–influenced Tocabe brings Denver's culinary evolution full circle and back to its earliest roots. On my first visit to the restaurant, Matt Chandra was quick to point out that Native American cuisine is too broad a term to describe what Tocabe offers, pointing out that Native American culture is vast, with tremendous diversity. Every region, nation, tribe and even family can offer a unique perspective on their own cuisine, using different ingredients and techniques to create their signature fare. There is no single cuisine that is representative of Native American food.

It just isn't that simple, and we are working to change the narrative of what Native American means....People don't know the diversity in the cuisine, they don't understand that what one nation does is different from others. Our food is representative of the Osage Nation, which was expelled from Oklahoma earlier in our history....We support the native community, we work together as a community, we offer fresh, healthy options, and we educate people on what it means to eat native.[95]

Mercantile Dining & Provision, one of the best restaurants in the city, is located inside of Union Station. *Author photo*.

CONCLUSION

To continue to perpetuate the myth that Denver lacks creativity, culinary voice or is in other ways behind the times, is a trite, petty oversight. Many world-famous journalists, culinary professionals and members of the media continue to generalize Denver as an unsophisticated, provincial cow town, something it hasn't been for decades. Except for one day each January, the days of cattle wandering in the streets of Denver are more than a century old. Denver was founded on gold quests and has always been a truly hidden jewel. Denver continues to be one of the fastest growing, most economically stable and transformative cities in the nation. Sure, the changes are coming at us more quickly than any of us can keep up with or even comprehend. Nevertheless, elements of the past remain to remind us of the Denver of days gone by. The Denver of glamour and glitz, of gold dust and gourmet delights. Modern Denver isn't as elegant as the Denver of the past, but it is fantastically diverse, modern, culturally rich and one of the healthiest places you will ever visit or inhabit.

According to Dr. Liz Thach, MW, the most economical way to create a world-class wine region is to develop and nurture a territorial brand.[96] The same can be said for a culinary hot spot. According to the famed wine expert, attaining greatness comes down to a series of critical moves. First, establishing an iconic product along with a cohesion of the actors. These actors must be willing to accept the imperative of a territorial brand and a common story. And finally, the brand and story must be disseminated by an effective brand manager. It seems as though Denver's

culinary professionals are collaborating to develop this territorial brand and common story built around the ideas of fresh, farm to table, locally sourced, postmodern creations. As often happens, brand exploiters in the form of critics, writers and bloggers are enthusiastically supportive of just a handful of restaurants and chefs. Denver is no different. A little group of food writers steers the show. The writers for Denver Eater, Zagat, Dining Out and Westword tend to focus on the same restaurants, clustered in central Denver, and rarely give anyone else a second glance. Some of those restaurants have been included in these pages, some have not. There are so many deserving and dedicated chefs and culinary professionals working and creating cuisine across the Colorado Front Range—too many to mention in these pages. The chefs, restaurateurs, restaurants and producers that I explored for this book were and are essential to the ongoing culinary evolution happening in Denver. The rest of them—the cooks, chefs, restaurants, cafés, food trucks, caterers, farmers' markers, food stands, specialty shops and grocery vendors—are just as important and devoted to doing their thing, and their best, to serve the hungry population.

Colorado Restaurant Industry Statistics

There are approximately 11,250 eating and drinking locations in Colorado.
Total restaurant sales in Colorado exceeded $11.6 billion in 2016 and are expected to exceed $12 billion in 2017. (This is a 7.6 percent increase over 2014 and 38 percent increase in sales since 2010.)
Colorado's food service industry employs 275,000 workers.
Colorado restaurants will generate approximately $309 million in local taxes.
More than 75 percent of Colorado's restaurants are independently owned and operated.
Colorado restaurants account for 12 percent of the state labor force.

National Restaurant Industry Statistics

Total U.S. foodservice industry sales will reach approximately $790 billion, 4 percent of GDP.

U.S. consumers will spend approximately $2.2 billion per day on food away from home.

The restaurant industry is the nation's second-largest private sector employer with 14.5 million people employed in 1 million locations.

Small Businesses with a Large Impact

Half of all adults have worked in the food service industry at some time.

One out of three adults found their first job in the restaurant industry.

Half of all adults are restaurant patrons on a typical day.

23 percent of table-service restaurant sales come from travelers and tourists.

Restaurants employ more minority managers and have more women in management and ownership positions than any other industry.

A Tight Margin

A typical $15 restaurant meal gets broken down as follows:

$5.04 employee salaries and wages
$4.95 food and beverage costs
$4.40 operating costs
$0.61 operator income before taxes

Source: Colorado Restaurant Association using National Restaurant Association and Colorado State Government data.[97]

NOTES

Introduction

1. "The 'Great White Way' of Denver's Theater Row," *Denver Post*, May 28, 2013, http://blogs.denverpost.com/library/2013/05/28/denvers-great-white-way/7926.
2. Scientific and Cultural Facilities District, http://scfd.org.
3. Denver Center for the Performing Arts, http://www.denvercenter.org.
4. "Denver Performing Arts Complex," Wikipedia, last modified December 31, 2017, https://en.wikipedia.org/wiki/Denver_Performing_Arts_Complex.
5. "Red Rocks Amphitheatre," Wikipedia, last modified May 6, 2018, https://en.wikipedia.org/wiki/Red_Rocks_Amphitheatre.
6. Colorado Business Committee for the Arts, http://cbca.org.
7. Martha C. White, "We Now Spend More at Restaurants than at Grocery Stores," *Time*, June 15, 2016, http://time.com/money/4370620/food-spending-restaurants-versus-groceries.
8. Jonathan Maze, "Colorado: World's Fast Casual Capital," *Restaurant Finance Monitor*, August 29, 2013, http://www.restfinance.com/Restaurant-Finance-Across-America/August-2013/Colorado-Worlds-Fast-Casual-Capital.
9. Jon Murray, "Denver's Growth Spurt Slows Down—A Little—As the City's Population Near 700,000," *Denver Post*, March 29, 2017, https://www.denverpost.com/2017/03/28/denvers-growth-spurt-slows-down.

10. Ben Markus, "Denver Construction Is A-Boomin', but for How Long?," Colorado Public Radio, April 4, 2017, http://www.cpr.org/news/story/denver-construction-is-a-boomin-but-for-how-long.

11. Laura Dannen Redman, "Denver Is Officially a Food City," *Condé Nast*, April 18, 2018, https://www.cntraveler.com/story/denver-is-officially-a-food-city.

12. "30 Most Exciting Food Cities in America 2017," Zagat, December 17, 2017, https://www.zagat.com/b/30-most-exciting-food-cities-in-america-2017.

Chapter 1

13. "Native Americans in the United States," Wikipedia, last modified May 30, 2018, https://en.wikipedia.org/wiki/Native_Americans_in_the_United_States.

14. "Morrill Land-Grant Acts," Wikipedia, last modified May 14, 2018, https://en.wikipedia.org/wiki/Morrill_Land-Grant_Acts; "Homestead Acts," Wikipedia, last modified May 18, 2018, https://en.wikipedia.org/wiki/Homestead_Acts; "Native Americans."

15. "Indian Reservation," Wikipedia, last modified May 3, 2018, https://en.wikipedia.org/wiki/Indian_reservation.

16. "Native American Cuisine," Wikipedia, last modified May 4, 2018, https://en.wikipedia.org/wiki/Native_American_cuisine.

17. "Baurs," History Colorado, http://www.historycolorado.org/sites/default/files/files/Researchers/Mss.02624.pdf/Baurs.

18. "Denver, the Birthplace of the Ice Cream Soda?," *Denver Post*, August 1, 2009.

19. "Baurs."

20. Ibid.

21. Ibid.

22. "Charles Heidsieck," Wikipedia, last modified October 1, 2017, https://en.wikipedia.org/wiki/Charles_Heidsieck; Joshua Malin, "The Story of Champagne Charlie: American Champagne Pioneer, Accused Confederate Spy, and One Time Owner of Denver," Vinepair, http://vinepair.com/wine-blog/the-story-of-champage-charlie.

Chapter 2

23. "The 1950s: Happy Days," U.S. History, http://www.ushistory.org/us/53.asp.
24. Tom Noel "Belly Up to Denver's Oldest Bar," My Brother's Bar flyer, October 3, 1997.
25. Ibid.
26. R. Phillips, "These 15 Old Restaurants in Denver Have Stood the Test of Time," Only in Your State, July 8, 2016, http://www.onlyinyourstate.com/colorado/denver/oldest-restaurants-in-denver; "Belly Up."

Chapter 3

27. "Big Night," Wikipedia, last modified April 22, 2018, https://en.wikipedia.org/wiki/Big_Night; "Big Night (1996)," IMDb, http://www.imdb.com/title/tt0115678.
28. Colleen O'Connor, "Patsy's Inn Closes after 95 Years of Italian Cuisine in Denver," Denver Post, last modified December 2, 2016, http://www.denverpost.com/2016/08/23/patsys-inn-restaurant-denver-closes.
29. "About This Family Style Restaurant." Cafe Jordano, http://cafejordano.com/history.html.
30. Jordano's Grill, http://www.jordanogrill.com.

Chapter 4

31. "History," National Western Stock Show, http://www.nationalwestern.com/about/history.
32. Buckhorn Exchange, http://buckhorn.com.
33. "History," Buckhorn Exchange, http://buckhorn.com/history.php.
34. "The History of The Fort," The Fort, http://thefort.com/the-history-of-the-fort.
35. Ibid.
36. Ibid.

Chapter 5

37. "Denver's Le Central Restaurant to Close after 34 Years of Business," *Denver Post*, last modified April 21, 2016, http://www.denverpost. com/2015/09/02/denvers-le-central-restaurant-to-close-after-34-years-of-business.
38. Pierre Wolf, Gene Amole and Dick Kreck, *Tastefully Yours: Savoring Denver's Restaurant Past* (Denver, CO: Professional Book Center, 2002).
39. Bethany Ao, "Denver Personality Pierre Wolfe Is the Country's Longest Running Radio Host at 91," *Denver Post*, August 16, 2016.
40. Patrick Sweeney, "Chef Pierre Dishes Up Dirt and History," *Denver Business Journal*, December 16, 2001, http://www.bizjournals.com/ denver/stories/2001/12/17/story6.html.
41. Pierre Wolfe, interview with the author, September 24, 2016.
42. Ibid.

Chapter 6

43. Kyle Wagner, "Casual but Elegant Mel's Is Bidding Adieu," *Denver Post*, last modified May 7, 2016, http://www.denverpost.com/2007/04/23/ casual-but-elegant-mels-is-bidding-adieu.
44. "Denver's Le Central Restaurant to Close."
45. "About KT," Kevin Taylor Restaurant Group, http://www.ktrg.net/ about-kt.
46. Mark Harden, "Chef Kevin Taylor, Son to Open Broomfield Restaurant," *Denver Business Journal*, last modified May 20, 2016, http:// www.bizjournals.com/denver/news/2016/05/20/chef-kevin-taylor-eyes-broomfield-for-latest.html.
47. "About KT."

Chapter 7

48. "The New Nordic Food Manifesto," Nordic Co-Operation, http://www. norden.org/en/theme/ny-nordisk-mad/the-new-nordic-food-manifesto.
49. Ryan Leinonen, interview with the author, February 2016.
50. Eater Staff, "Ryan Leinonen of Trillium Heads to the Beard House," June 23, 2014, https://denver.eater.com/2014/6/23/6205579/ryan-leinonen-of-trillium-heads-to-the-beard-house.

51. "About," Kitchen Bistros, https://www.thekitchenbistros.com/our-story.
52. "Our History," Big Green, https://biggreen.org/about/our-history.

Chapter 8

53. Aaron Forman, interview with the author, May 2016.
54. Ibid.
55. "Business Q&A: Cafe Prague, Morrison," *Denver Post*, May 13, 2014, http://www.denverpost.com/2014/05/13/business-qa-cafe-prague-morrison.
56. Bonanno Concepts, https://www.bonannoconcepts.com.
57. Ibid.
58. Mel Master, interview with the author, June 2016.
59. Josie Sexton, "These Are the 16 Stalls Coming in May to Frank Bonanno's Milk Market," Eater, March 21, 2018, https://denver.eater.com/2018/3/21/17147444/milk-market-restaurants-dairy-block.
60. Josie Sexton, "Four Things to Know About Frank Bonanno's Milk Market," Eater, May 9, 2018, https://denver.eater.com/2018/5/9/17336280/milk-market-dairy-block-frank-bonanno-opening.

Chapter 9

61. Pork Checkoff, http://www.pork.org/checkoff-reports/putting-the-gears-in-motion/pork-remains-fastest-growing-protein-in-foodservice.
62. "Charcuterie," Wikipedia, last modified June 5, 2018, https://en.wikipedia.org/wiki/Charcuterie.
63. "Study: Pork Popularity Growing Fast," Food Manufacturing, August 29, 2013, http://www.foodmanufacturing.com/news/2013/08/study-pork-popularity-growing-fast.
64. "Pork: Versatile and Healthy Protein," Pork Checkoff, http://www.porkbeinspired.com.
65. "Jamón Ibérico," Wikipedia, last modified June 1, 2018, https://en.wikipedia.org/wiki/Jam%C3%B3n_ib%C3%A9rico.
66. Brian Albano and Bill Miner, Il Porcellino Salumi, interview with the author, August 26, 2016.
67. Ibid.
68. Cory Nead, Brian Albano and Bill Miner, interview with the author, August 26, 2016.

69. "Curing (Food Preservation)," Wikipedia, last modified May 10, 2018, https://en.wikipedia.org/wiki/Curing_%28food_preservation%29.

70. "About," Brunson & Co., http://brunsonconcepts.com/about; Justin Brunson, interview with the author, January 2017.

71. "About the Show: SEARious Meats," Food Network, https://www.foodnetwork.com/shows/searious-meats.

Chapter 10

72. "The Team at Fruition," Fruition, http://www.fruitionrestaurant.com/our-story/fru-cru.

73. Alex Seidel, interview with the author, March 1, 2017

Chapter 11

74. Sam Dean, "The History of Hard Cider, From the Old Testament to the Apple Orchard," *Bon Appétit*, October 18, 2012, https://www.bonappetit.com/test-kitchen/ingredients/article/the-history-of-hard-cider-from-the-old-testament-to-the-apple-orchard.

75. Ted Bruning, *Golden Fire: The Story of Cider* (N.p.: Authors Online, 2012).

76. "Our Cider Journey," Stem Ciders, http://stemciders.com/our-cider-journey.

77. "City Parks," Denver Parks and Recreation, https://www.denvergov.org/content/denvergov/en/denver-parks-and-recreation/parks/city-parks.html.

78. "Bicycling in Denver," Denver, the Mile High City, https://www.denvergov.org/content/denvergov/en/bicycling-in-denver/infrastructure.html.

79. Denver Bcycle, https://denver.bcycle.com.

Chapter 12

80. Christopher Davies, interview with the author, November 17, 2016.

81. "About," James Beard Foundation, https://www.jamesbeard.org/about.

82. "Frasca, Alex Seidel, Eric Skokan, and Steve Redzikowski Named James Beard Semifinalists," Dining Out Denver & Boulder, http://diningout.com/denverboulder/frasca-alex-seidel-eric-skokan-steve-redzikowski-named-james-beard-semifinalists.

Chapter 13

83. "Millennials Spend 44 Percent of Food Dollars on Eating Out Says Food Institute," *Forbes*, October 10, 2017, https://www.forbes.com/sites/alexandratalty/2016/10/17/millennials-spend-44-percent-of-food-dollars-on-eating-out-says-food-institute/#194bf9393ff6; Martha C. White, "We Now Spend More at Restaurants Than at Grocery Stores," *Time*, June 15, 2016, http://time.com/money/4370620/food-spending-restaurants-versus-groceries.

84. "2015–2020 Dietary Guidelines," https://health.gov/dietaryguidelines/2015/guidelines/introduction/nutrition-and-health-are-closely-related.

85. "Goal 2: End Hunger, Achieve Food Security and Improved Nutrition and Promote Sustainable Agriculture," United Nations, http://www.un.org/sustainabledevelopment/hunger.

86. "Hunger in America," Society of St. Andrew, http://endhunger.org/hunger-in-america.

87. Dana Gunders, "Wasted: How America Is Losing Up to 40 Percent of Its Food from Farm to Fork to Landfill," Natural Resources Defense Council, August 2012, https://www.nrdc.org/sites/default/files/wasted-food-IP.pdf.

88. Ibid.

89. Adam Chandler, "Why Americans Lead the World in Food Waste," *The Atlantic*, July 15, 2016, https://www.theatlantic.com/business/archive/2016/07/american-food-waste/491513.

90. Ibid.

91. "Our Mission," We Don't Waste, https://www.wedontwaste.org/mission.

92. Eric Kim, "A Secular Shift to Online Food Ordering," TechCrunch, May 7, 2015, https://techcrunch.com/2015/05/07/a-secular-shift-to-online-food-ordering/#.wecjiw:UB3t.

93. Danny Klein, "American Indian Cuisine Goes Fast Casual," QSR, April 11, 2017, https://www.qsrmagazine.com/exclusives/american-indian-cuisine-goes-fast-casual.

94. Ibid.

95. Matt Chandra, interview with the author, April 22, 2017.

Conclusion

96. Dr. Liz Thatch, "How to Create a World-Class Wine Region," Wine Business, October 18, 2016, https://www.winebusiness.com/news/?go=getArticle&dataid=175862.

97. "Industry Statistics," Colorado Restaurant Association, http://www.corestaurant.org/newsroom/industry-statistics.

INDEX

ABOUT THE AUTHOR

Longtime Colorado resident Simone FM Spinner is an aesthetic philosopher, wine educator, doctoral fellow and environmental activist currently living in Cascais, Portugal. She earned her master of humanities at the University of Colorado–Denver, after writing her seminal thesis, "Aesthetics & Culture of Wine: Is Wine Art?" She also created and earned the first undergraduate degree in the study and business of wine for Metropolitan State University of Denver, twenty-one years after leaving the University of Colorado–Boulder, where she was a dance major. She holds a series of advanced wine education and sommelier credentials from the Wine & Spirits Education Trust, Court of Master Sommeliers, Spanish Wine Academy, Society of Wine Educators and various other beverage education organizations. Simone was hoping to complete her WSET diploma in 2017 but opted to join an international doctoral fellowship instead. A former ballet dancer, Pilates instructor and music industry survivor, Simone worked as a fine wine specialist and taught classes about wine studies, aesthetic philosophy, cultural studies and the interactions between art, music and wine at the University of Colorado–Denver and Metropolitan State University of Denver.

She has completed her first-year research studying the effects of climate change on European wine culture and the wine industry as a doctoral

fellow at the Lisbon Consortium with the Catholic University of Lisbon, Portugal; University of Giessen, Germany; and University of Copenhagen, Denmark, where she is also happily exploring the culinary culture of the regions. Simone owns two companies, Wine Rocks and Chasing Grapes LLC (www.winerocksllc.com), focused on wine-related consulting, writing, education, teambuilding corporate seminars and wine events. Simone is the senior editor for the French Wine Girl Travels blog and wrote a column about wine for *303 Magazine* and a column about wine and art for *Wine Country International Magazine*. Currently, she is penning a wine travel series called *Chasing Grapes* based on her wine region travels along with a memoir titled *Lessons from the Lisbon Coast*, chronicling the unique challenges, opportunities, rewards and lessons of moving to a foreign country without knowing anyone or speaking the language in order to pursue a doctorate degree, a new direction and new adventures.

In her spare time, Simone finds inspiration consuming the arts, traveling, dancing, practicing yoga, gardening, taking long walks along the ocean, cycling and going to concerts at Red Rocks Amphitheater with family and friends. Her home is in the foothills west of Denver, but she is living in a tiny seaside apartment in Cascais, Portugal, just west of Lisbon, with the loves of her life: her Shiba Inu dogs, Oscar Wilde and Zen Zen Spinner.